REFINED KNITS

Jennifer Wood

Sophisticated Lace, Cable,
and Aran Lace Knitting

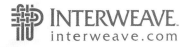
INTERWEAVE.
interweave.com

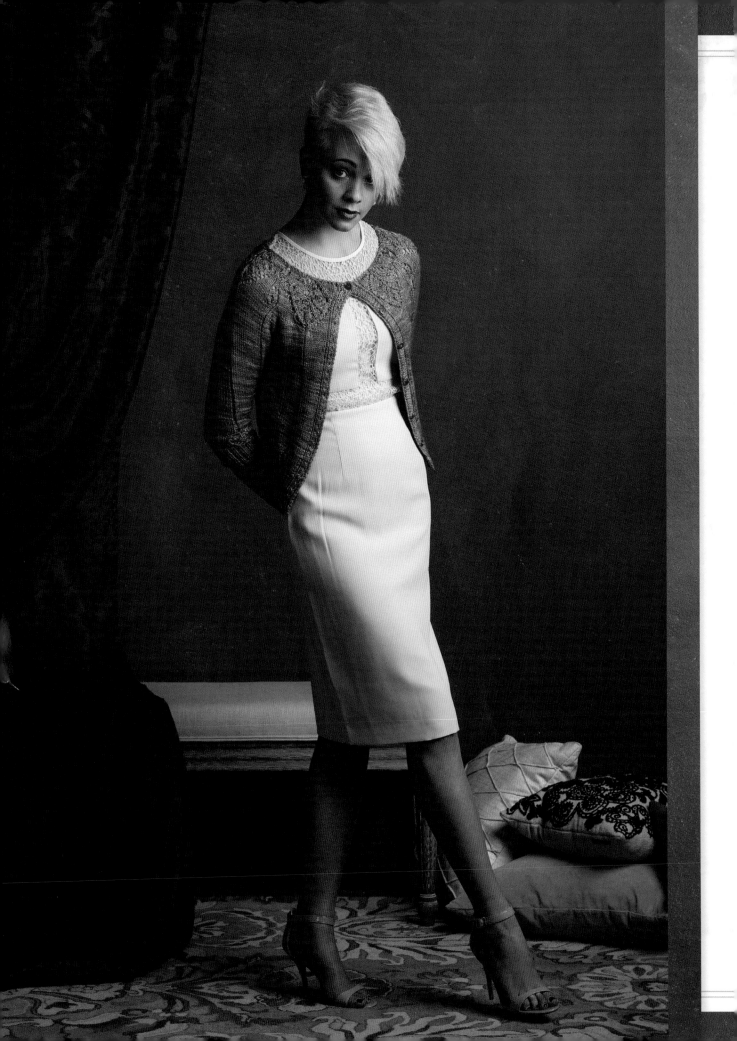

TABLE *of* CONTENTS

4 KNITTING WITH GRACE:
*Modern Patterns from
Old Techniques*

6 ENDURING CABLES

8 Willa Cardigan

22 Adelaide Reversible Scarf

28 Idril Pullover

38 Brielle Shawl Collar Cardigan

52 Elodie Waving Rib Mitts

56 Ada Reversible Pullover

62 TIMELESS LACE

64 Victoria Diamond Pullover

72 Louisa Cowl

78 Shayla Shrug

84 Vivian Sleeveless Pullover

90 Anwen Rectangular Shawl

96 Camelia Pinecone Cardigan

104 Dwyn Shawl

108 ELEGANT ARAN LACE

110 Corinne Oval Pullover

118 Keavy Simple Pullover

126 Billie Hat

132 Estee Light Cowl

138 Maisie Short-Sleeve Cardigan

144 GLOSSARY AND TECHNIQUES

154 RESOURCES AND INDEX

KNITTING *with* GRACE

Modern Patterns from Old Techniques

When my oldest daughter was in middle school (and I was in my mid-thirties), she read *The Witch of Blackbird Pond* by Elizabeth George Speare. The descriptions of colonial women knitting captivated her, and she begged me to teach her how to knit. So I purchased an instructional knitting book, two sets of needles, and some scratchy yarn. We sat down to knit.

First, we learned the knit stitch—to our surprise, our knitting did not have the pretty little V's like in the pictures. We learned the purl stitch. Voilà! We had the pretty little V's. I loved those V's enough to keep going, even after my daughter finished the book and put down her needles.

My first real knitting project was a cabled scarf. I do like a challenge! I wanted to learn how to knit cables, which add interest and complexity to a plain stockinette scarf. But I had no idea what I was getting into! I trudged on and finished the scarf because I was making it for my husband. It had quite a few mistakes, but it was made with lots of love.

As interesting as I thought cables, I did not do many cabled projects after my husband's scarf. I found using a cable needle a cumbersome, slow process—until I discovered cabling without a needle and reversible cabling. This opened up a whole new world of Aran knitting for me. Imagine—a beautifully cabled scarf with no ugly side!

Soon enough, I spied a sample scarf knitted in lace at my favorite knitting store. It was so beautiful that I had to learn how to knit the lace. Like my first cable scarf, I had no idea how difficult that lace scarf would be. I made the mistake of using mohair yarn. Even after I blocked it, the scarf hardly resembled the picture in the pattern. But I was determined to learn lace knitting. After more practice, I began to enjoy the rhythm of lace knitting, the swing of the needles for yarnovers and decreases and knit and purls all in one row.

TAKEN BY DESIGN

Something about this age-old craft took hold of me. When my hands are busy, my mind is free to think, wonder, pray, or listen to a good book. I knitted at every opportunity.

Before long, I wanted to write my own patterns and sell them—at the very least, I thought I could turn my patterns into money to spend on yarn. I launched Wood House Knits, self-publishing a range of adventurous cable and lace garment patterns for women.

I began with a few straightforward stockinette designs, adding only simple details such as eyelets to decorate them. They were fine, but I missed my two favorite techniques, cables and lace. Determined to design

wearable sweaters with intricate, graceful details, I focused on creating flattering silhouettes with pretty pattern stitches that are fun to knit.

Interweave Knits published one of my designs for the first time in the Fall 2011 issue—the Cardiff Coat was chosen as the cover! I realized then how important it is to me to make my patterns work for as many sizes as possible. Learning to size made me a better designer. Now, I start an Aran and lace design by thinking of how it would work for a range of sizes.

WONDROUS COMBINATIONS

Cables add interesting and structural details to garments. Useful and beautiful, even the oldest Aran patterns can be adapted to create new forms. Inventing new cable patterns enables me to connect with old designs while creating something modern. They add fortitude and history to new designs.

Knitted lace conjures images of the world around me—intricate shadows cast by the empty tree limbs on a moonlit winter's night. I am constantly amazed at the breathtaking designs that can be created with lacework.

Cables and lace are special enough by themselves, but there is something wondrous in combining the two—like uniting strength and grace. I absolutely love playing with stitch patterns, rearranging, adding a lace stitch here, a cable there until it becomes just right. Cabling and knitting lace are the two techniques that I concentrated on for this book. If you are new to these techniques, start with one of the simpler designs, such as Elodie (page 52) or Louisa (page 72) and work your way up to the more complex garments.

I loved designing the cable and lace pieces in this book. Once you begin knitting these beautiful, contemporary pieces based on old techniques, you will love the old-style knitting rhythm and the modern results.

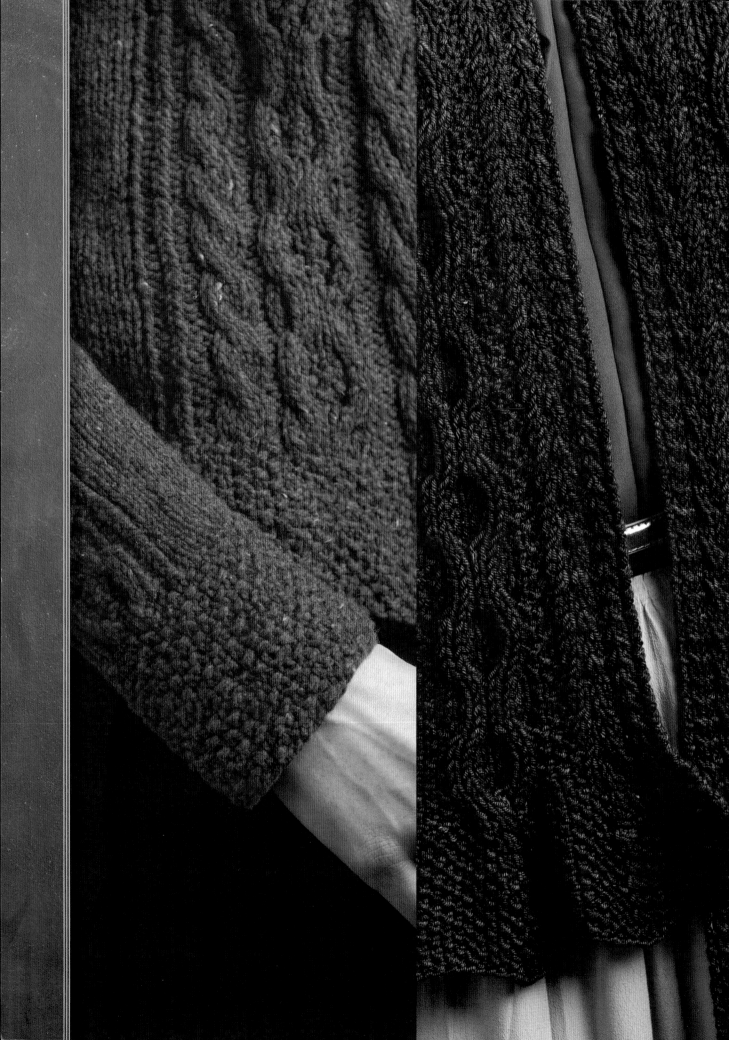

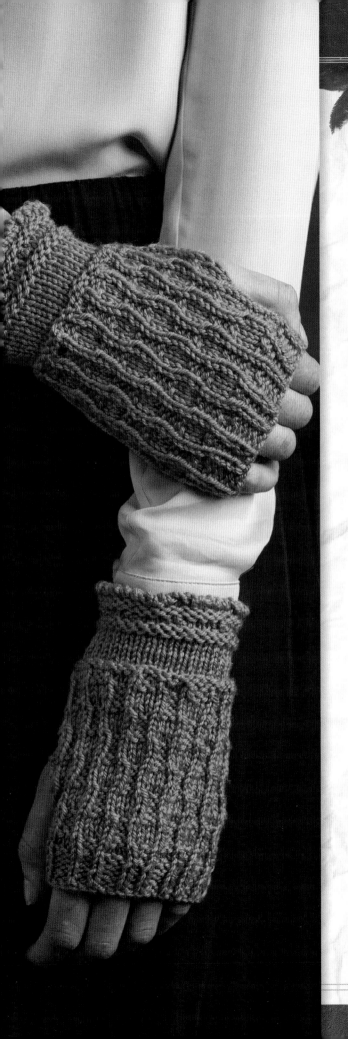

ENDURING
Cables

My daughter was watching me knit cables one day and said, "All you are doing is rearranging the stitches!" The array of beautiful patterns that can be made just by rearranging stitches is so intriguing.

Traditionally, cable panels are arranged to run down the front and back of a sweater, as in Willa (page 8) and Brielle (page 38) or in an all-over pattern as in the one that covers Ada (page 56).

But cables are timeless, and they can be worked in unique and modern ways, such as bordering the neckline of Idril (page 28) or adding a reversible detail to scarves such as Adelaide (page 22). A two-sided cable on a shawl collar such as Brielle (page 38) makes a traditional garment fresh and new. When you join the adventurous world of cable knitting, you can create modern garments rooted in a rich history.

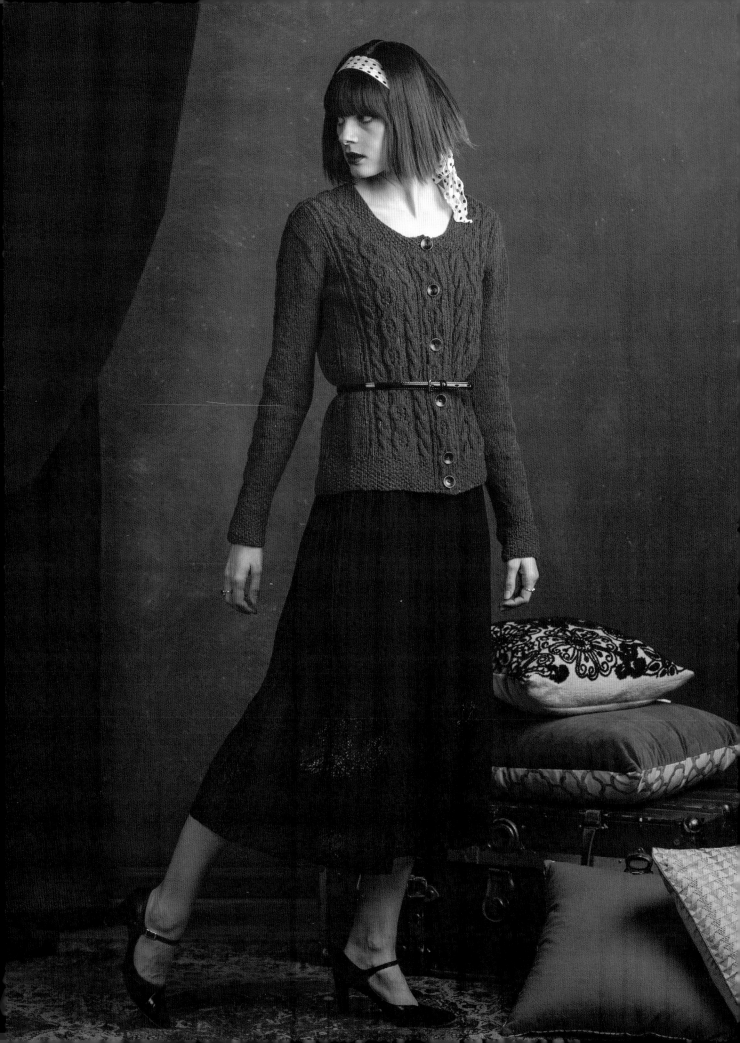

FINISHED SIZE

About 33 (36¼, 40, 43½, 46¼, 49, 51¾, 55¼)" (84 [92, 101.5, 110.5, 117.5, 124.5, 131.5, 140.5] cm) bust circumference, buttoned with 2" (5 cm) overlap and 20¾ (22¼ 22½, 23¼, 24, 24¼, 25¼, 26)" (52.5 [56.5, 57, 59, 61, 61.5, 64, 66] cm) long.

Cardigan shown measures 36¼" (101.5 cm).

YARN

Worsted weight (#4 Medium).

Shown here: Brooklyn Tweed Shelter (100% wool; 140 yd [128 m]/1¾ oz [50 g]), embers, 8 (8, 9, 9, 10, 10, 11, 11) skeins or 1,047 (1,109, 1,187, 1,249, 1,310, 1,372, 1,431, 1,495) yd (957 [1,014, 1,085, 1,142, 1,198, 1,254, 1,308, 1,367] m) of similar yarn.

NEEDLES

Body and sleeves: Size U.S. 8 (5 mm): 24" (60 cm) circular (cir) and a set of 4 or 5 double-pointed (dpn).

Neckband: Size U.S. 6 (4 mm) and 5 (3.75 mm) 16" (40 cm) cir.

Adjust needle sizes if necessary to obtain the correct gauge.

NOTIONS

Stitch markers (m); stitch holders or waste yarn; cable needle (cn); locking marker; tapestry needle.

Six ⅞" (2.2 mm) buttons.

GAUGE

18 sts and 26 rows = 4" (10 cm) in St st with larger needles.

73-st back cable pattern = 12½" (31.5 cm) wide with larger needles, blocked.

Willa
CARDIGAN

Cables and seed stitch go together like tea and cookies. The mix of the cabled circles and seed stitch give beauty and grace to a standard cardigan. Make it with an airy, lofty wool and you will have a cardigan that you will want to wear every day, whether to cozy up with tea and cookies at home or attend a high tea out.

Willa means resolute protection, and this cardigan will definitely protect you from winter temperatures. I named this cardigan after classic novelist Willa Cather for her portrayal of pioneer strength and grace.

I used Brooklyn Tweed Shelter, a splendid, lofty, tweedy 100 percent wool yarn that is the perfect mix of elegance and comfort for this cardigan.

Willa Explained

· ·

Willa Cardigan has several charts and a few different stitches, but, if you take your time and follow these tips, you should have no trouble knitting a magnificent cabled cardigan. These tips may be helpful for knitting Idril (page 28), Brielle (page 38), and Keavy (page 118), too.

When you start a front piece, you only have shoulder stitches on your needles and no neck stitches. This means that you start to work each row on the outside edges of the charts. You won't work the entire charts until you've added all of the neck stitches. For each size, start on a different charted stitch, depending on the number of stitches in the neck.

RIGHT FRONT

When you're working a right-side (RS) row on the right front, you start at the shoulder edge and work the Right Front Cable chart from the right edge toward the left edge and finish at the neck edge. When working a wrong-side (WS) row, start at the neck edge and work the chart from the left toward the right edge and finish at the shoulder edge.

The shoulder set-up row is a WS row, so read the Right Front chart from left to right. The smallest size starts the chart on stitch 15. So, purl the selvedge stitch and then work stitches 15 to 1 from Row 1 of the chart, then purl to the end.

On Short-row 1 (a RS row), knit to the chart marker, work stitches 1 to 15 from Row 2 of the chart, then knit the selvedge stitch.

On Short-row 2 (a WS row), purl the selvedge stitch, then

work 4 stitches, starting with stitch 15 from Row 3 of the chart, then wrap the next stitch and turn the work (Techniques, page 144).

On Short-row 3, work stitches 12 to 15 from Row 1 of the chart, then knit the selvedge stitch.

On Short-row 4, purl the selvedge stitch, work stitches 15 to 12, work stitch 11 and hide the wrap from Short-row 2, work stitches 10 to 6 from Row 2 of the chart, then wrap the next stitch and turn the work.

Continue working in this manner through the rest of the short-rows.

After wrapping and turning on Short-row 6, you are on the right side of your knitting. Work the next row of the chart to the last stitch, then knit the selvedge stitch. This row counts as the first of the 12 rows that are worked after the short-rows. Then, work 11 more complete rows.

LEFT FRONT

When working a RS row on the left front, start at the neck edge and work the Left Front chart from the right toward the left edge and finish at the shoulder edge. When working a WS row, start at the shoulder edge and work the chart from the left edge toward the right and finish at the neck edge.

The shoulder set-up row is a WS row, so you read the chart from left to right. If you're working the smallest size, you purl 2 stitches, place a marker for the chart pattern, then work Row 1 of the chart starting on stitch 29 and ending on stitch 15, working to the end of the row,

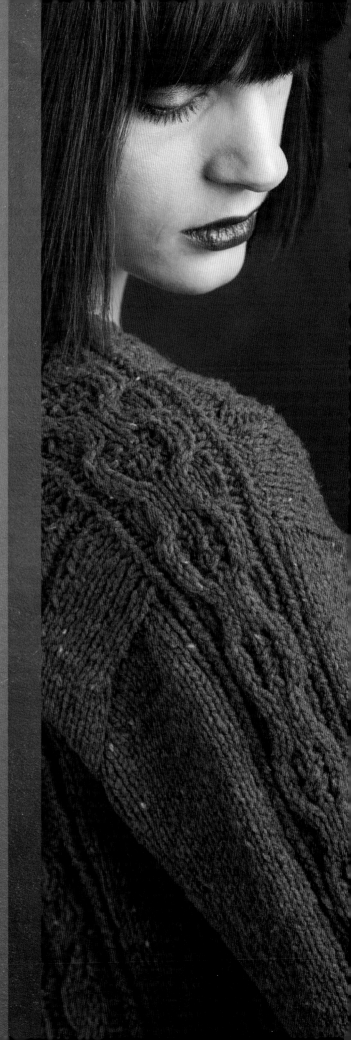

then cast on 1 stitch for the selvedge stitch.

On Short-row 1 (a RS row), knit the selvedge stitch, work stitches 15 to 18 from Row 2 of the Left Front chart, then wrap the next stitch and turn the work.

On Short-row 2 (a WS row), work stitches 18 to 15 from Row 3 of the chart, then purl the selvedge stitch.

On Short-row 3, knit the selvedge stitch, work stitches 15 to 18, work stitch 19 and hide the wrap from Short-row 1, work stitches 20 to 24 from the chart, then wrap the next stitch and turn the work.

On Short-row 4, work stitches 24 to 15 from the next chart row, then purl the selvedge stitch.

Continue working in this manner through the rest of the short-rows.

On the last short-row of the left front, finish the row at the neck edge. You have 12 full rows to work, instead of one partial row and 11 full rows like on the right front and on the back.

SELVEDGE STITCH

A selvedge stitch gives the neckline a cleaner edge when the increase stitches are worked between the selvedge stitch and front stitches rather than casting on new stitches. It also makes picking up stitches for the neckline easier. Selvedge stitches are usually cast on right after the front stitches are picked up and are included in the stitch counts.

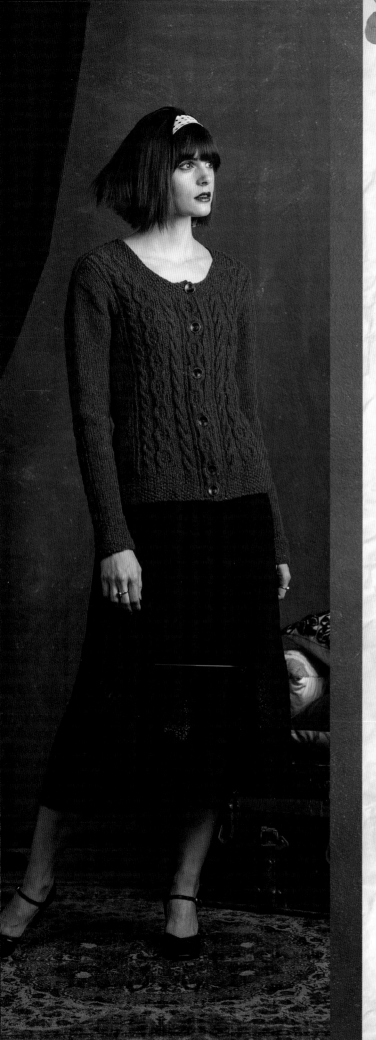

STITCH GUIDE

- **2/2 LC (2 over 2 left cross):** Sl 2 sts onto cable needle (cn) and hold in front, k2, k2 from cn.
- **2/2 RC (2 over 2 right cross):** Sl 2 sts onto cn and hold in back, k2, k2 from cn.
- **3/3 LC (3 over 3 left cross):** Sl 3 sts onto cn and hold in front, k3, k3 from cn.
- **3/3 RC (3 over 3 right cross):** Sl 3 sts onto cn and hold in back, k3, k3 from cn.

Seed stitch side panel:

- **Row 1 (RS):** P1, k1tbl, p1, *k1, p1, rep from * to last 4 sts, k1, p1, k1tbl, p1.
- **Row 2 (WS):** K1, p1tbl, k1,* k1, p1, rep from * to last 4 sts, k2, p1tbl, k1.

Turn to the Glossary on page 144 to learn how to work these stitches:

Hide wrap	RLI
K1tbl	Seed st in the round
P1tbl	Seed st for odd
LLI	number of sts
M1	Ssk
M1L	W&t
M1R	

❧

A word about construction:

Willa is constructed in one piece from the top down with saddle shoulders and set-in sleeves. The back and fronts are worked separately until joined with the sleeves. The shoulders are shaped using short-rows. There is no body shaping below the armholes, so you can easily adjust the length of the body and sleeves. The buttonbands are worked at the same time as the fronts. The buttonholes are worked in every other cable, but you can work them in every cable if you prefer more buttons.

Slip markers as you come to them unless instructed otherwise.

Turn to Willa Explained on page 10 for an in-depth overview on how to construct this cardigan.

CARDIGAN

Saddle (make 2)

With 2 dpn, CO 17 sts using the long-tail method (Techniques, page 144). Do not join.

Next row (RS): K1, work Row 1 of Saddle chart over 15 st, k1.

Next row: P1, work Row 2 of Saddle chart over 15 sts, p1.

Cont in established patt, working 2 edge sts in St st (knit RS rows, purl WS rows) until piece measures 3¾ (4¼, 4¼, 4¾, 4¾, 4¾, 4¾, 4¾)" (9.5 [11, 11, 12, 12, 12, 12, 12] cm), ending with a WS row.

Cut yarn. Place sts on a holder or waste yarn. Note which chart row you ended on so you will know which row to work when the pieces are joined.

Back

With cir needle, held sts at the right, and the RS of one saddle facing, pick up and k21 (23, 25, 24, 24, 26, 26, 26)

sts evenly along one long edge of saddle from held sts to CO edge, CO 37 (37, 37, 39, 43, 43, 47, 47) sts for back neck, then with RS facing and held sts of rem saddle at left, pick up and k21 (23, 25, 24, 24, 26, 26, 26) sts evenly along one long edge of rem saddle, from CO edge to held sts *(figure 1, page 15)*—79 (83, 87, 87, 91, 95, 99, 99) sts.

Shape shoulders

Set-up row (WS): P6 (8, 10, 10, 12, 14, 16, 16), place marker (pm) for left side cable, work Row 1 of Left Back chart over next 19 sts, pm, work Row 1 of the Center Back chart, pm, work Row 1 of the Right Back chart over next 19 sts, pm, purl to end.

Cont in established patt, working St st at each end and shape shoulders as foll.

NOTE: If the short-row wrap is on a rev St st, you do not need to hide the wrap.

Short-rows 1 and 2: Work to last 17 (19, 20, 19, 19, 19, 19, 19) sts, w&t—85 (89, 93, 93, 97, 101, 105, 105) sts.

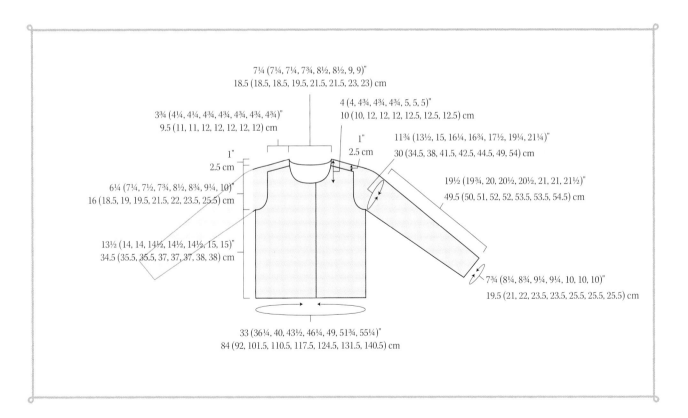

7¼ (7¼, 7¼, 7¾, 8½, 8½, 9, 9)"
18.5 (18.5, 18.5, 19.5, 21.5, 21.5, 23, 23) cm

3¾ (4¼, 4¼, 4¾, 4¾, 4¾, 4¾, 4¾)"
9.5 (11, 11, 12, 12, 12, 12, 12) cm

4 (4, 4¾, 4¾, 4¾, 5, 5, 5)"
10 (10, 12, 12, 12, 12.5, 12.5, 12.5) cm

1"
2.5 cm

11¾ (13½, 15, 16¼, 16¾, 17½, 19¼, 21¼)"
30 (34.5, 38, 41.5, 42.5, 44.5, 49, 54) cm

1"
2.5 cm

6¼ (7¼, 7½, 7¾, 8½, 8¾, 9¼, 10)"
16 (18.5, 19, 19.5, 21.5, 22, 23.5, 25.5) cm

19½ (19¾, 20, 20½, 20½, 21, 21, 21½)"
49.5 (50, 51, 52, 52, 53.5, 53.5, 54.5) cm

13½ (14, 14, 14½, 14½, 14½, 15, 15)"
34.5 (35.5, 35.5, 37, 37, 37, 38, 38) cm

7¾ (8¼, 8¾, 9¼, 9¼, 10, 10, 10)"
19.5 (21, 22, 23.5, 23.5, 25.5, 25.5, 25.5) cm

33 (36¼, 40, 43½, 46¼, 49, 51¾, 55¼)"
84 (92, 101.5, 110.5, 117.5, 124.5, 131.5, 140.5) cm

Short-rows 3–6: Work to wrapped st, hide wrap (see Techniques, page 144), work 5 more sts, w&t.

After last turn, work to end of row, hiding wrap as you come to it. Work 11 rows over all sts in established patt, hiding wraps as you come to them, ending with Row 19 of Center Back chart and Row 7 of Right Back and Left Back charts.

Cut yarn. Place sts on a holder or waste yarn.

NOTE: The selvedge st and sts at the armhole edge are worked in St st. The neck shaping begins inside the selvedge st.

Right Front

With a cir needle, with RS facing, and rem long edge of right saddle up, pick up and k21 (23, 25, 24, 24, 26, 26, 26) sts evenly along rem long edge of right saddle from held sts to CO edge, CO 1 selvedge st—22 (24, 26, 25, 25, 27, 27, 27) sts *(figure 2)*.

Shape shoulder

Set-up row (WS): P1, beg with st 15 (15, 15, 14, 12, 12, 10, 10) of the Right Front chart and work Row 1 over next 15 (15, 15, 16, 18, 18, 20, 20) sts, pm, p6 (8, 10, 10, 12, 14, 16, 16).

Short-row 1: Knit to m, work Row 2 of the Right Front chart to last st, k1.

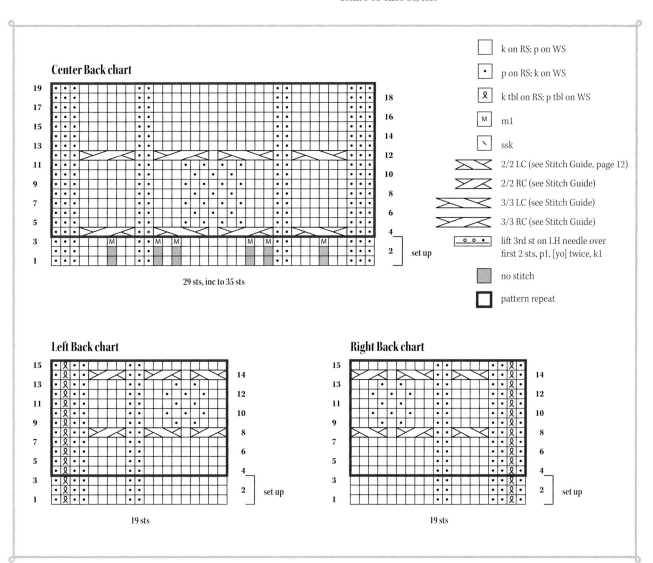

Center Back chart

29 sts, inc to 35 sts

Left Back chart

19 sts

Right Back chart

19 sts

k on RS; p on WS

p on RS; k on WS

k tbl on RS; p tbl on WS

m1

ssk

2/2 LC (see Stitch Guide, page 12)

2/2 RC (see Stitch Guide)

3/3 LC (see Stitch Guide)

3/3 RC (see Stitch Guide)

lift 3rd st on LH needle over first 2 sts, p1, [yo] twice, k1

no stitch

pattern repeat

Short-row 2: P1, work Row 3 of the Right Front chart for 4 (4, 5, 5, 5, 7, 7, 7) sts, w&t.

Short-row 3: Work next row of the Right Front chart to last st, k1.

Short-row 4: P1, work next row of the Right Front chart to wrapped st, hide wrap, work 5 more sts in chart patt, w&t.

Short-rows 5 and 6: Rep Short-rows 3 and 4.

After last turn, work to end of row. Work 11 rows over all sts in established patt, working selvedge st and sts at armhole edge in St st, hiding the last wrap when you come to it, and ending with Row 19 of chart.

Cut yarn. Place sts on a holder or waste yarn.

Left Front

With cir needle, RS facing, and rem long edge of left saddle up, pick up and k21 (23, 25, 24, 24, 26, 26, 26) sts evenly along rem long edge of left saddle from CO edge to held sts (*figure 2*).

Shape Shoulder

Set-up row (WS): P6 (8, 10, 10, 12, 14, 16, 16) sts, pm, work Row 1 of the Left Front chart, CO 1 selvedge st—22 (24, 26, 25, 25, 27, 27, 27) sts.

Short-row 1: K1, work Row 2 of the Left Front chart for 4 (4, 5, 5, 5, 7, 7, 7) sts, w&t.

Short-row 2: Work Row 3 of the Left Front chart to last st, p1.

Short-row 3: K1, work the next row of the Left Front chart to wrapped st, hide wrap, work 5 more sts, w&t.

Short-row 4: Work the next row of the Left Front chart to last st, p1.

Short-rows 5 and 6: Rep Short-rows 3 and 4.

Work 12 rows over all sts in established patt, hiding the last wrap when you come to it, ending with Row 19 of the Left Front chart.

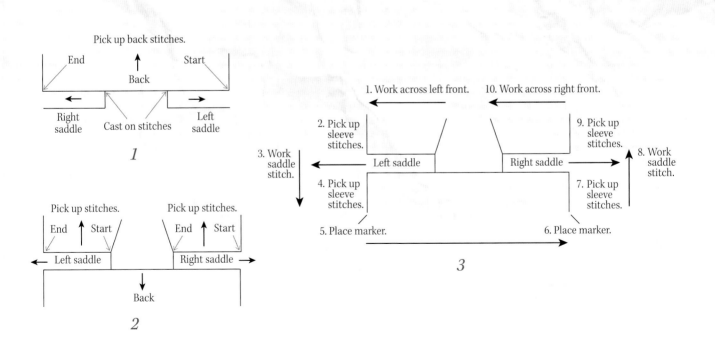

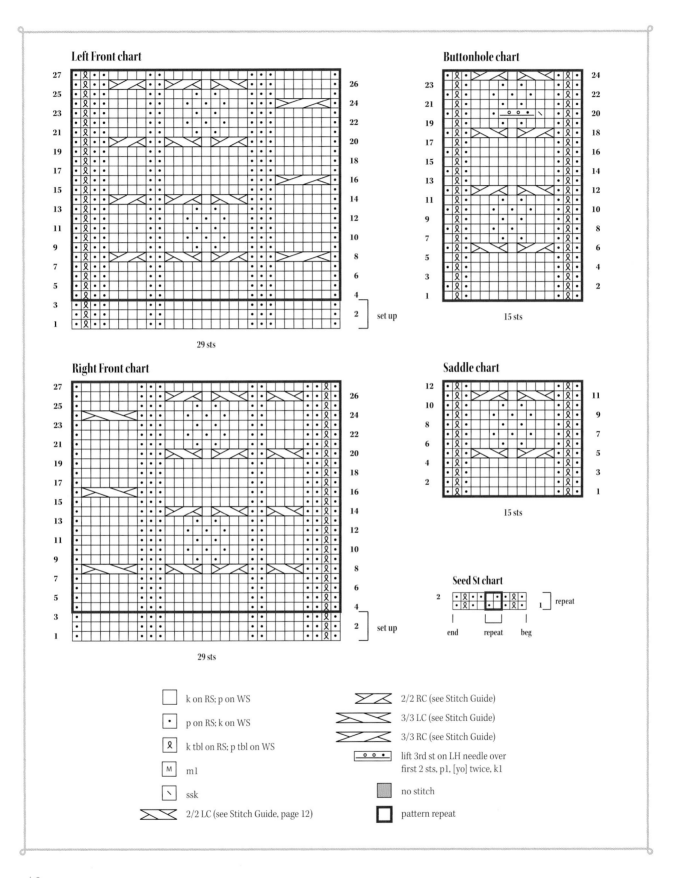

Left Front chart

29 sts

set up

Right Front chart

29 sts

set up

Buttonhole chart

15 sts

Saddle chart

15 sts

Seed St chart

repeat

end · repeat · beg

	k on RS; p on WS
·	p on RS; k on WS
ʎ	k tbl on RS; p tbl on WS
M	m1
＼	ssk
⟋⟍	2/2 LC (see Stitch Guide, page 12)

⟍⟋	2/2 RC (see Stitch Guide)
⟍⟋	3/3 LC (see Stitch Guide)
⟍⟋	3/3 RC (see Stitch Guide)
∘∘∘	lift 3rd st on LH needle over first 2 sts, p1, [yo] twice, k1
	no stitch
▢	pattern repeat

Yoke

NOTE: Begin shaping the neck on the next row. Refer to the chart to determine if the increased stitch is worked as a knit or purl stitch. Work cables only when there are enough stitches to cross all stitches in the cable.

With RS facing, return held right front and back sts to needle as foll: left front, back, right front (*figure 3, page 15*).

Begin sleeves

Next row (RS): Beg at left front, k1, m1l, work in established patt to armhole edge, pm for armhole, pick up and k9 sts along side of left front to saddle sts, pm, p2tog, work next 13 sts in established patt, p2tog, pm, pick up and k9 sts along side edge of back, pm for armhole, work 85 (89, 93, 93, 97, 101, 105, 105) back sts in established patt, pm for armhole, pick up and k9 sts along side edge of back to saddle sts, pm, p2tog, work next 13 sts in established patt, p2tog, pm, pick up and k9 sts along side edge of right front, pm for armhole, work in established patt to last st, m1r, k1—197 (205, 213, 211, 215, 223, 227, 227) sts; 23 (25, 27, 26, 26, 28, 28, 28) sts for each front, 33 sts for each sleeve, and 85 (89, 93, 93, 97, 101, 105, 105) sts for the back.

Next row (WS): P1, *work in established patt to armhole m, purl to saddle cable m, work next 15 sts in established patt, purl to armhole m; rep from * once more, work in established patt to last st, p1.

Inc row (RS): K1, m1l, *work in established patt to armhole m, sl m, RLI, work to next armhole m, LLI, sl m; rep from * once more, work to last st, m1r, k1—6 sts inc'd.

Work 1 WS row even.

Rep last 2 rows 5 (5, 7, 7, 7, 8, 8, 8) more times—233 (241, 261, 259, 263, 277, 281, 281) sts; 29 (31, 35, 34, 34, 37, 37, 37) sts for each front, 45 (45, 49, 49, 49, 51, 51, 51) sts for each sleeve, and 85 (89, 93, 93, 97, 101, 105, 105) sts for the back.

Next row (RS): Using the cable method (Techniques, page 144), CO 25 (25, 23, 24, 26, 25, 27, 27) sts and, working back across sts just CO, p8, k1 tbl, p8, k1 tbl, p1 for buttonband, pm, work to armhole m working rem CO sts and selvedge st into chart patt, sl m, RLI, work in established patt to next armhole m, LLI, sl m, work

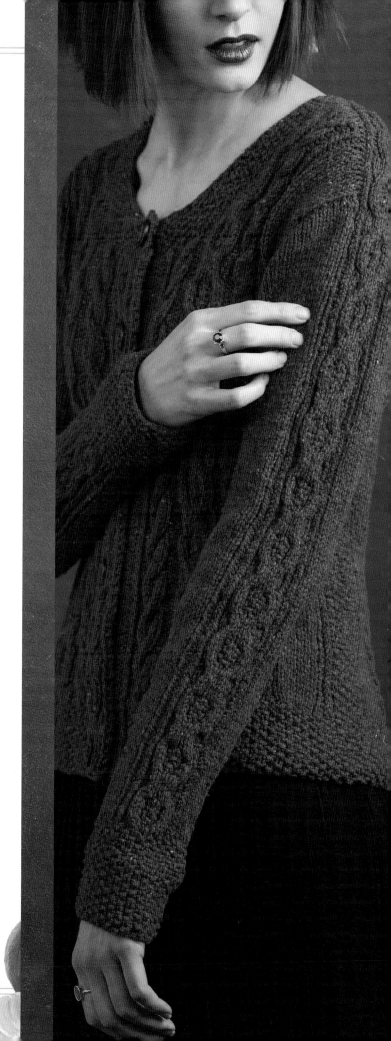

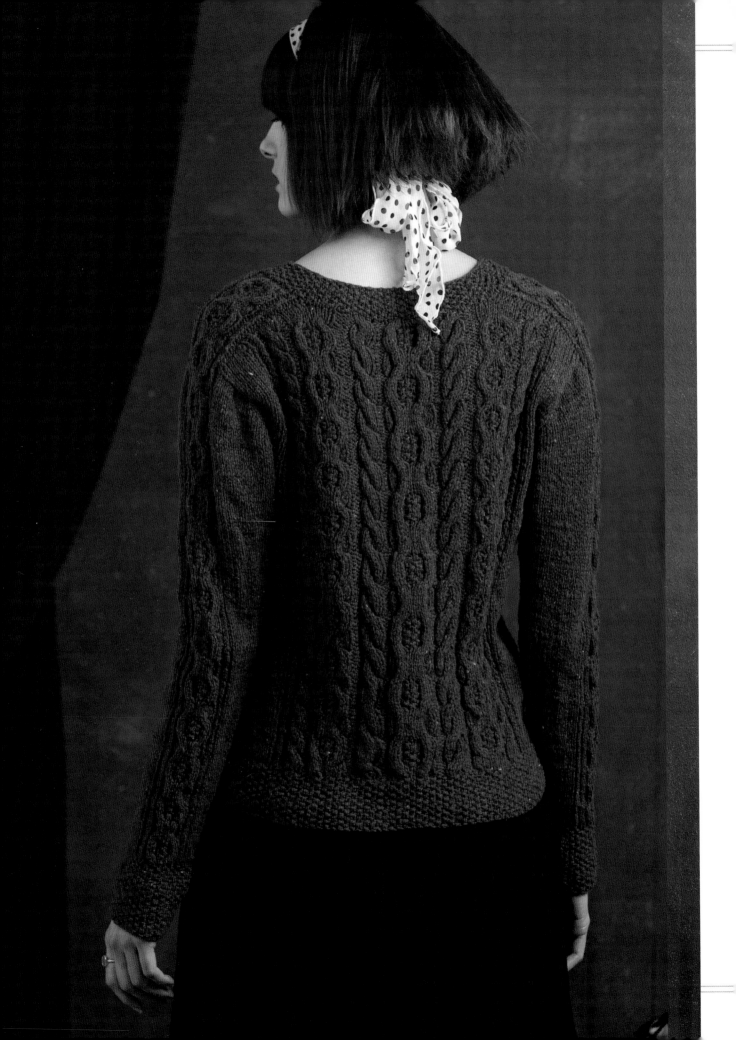

to next armhole m, sl m, RLI, work to next armhole m, LLI, sl m, work to end of row—29 (29, 27, 28, 30, 29, 31, 31) sts inc'd.

Next row (WS): CO 21 (21, 19, 20, 22, 21, 23, 23) sts using the cable method, and, working back across sts just CO, work Row 1 of Buttonhole chart over 15 sts, pm, work to last m working rem CO sts and selvedge st into chart patt, k1, p1 tbl, k8, p1 tbl, k8—283 (291, 307, 307, 315, 327, 335, 335) ssts; 54 (56, 58, 58, 60, 62, 64, 64) sts for the left front, 50 (52, 54, 54, 56, 58, 60, 60) sts for the right front, 47 (47, 51, 51, 51, 53, 53, 53) sts for each sleeve, and 85 (89, 93, 93, 97, 101, 105, 105) sts for the back.

Inc row (RS): [Work in established patt to armhole m, sl m, RLI, work to next armhole m, LLI, sl m] 2 times, work to end—4 sts inc'd.

Work 1 WS row even.

Rep last 2 rows 1 (4, 3, 3, 3, 3, 6, 7) more time(s) 291 (311, 323, 323, 331, 343, 363, 367 sts; 54 (56, 58, 58, 60, 62, 64, 64) sts for the left front, 50 (52, 54, 54, 56, 58, 60, 60) sts for the right front, 51 (57, 59, 59, 59, 61, 67, 69) sts for each sleeve, and 85 (89, 93, 93, 97, 101, 105, 105) sts for the back.

Shape armholes

NOTE: In the next section, the increased body stitches will be worked from the Seed St chart, starting on the two outside edges and working toward the center.

Inc row (RS): [Work to 1 st before armhole m, pm for seed st side panel, m1, k1, sl m, RLI, work to next armhole m, LLI, sl m, k1, m1, pm for seed st side panel] 2 times, work to end—8 sts inc'd.

Work 1 WS row even, working sts between seed st side panel m and armhole m on each front and back in seed st side panel.

Inc row: [Work to 1 st before armhole m, m1, work 1, sl m, RLI, work to next armhole m, LLI, sl m, work 1, m1] 2 times, work to end—8 sts inc'd.

Work 1 WS row even.

Rep last 2 rows 0 (0, 0, 1, 3, 3, 2, 3) more time(s)—307 (327, 339, 347, 371, 383, 395, 407) sts; 56 (58, 60, 61, 65, 67, 68, 69)

sts for the left front, 52 (54, 56, 57, 61, 63, 64, 65) sts for the right front, 55 (61, 63, 65, 69, 71, 75, 79) sts for each sleeve, and 89 (93, 97, 99, 107, 111, 113, 115) sts for the back.

Note the last row of Saddle chart worked so you will know which row to begin with when you work the sleeves.

Body
Divide body and sleeves
Dividing row (RS): Removing the armhole m as you go, work to armhole m in established patt, place next 55 (61, 63, 65, 69, 71, 75, 79) sts on a holder or waste yarn for left sleeve, CO 3 (5, 9, 13, 11, 13, 17, 21) sts, work 89 (93, 97, 99, 107, 111, 113, 115) back sts, place next 55 (61, 63, 65, 69, 71, 75, 79) sts on a holder or waste yarn for right sleeve, CO 3 (5, 9, 13, 11, 13, 17, 21) sts, work to end—203 (215, 231, 243, 255, 267, 279, 291) sts.

Working CO sts at underarms in seed st panel, cont in established patt until piece measures 11½ (12, 12, 12½, 12½, 12½, 13, 13)" (29 [30.5, 30.5, 31.5, 31.5, 31.5, 33, 33] cm) from armhole, ending with a WS row.

Bottom Band
Set-up row (RS): Work in established patt to m, sl m, p1, k1, [k2tog] 2 times, k1, p3, [ssk] 2 times, k1, [k2tog] 2 times, p2, k1, k2tog, k1, p2tog, k1, p1, removing m, work in patt to the Left Back chart m and dec 4 sts (2 sts evenly in each St st section), p1, k1, p2tog, k1, ssk, k1, p2, [ssk] 2 times, k1, [k2tog] 2 times, p1, p2tog, k1, [ssk] 2 times, k1, p2, [ssk] 3 times, k1, [k2tog] 3 times, p2, k1, [k2tog] 2 times, k1, p2tog, p1, [ssk] 2 times, k1, [k2tog] 2 times, p2, k1, k2tog, k1, p2tog, k1, p1, work in patt to the Right Front chart m and dec 4 sts (2 sts evenly in each St st section), p1, k1, p2tog, k1, ssk, k1, p2, [ssk] 2 times, k1, [k2tog] 2 times, p3, k1, [ssk] 2 times, k1, p1, sl m, work the Buttonhole chart over the rem 15 sts—155 (167, 183, 195, 207, 219, 231, 243) sts rem.

Next row (WS): Work the Buttonhole chart over 15 sts and, beg with a knit st and work in seed st to buttonband m, making sure patt lines up with underarm seed st panels, work in established patt to end.

Cont in established patt until bottom band measures 2" (5 cm).

BO all sts in patt.

Sleeves

With dpns and RS facing, beg at center of underarm CO sts and pick up and k2 (3, 5, 7, 6, 7, 9, 11) sts evenly along the CO edge, work held 55 (61, 63, 65, 69, 71, 75, 79) sleeve sts in established patt, pick up and k1 (2, 4, 6, 5, 6, 8, 10) st(s) along rem CO edge to center of underarm—58 (66, 72, 78, 80, 84, 92, 100) sts.

Pm for beg of rnd and join for working in rnds.

Working picked up sts in St st, work 13 (8, 7, 6, 6, 6, 5, 4) rnds even.

Dec rnd: K1, k2tog, work to last 2 sts, ssk—2 sts dec'd.

Rep dec rnd every 14 (9, 8, 7, 7, 7, 6, 5) rnds 6 (11, 9, 15, 8, 11, 10, 19) more times, then every 0 (0, 7, 0, 6, 6, 5, 4) rnds 0 (0, 4, 0, 8, 5, 10, 5) times—40 (42, 44, 46, 46, 50, 50, 50) sts rem.

Cont even until piece measures 16½ (16¾, 17, 17½, 17½, 18, 18, 18½)" (42 [42.5, 43, 44.5, 44.5, 45.5, 45.5, 47] cm) from armhole.

Cuff

Set-up rnd: Work to cable m and dec 3 (2, 1, 1, 1, 1, 1, 1) st(s) evenly spaced, remove m, p1, k1, p1, [ssk] 2 times, k1, [k2tog] 2 times, p1, k1, p1, remove m, work to end and dec 3 (2, 1, 1, 1, 1, 1, 1) st(s) evenly spaced—34 (34, 38, 40, 40, 44, 44, 44) sts rem.

Work even in seed st for 3" (7.5 cm).

BO all sts loosely in patt.

Finishing

Work buttonband

Fold 8 purl edge sts of buttonband to inside along first twisted knit st. Sew band to the WS along knit st before second twisted st.

Work neckband

With size 8 (5 mm) cir needle and RS facing, beg at edge of buttonhole band, pick up and k14 (14, 13, 14, 15, 14, 15, 15) along right neck CO sts, 21 (21, 24, 24, 24, 25, 25, 25) sts along right neck to saddle, 10 sts along saddle CO edge, 28 (28, 28, 28, 32, 32, 34, 34) sts along back neck, 10 sts along saddle CO edge, 21 (21, 24, 24, 24, 25, 25, 25) sts along left neck to CO sts, then 15 (15, 12, 13, 14, 15, 16, 16) sts along left neck CO edge to end of buttonband—119 (119, 121, 123, 129, 131, 135, 135) sts.

Work 2 rows in seed st.

Change to size 6 (4 mm) cir needle. Work 1 row in seed st.

Buttonhole row (RS): K1, p1, k2tog, [yo] twice, ssp, work in seed st to end.

Work 1 row in seed st, working yo in seed st patt.

Change to size 5 (3.75 mm) cir needle. Work 4 rows in seed st.

BO all sts in patt.

Weave in loose ends. Block to finished measurements.

Sew buttons to buttonband opposite buttonholes. Fold up cuffs to RS.

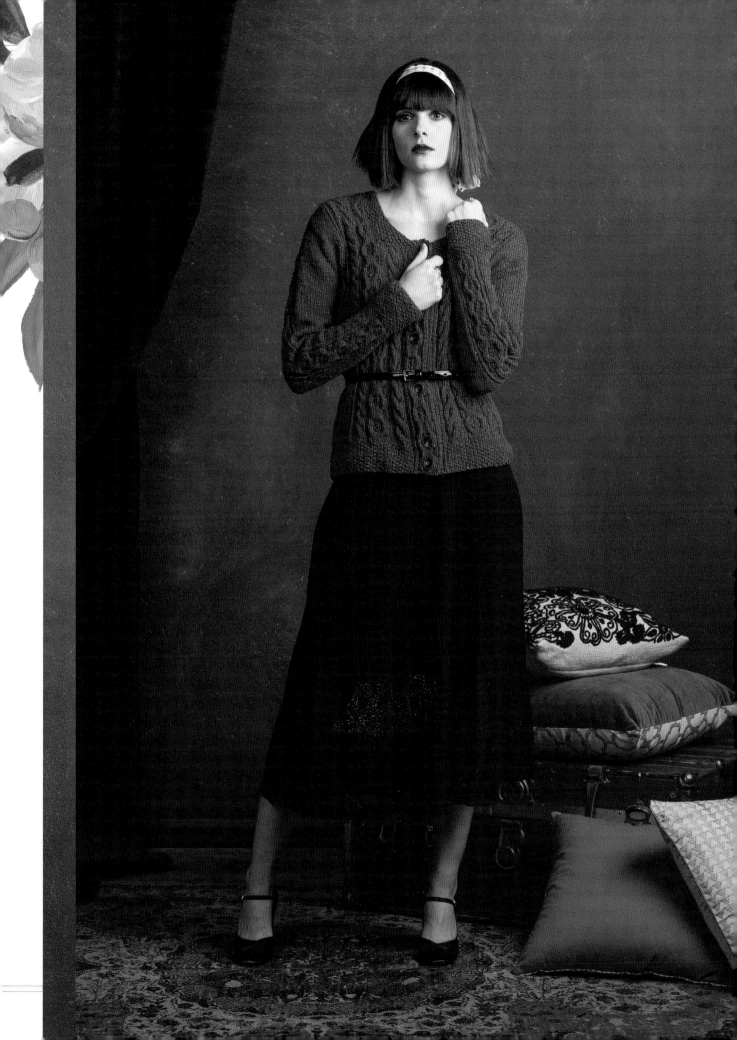

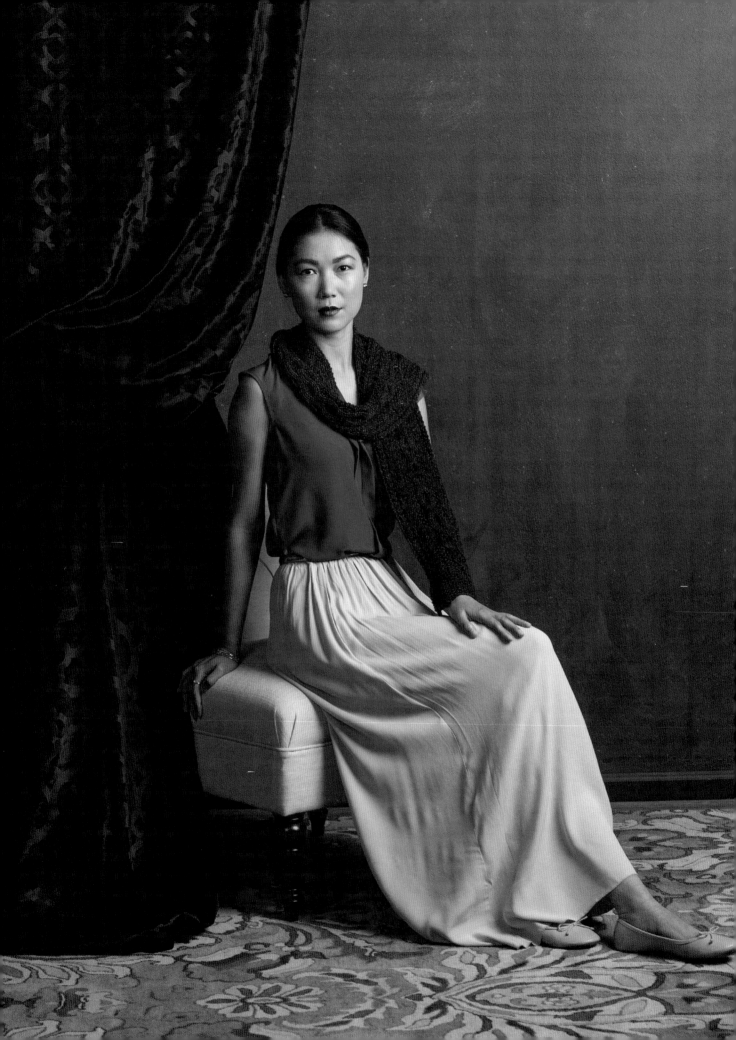

FINISHED SIZE

About 72" (182 cm) long and 5¾" (14.5 cm) wide.

YARN

Worsted (#4 Medium).

Shown here: Tanis Fiber Arts Orange Label Cashmere/Silk Worsted (75% merino, 15% cashmere, 10% silk; 205 yd [187 m]/4 oz [115 g]), plum, 3 skeins or 607 yd (555 m) of similar yarn.

NEEDLES

Size U.S. 8 (5 mm) and 9 (5.5 mm).

Adjust needle sizes if necessary to obtain the correct gauge.

NOTIONS

Cable needle (cn); locking marker; tapestry needle.

GAUGE

35 sts and 19 rows = 4" (10 cm) in the chart patt on smaller needles, blocked.

Adelaide
REVERSIBLE SCARF

I chose the big circle cables on this scarf because they remind me of precious jewels imbedded in metal. Not only are Adelaide's cables reversible, each side of the scarf is the reverse of the other. The side cables point up on one side and down on the other side. The circle on one side of the center cable pattern is matched with the straight part of the cable on the other side.

Because the circle cables remind me of gems and the yarn is purple—the color of royalty—this scarf needed an aristocratic name. Adelaide means nobility.

I used Tanis Fiber Arts Orange Label Cashmere/Silk Worsted to stitch up this scarf. It is extremely soft and has great stitch definition—perfect for a reversible cabled scarf.

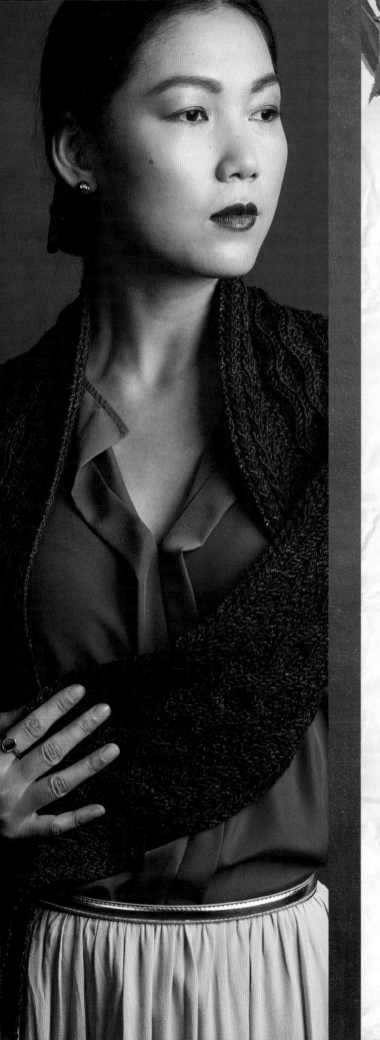

STITCH GUIDE

Seed stitch (multiple of 2 sts):
- 🌰 **Row 1:** * K1, p1; rep from * to end of row.
- 🌰 Repeat Row 1 for patt.
- 🌰 **m1 (make 1):** If st to be increased is a knit st, make 1 kwise; if st to be increased is a purl st, make 1 pwise (Techniques, page 144).
- 🌰 **2/2 LRC (2 over 2 left ribbed cross):** Sl 2 sts onto cn and hold in front, k1, p1, then k1, p1 from cn.
- 🌰 **2/2 RRC (2 over 2 right ribbed cross):** Sl 2 sts onto cn and hold in back, k1, p1, then k1, p1 from cn.
- 🌰 **4/4 LRC (4 over 4 left ribbed cross):** Sl 4 sts onto cn and hold in front, k1, p1 twice, then k1, p1 twice from cn.
- 🌰 **4/4 RRC (4 over 4 right ribbed cross):** Sl 4 sts onto cn and hold in back, k1, p1 twice, then k1, p1 twice from cn.

Turn to the Glossary on page 144 to learn how to work these stitches:

K2tog
P2tog
M1
M1P

A word about construction:

Because this scarf is reversible, it is helpful to mark the right side with a locking stitch marker or safety pin. All cables are worked on the right side.

The chart starts on a wrong-side row, so the first row will be worked from left to right.

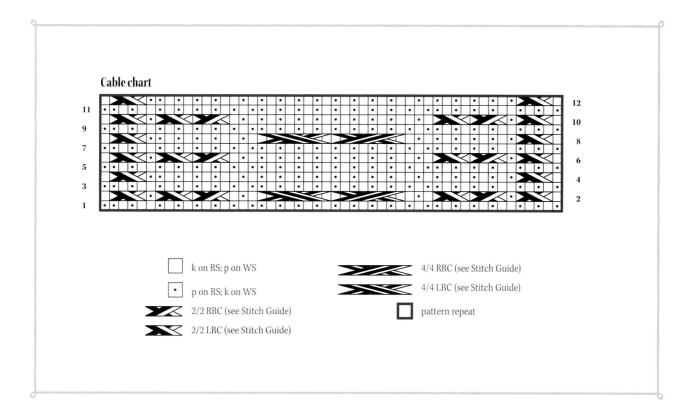

Cable chart

Legend:
- ☐ k on RS; p on WS
- ⊡ p on RS; k on WS
- 2/2 RRC (see Stitch Guide)
- 2/2 LRC (see Stitch Guide)
- 4/4 RRC (see Stitch Guide)
- 4/4 LRC (see Stitch Guide)
- ☐ pattern repeat

REVERSIBLE SCARF

First Ruffle

With larger needles, CO 58 sts using the long-tail method (Techniques, page 144). Change to smaller needles.

Row 1 (WS): Beg with a purl st and working 10 sts in seed st, [k1, p1] 2 times, [beg with a purl st and working 13 sts in seed st, (k1, p1) 2 times] 2 times, beg with a purl st and work in seed st to the end of the row.

Row 2 (RS): Work 10 sts in seed st as established, 2/2 LRC, [work 13 sts in seed st, 2/2 LRC] 2 times, work in seed st to end of row.

Rep last 2 rows 6 more times, ending with a RS row.

Cont working cables every RS row as estab and at the same time work dec rows as follows:

Dec row 1 (WS): [Work in seed st to cable, k1, p1, k1, p2tog] 3 times, work in seed st to end—55 sts rem.

Work 1 RS row even.

Dec row 2 (WS): [Work to 1 st before cable, k2tog, p1, k1, p1] 3 times, work in seed st to end—52 sts rem.

Work 1 RS row even.

Dec row 3 (WS): Work to 1 st before first cable, k2tog, p1, k1, p1, work to last cable, k1, p1, k1, p2tog, work in seed st to end—50 sts rem.

Work 1 RS row even.

Body

Work Rows 1–12 of the Cable chart until piece measures 66½" (169 cm) from beg or 3" (7.5 cm) less than desired length, ending on either Row 3 or Row 9 of chart rep.

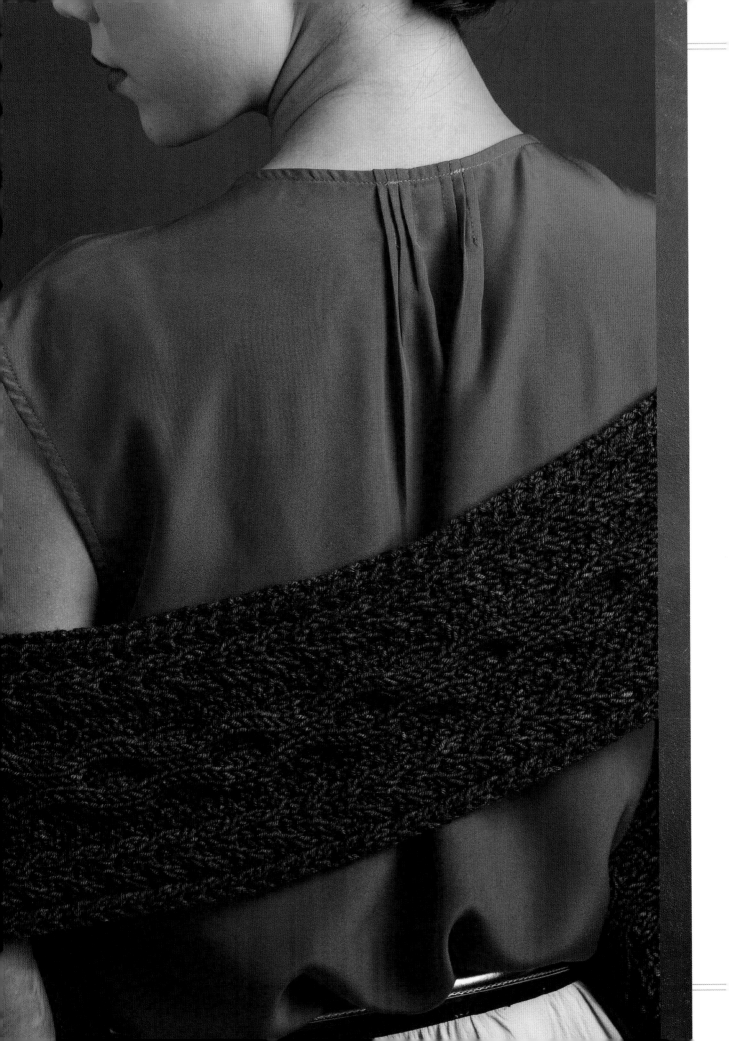

Second Ruffle

Next row (RS): Beg with a purl st and work 8 sts in seed st, 2/2 LRC, [beg with a purl st and work 11 sts in seed st, 2/2 LRC] 2 times, beg with a purl st and work in seed st to end.

Cont working cables every RS row as estab and *at the same time* work inc rows as follows:

Inc row 1 (WS): Work in established patt to first cable, m1, [k1, p1] 2 times, work to last cable, [k1, p1] 2 times, m1, work in seed st to end—52 sts.

Work 1 RS row even.

Inc row 2 (WS): [Work in established patt to cable, m1, (k1, p1) 2 times] 3 times, work in seed st to end—55 sts.

Work 1 RS row even.

Inc row 3 (WS): Work in established patt to cable, (k1, p1) 2 times, m1] 3 times, work in seed st to end—58 sts.

Work 1 RS row even.

Rep Rows 1 and 2 from first ruffle 7 times.

BO loosely in patt using larger needles.

Finishing

Weave in loose ends. Block to finished measurements.

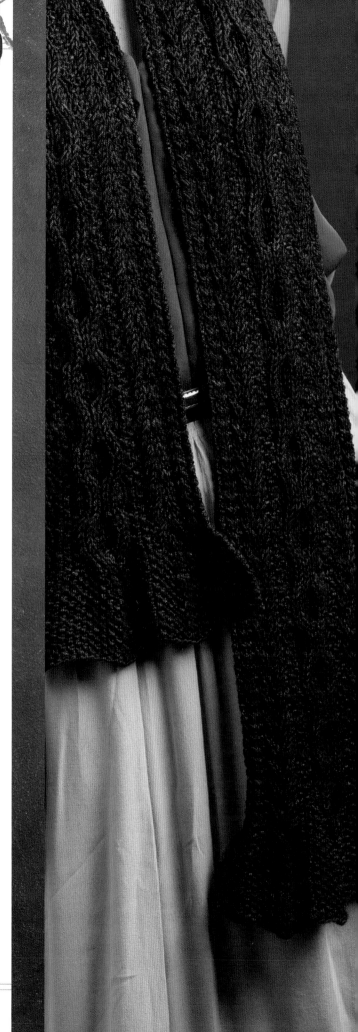

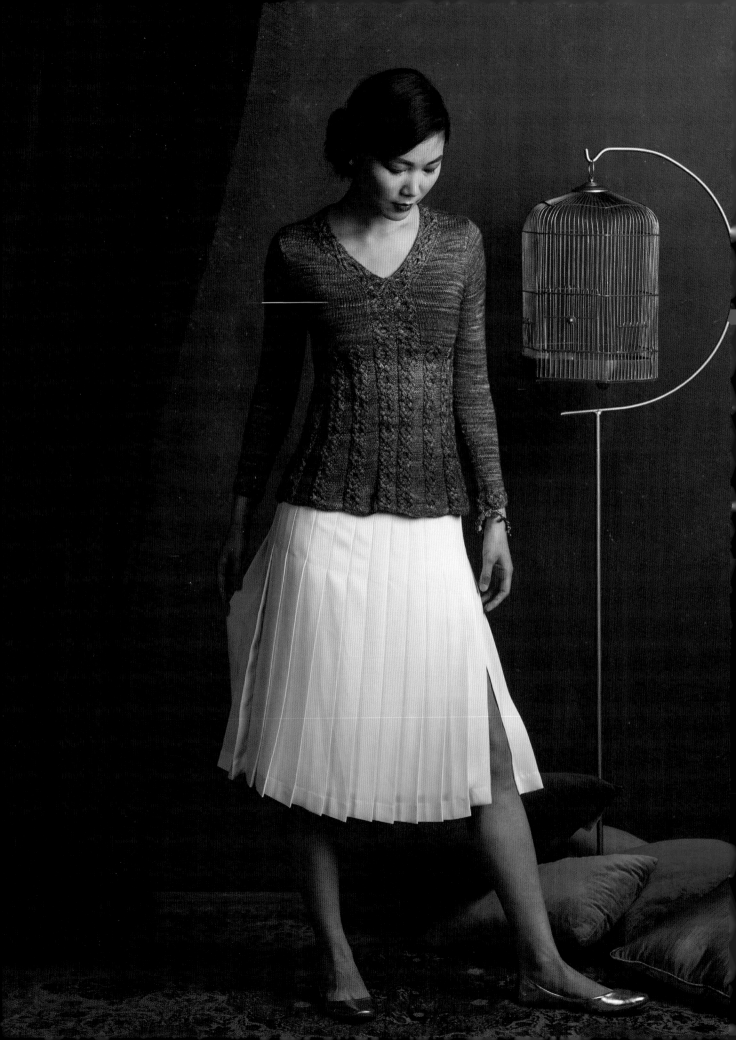

FINISHED SIZE

About 29½ (32, 34½, 37¾, 40¼, 42¾, 45½, 47)" (75 [81.5, 87.5, 96, 102, 108.5, 115.5, 119.5] cm) bust circumference and 23 (23¼, 24¾, 25½, 26¼, 27½, 28, 28½)" (58.5 (59, 63, 65, 66.5, 70, 71, 72.5) cm) long.

Pullover shown measures 29½" (75 cm).

YARN

Fingering weight (#1 Super Fine).

Shown here: Anzula Dreamy (75% super-wash merino wool, 15% cashmere, 10% silk; 385 yd [352 m]/4 oz [115 g], elephant, 4 (4, 5, 5, 5, 6, 6, 7) skeins or 1,229 (1,373, 1,547, 1,712, 1,832, 1,996, 2,097, 2201) yd (1,124 [1,255, 1,414, 1,565, 1,675, 1,825, 1,917, 2012.5] m) of similar yarn.

NEEDLES

Size U.S. 4 (3.5 mm): 24" (60 cm) circular (cir) and set of 4 or 5 double-pointed (dpn).

Adjust needle size if necessary to obtain the correct gauge.

NOTIONS

Stitch markers (m), one in a unique color for beg of rnd; cable needle (cn); stitch holders or waste yarn; locking markers; tapestry needle.

GAUGE

25 sts and 35 rows = 4" (10 cm) in St st.

12-st cable = 1⅛" (2.9 cm) wide and 40 rows = 4" (10 cm), blocked.

Idril
PULLOVER

My son and his friend thought this sweater looked like the Mithril armor that Frodo Baggins wears in the Lord of the Rings. *Just as the beauty of Mithril did not tarnish or grow dim, neither will this beautiful cabled sweater. I chose a female character name from the stories of J. R. R. Tolkien—Idril was the daughter of Turgon, the king of Gondolin.*

Four little stitch cables arranged in a mixture of right and left crosses make a lovely design, perfect for a border. After outlining the front of the neck with the pattern, I decided the cables were so pretty there should be more, so I added an A-line body with many more cables.

The yarn I used for Idril is Anzula Dreamy, which is a mixture of merino, cashmere, and silk. It has the perfect mix of good stitch definition and drape to make Idril gracefully skim over the hips.

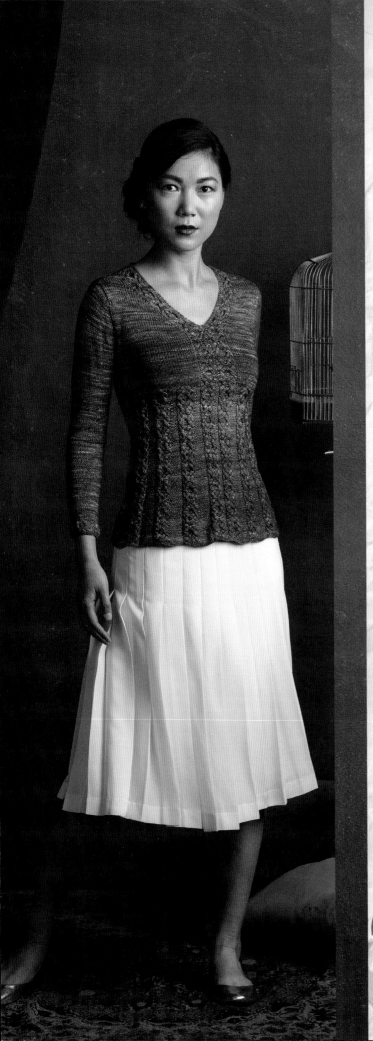

STITCH GUIDE

- **p1f&b&f:** Purl into front, back, then front of same st to inc 2 sts.
- **2/2 LC (2 over 2 left cross):** Sl 2 sts onto cn and hold in front, k2, k2 from cn.
- **2/2 RC (2 over 2 right cross):** Sl 2 sts onto cn and hold in back, k2, k2 from cn.

Turn to the Glossary on page 144 to learn how to work these stitches:

Hide wrap	P2tog
K1f&b	P2tog tbl
K2tog	P3tog
LLI	RLI
M1	Ssk
M1p	W&t
P1f&b	

A word about construction:

Idril is constructed in one piece from the top down with short-row shoulder shaping, so you can easily adjust the length of the body and the sleeves. The back and fronts are worked separately until joined with the sleeves. The yoke is worked flat until the fronts are joined for working in the round. The cabled neckband is worked only on the front.

If you'd like a looser fitting body, use the instructions from a larger size, taking care to increase enough stitches to correctly work the new instructions.

I used a lot of markers in this pattern to make the instructions clearer; you certainly do not have to use them all. I recommend at least using a different color marker for the beginning of the round.

For helpful hints about construction, see Willa Explained on page 10.

PULLOVER

Back

NOTE: The first two rows have rev St st worked at the back neck. The short-rows are worked in St st.

With cir needle, CO 80 (84, 88, 94, 98, 100, 100, 100) sts using the cable method (Techniques, page 144). Do not join.

Shape shoulders

First row (RS): K14 (13, 14, 15, 17, 17, 17, 17), p9 sts for right shoulder, place marker (pm), p 34 (40, 42, 46, 46, 48, 48, 48) sts for back, pm, p9 sts, k14 (13, 14, 15, 17, 17, 17, 17) sts for left shoulder.

Next row (WS): Purl to m, sl m, knit to next m, sl m, purl to end.

Short-rows 1 and 2: Work to 5 sts past second m, w&t.

Short-rows 3 and 4: Work to wrapped st, hide wrap, knit 4 more sts, w&t.

Short-rows 5–8: Work to wrapped st, hide wrap, work 3 (3, 3, 3, 4, 4, 4, 4) more sts, w&t.

After the last turn, work to end of row, hiding the wrap as you come to it. Work 21 more rows evenly over all sts, hiding the last wraps as you come to them, and remove m.

Cut yarn. Place sts on a holder or waste yarn. Place locking m at each end of CO row for shoulders 23 (22, 23, 24, 26, 26, 26, 26) sts from each end.

Right Front

With cir needle, CO edge held at top of the work, and RS facing, pick up and k23 (22, 23, 24, 26, 26, 26, 26) sts along CO edge from armhole to locking marker.

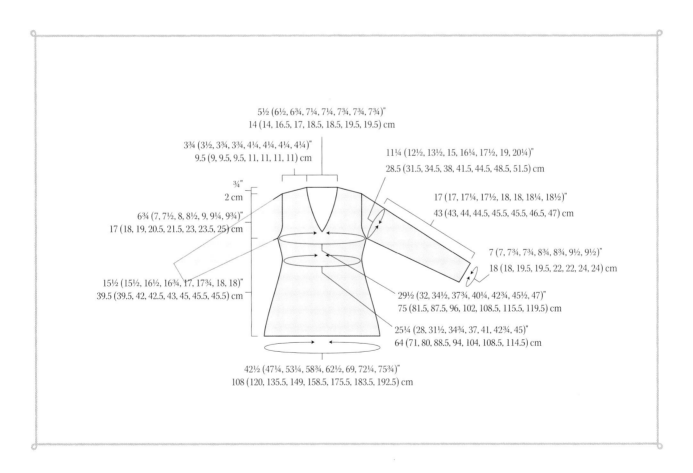

5½ (6½, 6¾, 7¼, 7¼, 7¾, 7¾, 7¾)"
14 (14, 16.5, 17, 18.5, 18.5, 19.5, 19.5) cm

3¾ (3½, 3¾, 3¾, 4¼, 4¼, 4¼, 4¼)"
9.5 (9, 9.5, 9.5, 11, 11, 11, 11) cm

11¼ (12½, 13½, 15, 16¼, 17½, 19, 20¼)"
28.5 (31.5, 34.5, 38, 41.5, 44.5, 48.5, 51.5) cm

¾"
2 cm

17 (17, 17¼, 17½, 18, 18, 18¼, 18½)"
43 (43, 44, 44.5, 45.5, 45.5, 46.5, 47) cm

6¾ (7, 7½, 8, 8½, 9, 9¼, 9¾)"
17 (18, 19, 20.5, 21.5, 23, 23.5, 25) cm

7 (7, 7¾, 7¾, 8¾, 8¾, 9½, 9½)"
18 (18, 19.5, 19.5, 22, 22, 24, 24) cm

15½ (15½, 16½, 16¾, 17, 17¾, 18, 18)"
39.5 (39.5, 42, 42.5, 43, 45, 45.5, 45.5) cm

29½ (32, 34½, 37¾, 40¼, 42¾, 45½, 47)"
75 (81.5, 87.5, 96, 102, 108.5, 115.5, 119.5) cm

25¼ (28, 31½, 34¾, 37, 41, 42¾, 45)"
64 (71, 80, 88.5, 94, 104, 108.5, 114.5) cm

42½ (47¼, 53¼, 58¾, 62½, 69, 72¼, 75¾)"
108 (120, 135.5, 149, 158.5, 175.5, 183.5, 192.5) cm

Shape shoulder
Set-up row (WS): [P1, p1f&b] 2 times, [p1f&b] 2 times, [p1f&b, p1] 2 times, pm, purl to end of row—29 (28, 29, 30, 32, 32, 32, 32) sts.

Short-row 1 (RS): Knit to m, work Row 1 of the Right Front Cable chart over rem 16 sts.

Short-row 2: Work Row 2 of the Right Front Cable chart over 16 sts, sl m, w&t.

Short-row 3: Work Row 3 of the Right Front Cable chart to end.

Short-row 4: Work Row 4 of the Right Front Cable chart over 16 sts, sl m, hide wrap, p3 (3, 3, 3, 4, 4, 4, 4), w&t.

Short-row 5: Knit to m, sl m, work Row 5 of the Right Front Cable chart to end.

Short-row 6: Work to wrapped st, hide wrap, p3 (3, 3, 3, 4, 4, 4, 4), w&t.

After the last turn, work to end of row. Work 7 (5, 5, 7, 9, 7, 7, 7) more rows over all the sts in established patt, working St st (knit RS rows, purl WS rows) at armhole edge.

Shape neckline
Inc row (RS): Knit to m, LLI, sl m, work in established patt to the end—1 st inc'd.

Work 1 WS row even.

Rep last 2 rows 6 (7, 7, 6, 5, 6, 6, 6) more times—36 [36, 37, 37, 38, 39, 39, 39) sts.

Cut yarn. Place sts on a holder or waste yarn.

Left Front
With cir needle, CO edge at top of the work, and RS facing, pick up and k23 (22, 23, 24, 26, 26, 26, 26) sts from locking m to armhole edge.

Shape shoulder
Set-up row (WS): P13 (12, 13, 14, 16, 16, 16, 16) sts, pm, [p1, p1f&b] 2 times, [p1f&b] 2 times, [p1f&b, p1] 2 times—29 (28, 29, 30, 32, 32, 32, 32) sts.

Short-row 1 (RS): Work Row 1 of the Left Front Cable

chart over 16 sts, sl m, w&t.

Short-row 2: Work Row 2 of the Left Front Cable chart to end.

Short-row 3: Work Row 3 of the Left Front Cable chart over 16 sts, sl m, hide wrap, k3 (3, 3, 3, 4, 4, 4, 4), w&t.

Short-row 4: Purl to m, sl m, work Row 4 of the Left Front Cable chart to end.

Short-row 5: Work Row 5 of the Left Front Cable chart over 16 sts, sl m, knit to wrapped st, hide wrap, k3 (3, 3, 3, 4, 4, 4, 4), w&t.

Short-row 6: Rep Short-row 4.

Work 8 (6, 6, 8, 10, 8, 8, 8) more rows over all sts in established patt, working St st at armhole edge.

Shape neckline
Inc row (RS): Work the next row of the Left Front Cable chart to m, sl m, RLI, knit to end—1 st inc'd.

Work 1 WS row even.

Rep last 2 rows 6 (7, 7, 6, 5, 6, 6, 6) more times—36 [36, 37, 37, 38, 39, 39, 39) sts.

Yoke
With RS facing, return held right front and back sts to the needle as foll: left front, back, right front (*figure 3, page 15*).

Begin sleeves
Next row (RS): Beg at left front neckline, work the Left Front Cable chart as established, sl m, RLI, knit to edge, pm for armhole, pick up and k32 sts along left armhole edge, pm for armhole, work back sts, pm for armhole, pick up and k32 sts along right armhole edge, pm for armhole, knit to m, LLI, sl m, work the Right Front Cable chart as established—218 (222, 228, 234, 240, 244, 244, 244) sts; 37 (37, 38, 38, 39, 40, 40, 40) sts for each front, 32 sts for each sleeve, and 80 (84, 88, 94, 98, 100, 100, 100) sts for the back.

Next row (WS): Work the Right Front Cable chart as established, *sl m, purl to m; rep from * 4 more times, sl m, work the Front Left Cable chart as established.

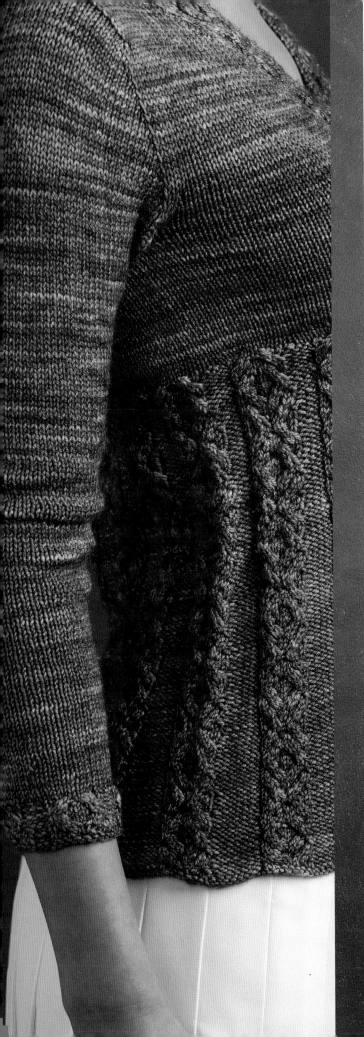

Inc rnd 3: [Work 4 cables and purl sts between them as established, sl m, m1p, purl to next cable panel m, m1p, sl m, work next 3 (3, 4, 4, 5, 6, 6, 6) cables and purl sts between them, sl m, m1p, purl to next cable m, m1p] 2 times, work to end—8 sts inc'd.

Work 7 (7, 6, 6, 6, 5, 5, 5) rnds even.

Inc rnd 4: Work 5 cables and purl sts between them as established, m1p, purl to next cable panel m, m1p, work next 1 (1, 2, 2, 3, 4, 4, 4) cable(s) and purl sts between them, m1p, purl to next cable m, m1p, work next 6 cables and purl sts between them, m1p, purl to next cable m, m1p, work next 1 (1, 2, 2, 3, 4, 4, 4) cable(s) and purl sts between them, m1p, purl to next cable m, m1p, work to end—8 sts inc'd.

Work 7 (7, 6, 6, 6, 5, 5, 5) rnds even.

Sizes 34½ (37¾)" (87.5 [96] cm) only:
Inc rnd 5: Work 6 cables and purl sts between them as established, m1p, purl to next cable m, m1p, work next 8 cables, m1p, purl to next cable m, m1p, work to end—4 sts inc'd.

Work 6 (6) rnds even.

Sizes 40¼ (42¾, 45½, 47)"
(102 [108.5, 115.5, 119.5] cm) only:
Inc rnd 5: Work 6 cables and purl sts between them as established, m1p, purl to cable m, m1p, work next 1 (2, 2, 2) cable(s) and purl sts between them, m1p, purl to next cable m, m1p, work next 8 cables and purl sts between them, m1p, purl to next cable m, m1p, work next 1 (2, 2, 2) cable(s) and purl sts between them, m1p, purl to cable m, m1p, work to end—8 sts inc'd.

Work 6 (5, 5, 5) rnds even.

Sizes 42¾ (45½, 47)"
(108.5 [115.5, 119.5] cm) only:
Inc rnd 6: Work 7 cables and purl sts between them as established, m1p, purl to cable m, m1p, work next 10 cables and purl sts between them, m1p, purl to next cable m, m1p, work to end—4 sts inc'd.

Work 5 rnds even.

Rep last 2 rnds 0 (0, 0, 0, 1, 2, 2, 4) time(s)— 287 (303, 315, 339, 355, 363, 363, 371) sts; 91 (95, 99, 105, 109, 111, 111, 111) sts for the front, 58 (62, 64, 70, 74, 76, 76, 80) sts for each sleeve, and 80 (84, 88, 94, 98, 100, 100, 100) sts for the back.

Shape armholes

Inc rnd: [RLI, knit to armhole m, LLI, sl m, k1, RLI, work to 1 st before next armhole m, LLI, k1, sl m] twice—8 sts inc'd.

Work 1 rnd even.

Rep last 2 rnds 2 (2, 3, 2, 2, 3, 5, 5) more times—311 (327, 347, 363, 379, 395, 411, 419) sts; 97 (101, 107, 111, 115, 119, 123, 123) sts for the front, 64 (68, 72, 76, 80, 84, 88, 92) sts for each sleeve, and 86 (90, 96, 100, 104, 108, 112, 112) sts for the back.

Body
Divide body and sleeves

Dividing rnd: Removing armhole m, place 64 (68, 72, 76, 80, 84, 88, 92) left sleeve sts on a holder or waste yarn, CO 3 (5, 6, 9, 11, 13, 15, 17) sts, pm for beg of rnd, CO 3 (5, 6, 9, 11, 13, 15, 17) sts, work back sts, place 64 (68, 72, 76, 80, 84, 88, 92) right sleeve sts on a holder or waste yarn, CO 6 (10, 12, 18, 22, 26, 30, 34) sts, work front sts in established patt, knit to end—195 (211, 227, 247, 263, 279, 295, 303) sts rem.

Working CO sts in St st, work evenly until piece measures 3½ (3¾, 3¾, 4, 4¼, 4½, 4¾, 5)" (9 [9.5, 9.5, 10, 11, 11.5, 12, 12.5] cm) from armhole.

NOTE: Try on the sweater to make sure your work is long enough to reach under your bust before starting the lower cable section. Work additional rounds in the established pattern if necessary.

Decrease bust stitches

Dec rnd: Knit to 26 (24, 18, 18, 20, 12, 16, 12) sts before cable panel m, [ssk] 13 (12, 9, 9, 10, 6, 8, 6) times, sl m, work next 27 sts in established patt, sl m, [k2tog] 13 (12, 9, 9, 10, 6, 8, 6) times, knit to end—169 (187, 209, 229, 243, 267, 279, 291) sts rem.

Work 2 rnds even.

Cabled Body

NOTE: The first Cable Panel chart marker that you slip becomes the new beginning of the round marker. Make sure the beginning of the round marker is a different color from the other stitch markers.

Set-up rnd: Remove beg-of-rnd m, knit to first Cable Panel m (new beg-of-rnd), sl m, work next 13 sts in established patt, p1f&b&f, work next 13 sts in patt, sl m, knit to new beg-of-rnd and inc 84 (96, 110, 124, 131, 145, 154, 163) sts evenly to the end of the rnd—255 (285, 321, 355, 376, 414, 435, 456) sts.

Next rnd: Work the next row of the Cable Panel chart around the work as foll: work 13 sts in established patt, pm, p3, pm, work next 12 sts in the Cable Panel chart, pm, [p4 (6, 6, 8, 7, 7, 8, 9), pm for cable panel, work next 12 sts in the Cable Panel chart, pm] 14 (14, 16, 16, 18, 20, 20, 20) times, purl to end of rnd, remove m, p1, place new beg-of-rnd m.

Work 16 rnds in established patt, working sts between cable panel m in rev St st (purl every rnd).

Shape body

NOTE: The body increases start on the two purl sections on each side of the two front cables and in the center of the back purl section, and then they work out toward the sides. There are no increases between the two front cables.

Inc rnd 1: Work first 2 cables and purl sts between them as established, sl m, m1p, purl to next cable m, m1p, sl m, [work next 7 (7, 8, 8, 9, 10, 10, 10) cables and purl sts between them, sl m, m1p purl to next cable m, m1p, sl m] 2 times—6 sts inc'd.

Work 7 (7, 6, 6, 6, 5, 5, 5) more rnds even.

Inc rnd 2: Work first cable and 3 purl sts as established, [work 2 cables and purl sts between them, sl m, m1p, purl to next cable m, m1p, sl m, work next 5 (5, 6, 6, 7, 8, 8, 8) cables and purl sts between them, sl m, m1p, purl to next cable m, m1p, sl m] 2 times, work to the end—8 sts inc'd.

Work 7 (7, 6, 6, 6, 5, 5, 5) rnds even.

Right Cable chart

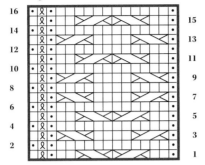

Left Cable chart

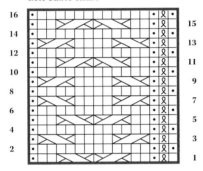

Cable Panel chart

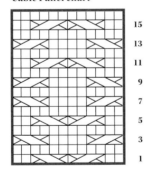

☐	k on RS; p on WS
•	p on RS; k on WS
૪	k tbl on RS; p tbl on WS
⬓	2/2 LC (see Stitch Guide, page 30)
⬓	2/2 RC (see Stitch Guide)
☐	pattern repeat

Increase neck and sleeve stitches

Inc row (RS): Work the Left Front Cable chart to m, sl m, RLI, knit to armhole m, sl m, RLI, knit to next armhole m, LLI, sl m, work back sts, sl m, RLI, knit to next armhole m, LLI, sl m, work to armhole m, LLI, sl m, work the Right Front Cable chart—6 sts inc'd.

Working new sts in St st, work 1 WS row even.

Rep last 2 rows 10 (12, 13, 16, 17, 17, 17, 17) more times, ending with a WS row—284 (300, 312, 336, 350, 352, 352, 352) sts; 48 (50, 52, 55, 57, 58, 58, 58) sts for each front, 54 (58, 60, 66, 68, 68, 68, 68) sts for each sleeve, and 80 (84, 88, 94, 98, 100, 100, 100) sts for the back.

Bodice

NOTE: Begin working the Cable Panel chart for the sts between the right front cable and left front cable markers. Work the same chart row that corresponds to the row in the Right Front Cable and Left Front Cable charts.

Join pieces to work in the round

Joining row (RS): Cut yarn, sl front left sts to RH needle, remove armhole m and place unique color m for beg-of-rnd, RLI, knit to next armhole m, LLI, sl m, knit to armhole m, sl m, RLI, knit to next armhole m, LLI, sl m, knit to next m, p1, work corresponding row of the Cable Panel chart over next 12 sts, p2tog tbl, [p2tog] 2 times to join fronts, work corresponding row of the Cable Panel chart over next 12 sts, p1, sl m, work to end—285 (301, 313, 337, 351, 353, 353, 353) sts; 93 (97, 101, 107, 111, 113, 113, 113) sts for the front, 80 (84, 88, 94, 98, 100, 100, 100) sts for the back, and 56 (60, 62, 68, 70, 70, 70, 70) sts for each sleeve.

Next rnd: Knit to cable panel m, sl m, work next 13 sts in established patt, p3tog, work next 13 sts in established patt, knit to end—283 (299, 311, 335, 349, 351, 351, 351) sts rem; 91 (95, 99, 105, 109, 111, 111, 111) sts for the front, 80 (84, 88, 94, 98, 100, 100, 100) sts for the back, and 56 (60, 62, 68, 70, 70, 70, 70) sts for each sleeve.

Increase sleeve stitches

Inc rnd: RLI, knit to next armhole m, LLI, sl m, knit to next armhole m, sl m, RLI, knit to next armhole m, LLI, sl m, work in established patt to the end—4 sts inc'd.

Work 1 rnd even.

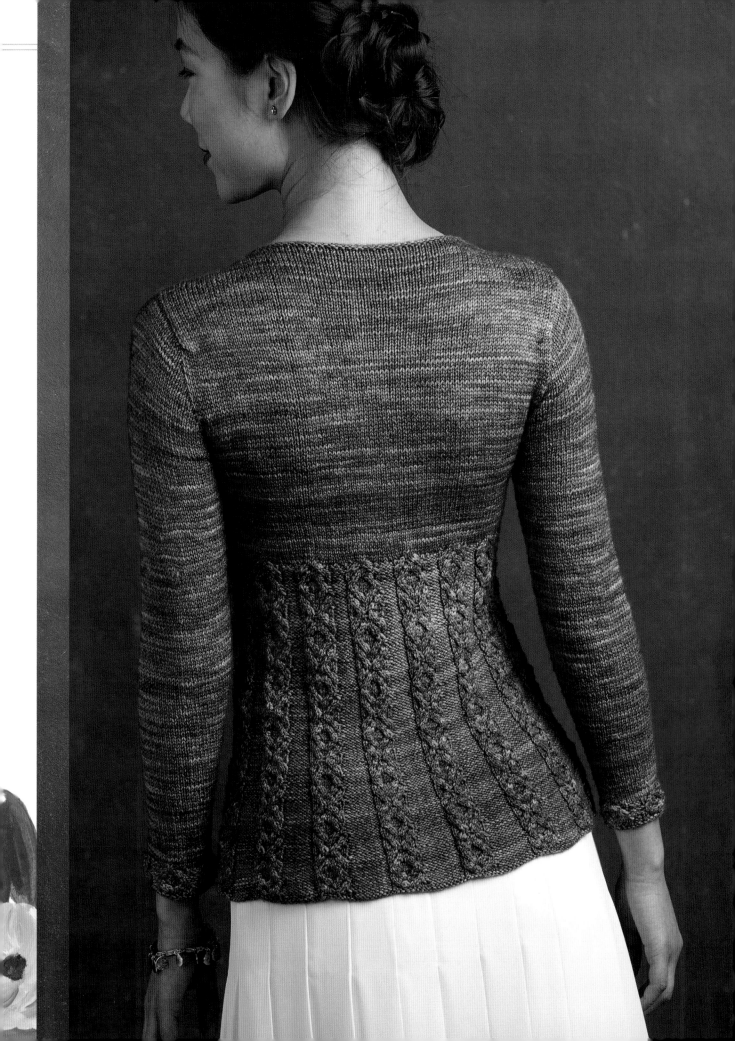

All sizes:

Rep inc rnds 1–4 (4, 5, 5, 5, 6, 6, 6) two more times—345 (375, 423, 457, 490, 540, 561, 582) sts, with 3 purl sts between the center front cables and 10 (12, 12, 14, 13, 13, 14, 15) purl sts between each rem cable around. Piece should measure 15½ (15½, 16½, 16¾, 17, 17¾, 18, 18)" (39.5 [39.5, 42, 42.5, 43, 45, 45.5, 45.5] cm) from armhole.

BO rnd: *[P1, BO] 2 times, [p2tog, BO] 4 times, [p1, BO] 2 times. BO rev St st pwise; rep from * around.

Sleeves

With dpn and RS facing, beg at center of underarm and pick up and k3 (5, 6, 9, 11, 13, 15, 17) sts along CO edge, k64 (68, 72, 76, 80, 84, 88, 92) sleeve sts from holder or waste yarn, then pick up and k3 (5, 6, 9, 11, 13, 15, 17) sts along rem CO edge to center of underarm—70 (78, 84, 94, 102, 110, 118, 126) sts.

Pm for beg of rnd and join for working in rnds.

Work 9 (7, 7, 5, 5, 5, 5, 5) more rnds even.

Dec rnd: K1, k2tog, knit to last 2 sts, ssk—2 sts dec'd.

Rep dec rnd every 10 (8, 8, 6, 6, 6, 6, 6) rnds 12 (14, 11, 22, 22, 15, 12, 5) more times, then every 0 (6, 6, 0, 0, 4, 4, 4) rnds 0 (2, 6, 0, 0, 11, 16, 27) times—44 (44, 48, 48, 56, 56, 60, 60) sts rem.

Cont evenly until sleeve measures 15¾ (15¾, 16, 16¼, 16¾, 16¾, 17, 17¼)" (40 [40, 40.5, 41.5, 42.5, 42.5, 43, 44] cm) or about 1¼" (3.2 cm) less than desired length, and dec 0 (0, 0, 1, 1, 0, 0) st(s) on last rnd—44 (44, 48, 48, 55, 55, 60, 60) sts rem.

Cabled Cuff

Set-up rnd: [(K1, k1f&b) 2 times, (k1f&b, k1) 2 times, pm for cable panel, p3 (3, 4, 4, 3, 3, 4, 4), pm for cable panel], 4 (4, 4, 5, 5, 5, 5, 5) times—60 (60, 64, 64, 75, 75, 80, 80) sts.

Next rnd: [Work Row 5 of the Cable Panel chart over the next 12 sts, sl m, p3 (4, 4, 3, 3, 4, 4, 4), sl m] 4 (4, 4, 5, 5, 5, 5, 5) times.

Work Rows 6–12 of the Cable Panel chart in patt as established.

BO rnd *[P1, BO] 2 times, [p2tog, BO] 4 times, [p1, BO] 2 times, BO rev St st pwise; rep from * around.

Finishing

Weave in loose ends. Block to finished measurements.

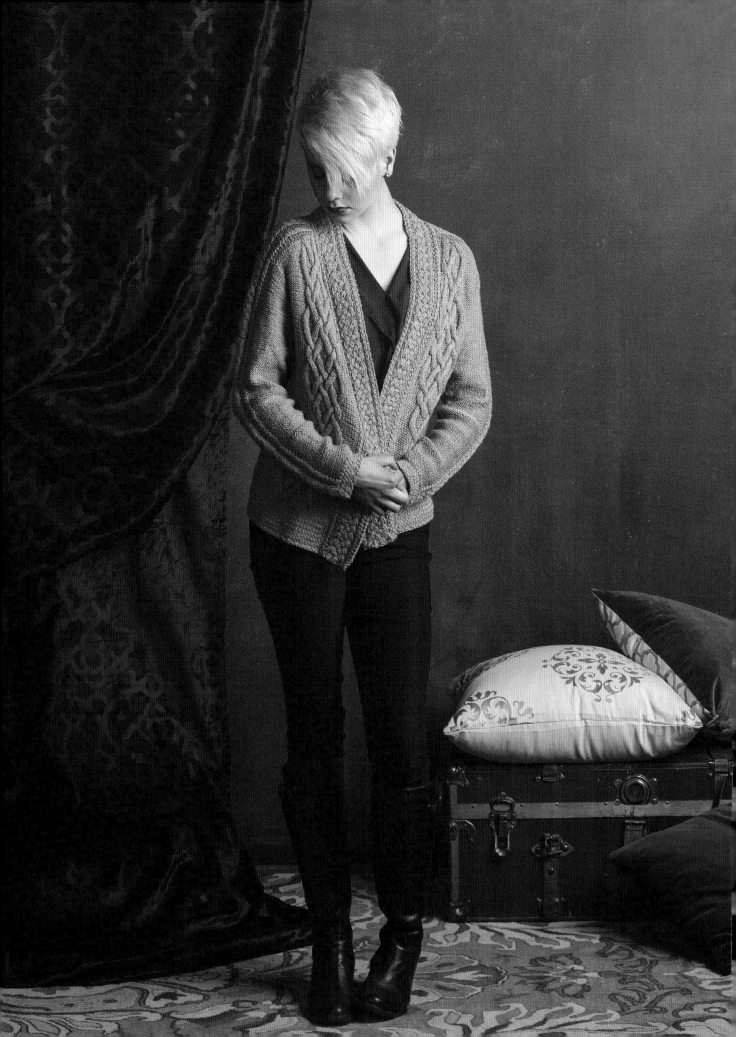

FINISHED SIZE

About 33¼ (36, 39, 42, 44¾, 47¾, 50¾, 53½)" (84.5 [91.5, 99, 106.5, 113.5, 121.5, 129, 136] cm) bust circumference plus 2½" (6.5 cm) overlap and 21¼ (22¼, 22¾, 23¾, 24¼, 24¾, 25¾, 26)" (54 [56.5, 58, 60.5, 61.5, 63, 65.5, 66] cm) long.

Cardigan shown is size 36" (91.5 cm).

YARN

DK weight (#3 Light).

Shown here: Shibui Staccato (70% superwash merino wool, 30% silk; 191 yd [175 m]/1¾ oz [50 g]), caffeine, 10 (10, 11, 11, 12, 12, 13, 13) skeins or 1,769 (1,867, 1,965, 2,067, 2,168, 2,266, 2,368, 2,466) yd (1,617 [1,707, 1,797, 1,890, 1,982, 2,072, 2,165, 2,255] m) of similar yarn.

Also shown: Shibui Pebble (48% recycled silk, 36% fine merino wool, 16% cashmere; 224 yd [205 m]/¾ oz [25 g]), caffeine, 5 (5, 6, 6, 6, 6, 7, 7) skeins or 1,049 (1,107, 1,165, 1,226, 1,286, 1,344, 1,404, 1,462) yd (959 [1,012, 1,065, 1,121, 1,176, 1,229, 1,284, 1,337] m) of similar yarn.

NEEDLES

U.S. size 6 (4 mm): 24" (60 cm) circular (cir) and a set of 4 or 5 double-pointed (dpn).

Adjust needle size if necessary to obtain the correct gauge.

NOTIONS

Stitch markers (m); locking marker; stitch holders or waste yarn; cable needle (cn); tapestry needle.

GAUGE

22 sts and 28 rows = 4" (10 cm) in St st.

32-st Cable Panel chart = 4" (10 cm) wide, blocked.

18-st Saddle/Sleeve/Side chart = 2¼" (5.5 cm) wide, blocked.

Brielle
SHAWL COLLAR CARDIGAN

Brielle is a Celtic name, fitting for the cables in this cardigan. It means strength, power, and force, which reflect the fortitude necessary to complete this experimental cardigan. The shawl collar is a reversible cable, knitted from the top down so that the collar is worked along with the sweater.

Brielle is not a quick knit, but if you take it one step at a time, you'll work your way through the many pieces. Watching it come together is fascinating. When you finish, you will be proud of your accomplishment.

I held two yarns together for this design, which allows for a nice mixture of textures. I used Shibui Staccato and Pebble yarns, creating a blend of merino, silk, cashmere, and nylon. Together they have great stitch definition and drape with a slight halo and tweedy effect. Each of these is a fingering weight; when held together, they are equivalent to a DK weight yarn. You may substitute a single DK weight yarn.

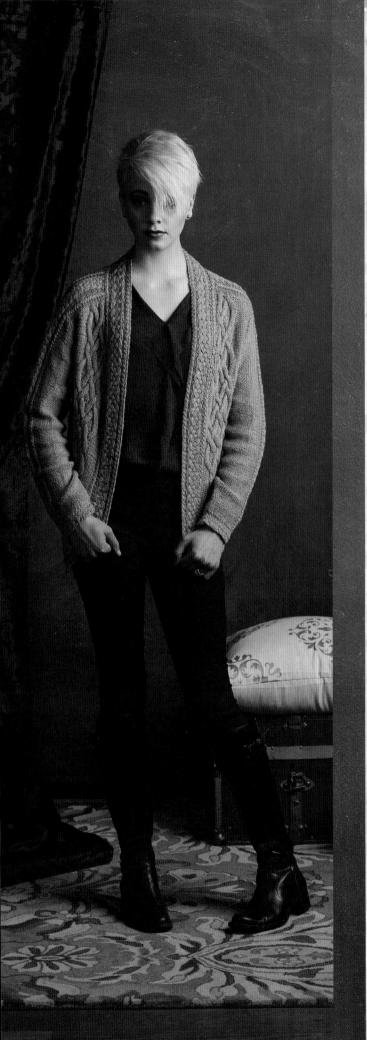

STITCH GUIDE

- **Left twist (LT):** Sl 1 st onto cn and hold in front, k1, k1 from cn.
- **Right twist (RT):** On RS rows, sl 1 st onto cn and hold in back, k1, k1 from cn. On WS rows, sl 1 st onto cn and hold in back, p1, p1 from cn.
- **1/1 LPC (1 over 1 left purl cross):** Sl 1 st onto cn and hold in front, p1, k1 from cn.
- **1/1 RPC (1 over 1 right purl cross):** Sl 1 st onto cn and hold in back, k1, p1 from cn.
- **2/2 LC (2 over 2 left cross):** Sl 2 sts onto cn and hold in front, k2, k2 from cn.
- **2/2 RC (2 over 2 right cross):** Sl 2 sts onto cn and hold in back, k2, k2 from cn.
- **2/2 LRC (2 over 2 left rib cross):** Sl 2 sts onto cn and hold in front, k1, p1, then k1, p1 from cn.
- **3/1 LPC (3 over 1 left purl cross):** Sl 3 sts onto cn and hold in front, p1, k3 from cn.
- **3/1 RPC (3 over 1 right purl cross):** Sl 1 st onto cn and hold in back, k3, p1 from cn.
- **3/3 LC (3 over 3 left cross):** Sl 3 sts onto cn and hold in front, k3, k3 from cn.
- **3/3 RC (3 over 3 right cross):** Sl 3 sts onto cn and hold in back, k3, k3 from cn.
- **4/4 LRC (4 over 4 left rib cross):** Sl 4 sts onto cn and hold in front, [k1, p1] twice, then [k1, p1] twice from cn.
- **4/4 RRC (4 over 4 right rib cross):** Sl 4 sts onto cn and hold in back, [k1, p1] twice, then [k1, p1] twice from cn.

Turn to the Glossary on page 144 to learn how to work these stitches:

LLI-P
LT
M1
M1r
M1p
RT
RLI-P
SSP
W&t
WYIB

SHAWL COLLAR CARDIGAN

A word about construction:

Brielle is constructed from the top down, starting in pieces that are joined together as you knit. The back and front pieces are joined when beginning the sleeves, and the cardigan is worked in one piece from that point. It has saddle shoulders and set-in sleeves. The shoulders are shaped by short-rows worked in reverse stockinette stitch, which means you don't have to hide the wraps. Because there is no body shaping below the armholes, the length of the body and sleeves are easy to adjust.

Use different colored markers for each section to make the instructions easier to follow.

Collar

NOTE: Once you start working the collar, mark the right side with a locking marker.

With 2 dpn and holding a strand of both yarns together, CO 32 sts using the provisional method (Techniques, page 144). Do not join.

Work Rows 1–4 of the Collar Cable chart until piece measures 5¾ (6, 6, 6, 6¼, 6¼, 6½, 6½)" (14.5 [15, 15, 15, 16, 16, 16.5, 16.5] cm), ending with a WS row *(figure 1)*. Cut yarns and place sts on a holder or waste yarn.

With WS facing, carefully remove provisional CO and place collar sts onto dpn.

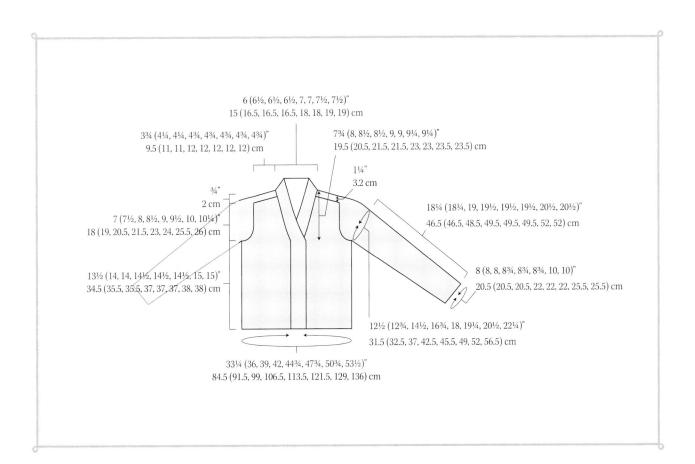

6 (6½, 6½, 6½, 7, 7, 7½, 7½)"
15 (16.5, 16.5, 16.5, 18, 18, 19, 19) cm

3¾ (4¼, 4¼, 4¾, 4¾, 4¾, 4¾, 4¾)"
9.5 (11, 11, 12, 12, 12, 12, 12) cm

7¾ (8, 8½, 8½, 9, 9, 9¼, 9¼)"
19.5 (20.5, 21.5, 21.5, 23, 23, 23.5, 23.5) cm

1¼"
3.2 cm

¾"
2 cm

7 (7½, 8, 8½, 9, 9½, 10, 10¼)"
18 (19, 20.5, 21.5, 23, 24, 25.5, 26) cm

18¼ (18¼, 19, 19½, 19½, 19½, 20½, 20½)"
46.5 (46.5, 48.5, 49.5, 49.5, 49.5, 52, 52) cm

13½ (14, 14, 14½, 14½, 14½, 15, 15)"
34.5 (35.5, 35.5, 37, 37, 37, 38, 38) cm

8 (8, 8, 8¾, 8¾, 8¾, 10, 10)"
20.5 (20.5, 20.5, 22, 22, 22, 25.5, 25.5) cm

12½ (12¾, 14½, 16¾, 18, 19¼, 20½, 22¼)"
31.5 (32.5, 37, 42.5, 45.5, 49, 52, 56.5) cm

33¼ (36, 39, 42, 44¾, 47¾, 50¾, 53½)"
84.5 (91.5, 99, 106.5, 113.5, 121.5, 129, 136) cm

Collar Cable chart

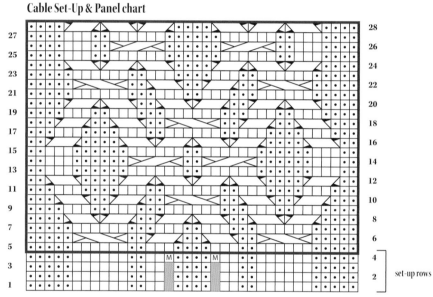

3 4

1 2

Work edge st in garter st, then
work in rev St st
after joining to front.

Work edge st in garter st, then
work in rev St st
after joining to front.

Saddle/Side/Sleeve chart

3 4

1 2

Cable Set-Up & Panel chart

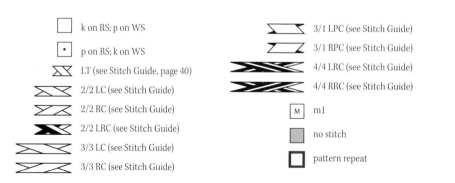

27 28
25 26
23 24
21 22
19 20
17 18
15 16
13 14
11 12
9 10
7 8
5 6
 4
3 2
1 } set-up rows

☐ k on RS; p on WS	3/1 LPC (see Stitch Guide)
• p on RS; k on WS	3/1 RPC (see Stitch Guide)
LT (see Stitch Guide, page 40)	4/4 LRC (see Stitch Guide)
2/2 LC (see Stitch Guide)	4/4 RRC (see Stitch Guide)
2/2 RC (see Stitch Guide)	M m1
2/2 LRC (see Stitch Guide)	no stitch
3/3 LC (see Stitch Guide)	☐ pattern repeat
3/3 RC (see Stitch Guide)	

Work Rows 1–4 of the Collar Cable chart until piece measures 11½ (12, 12, 12, 12½, 12½, 13, 13)" (29 [30.5, 30.5, 30.5, 31.5, 31.5, 33, 33] cm) from held sts at the other end, ending with the same row as the first half of collar *(figure 2)*.

Cut yarns and place sts on a holder or waste yarn. Place markers (pm) on one long edge 2¾" (7 cm) from each holder or waste yarn.

Right Saddle

With cir needle and RS facing, beg at left m and pick up and k22 sts evenly along edge to held sts, CO 1 st—23 sts *(figure 3)*.

Next row (WS): P1, work Row 1 of the Saddle/Side/Sleeve chart, CO 1 st—24 sts.

Next row (RS): K1, work Row 2 of the Saddle/Side/Sleeve chart, k1.

Cont in established patt until piece measures 3¾ (4¼,

4¼, 4¾, 4¾, 4¾, 4¾, 4¾)" (9.5 [11, 11, 12, 12, 12, 12, 12] cm) from pick-up edge, ending with a WS row. Make a note of the last chart row you worked.

Cut yarns and place sts on a holder or waste yarn.

Left Saddle

With cir needle and RS facing, beg at held sts on right end of collar, pick up and k22 sts evenly to right m, CO 1 st—23 sts *(figure 3)*.

Next row (WS): P1, work Row 1 of the Saddle/Side/Sleeve chart, CO 1 st—24 sts.

Next row (RS): K1, work Row 2 of the Saddle/Side/Sleeve chart, k1.

Cont in established patt until piece measures 3¾ (4¼, 4¼, 4¾, 4¾, 4¾, 4¾, 4¾)" (9.5 [11, 11, 12, 12, 12, 12, 12] cm) from pick-up edge, ending with the same row as right saddle.

Cut yarns and place sts on a holder or waste yarn.

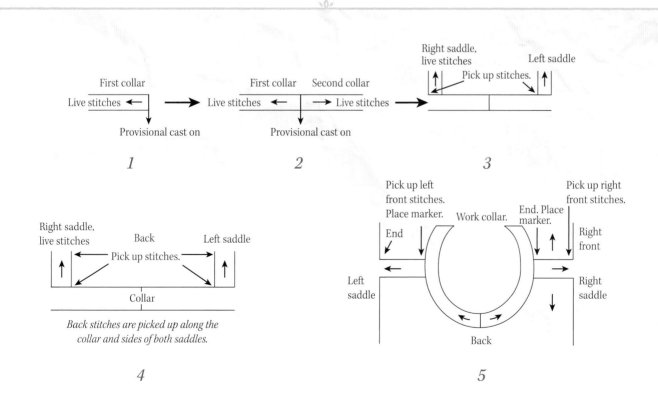

Back stitches are picked up along the collar and sides of both saddles.

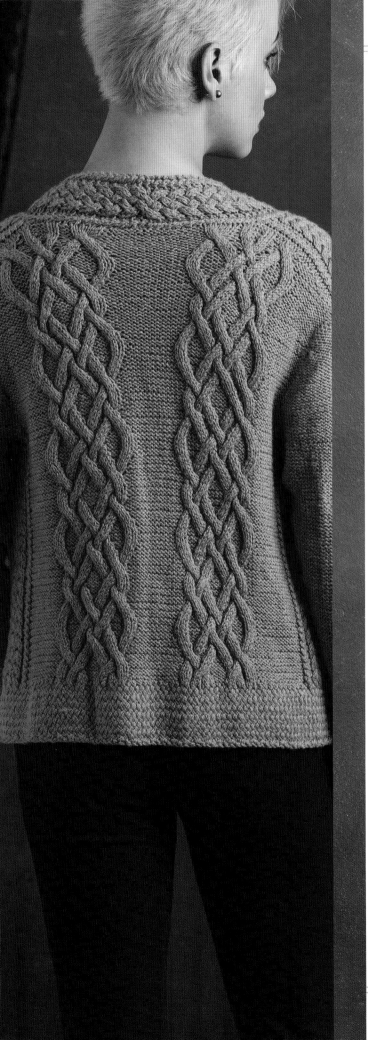

Back

With cir needle and RS facing, pick up and k25 (26, 27, 29, 30, 30, 30, 30) sts evenly along the long edge of left saddle to join to collar, 38 (40, 42, 42, 46, 46, 48, 48) sts evenly along back edge of collar to join to right saddle, then 25 (26, 27, 29, 30, 30, 30, 30) sts evenly along the long edge of right saddle to held sts *(figure 4, page 43)* 88 (92, 96, 100, 106, 106, 108, 108) sts.

Shape shoulders

Set-up row (WS): K8 (9, 10, 12, 13, 13, 13, 13), pm for cable panel, work Row 1 of the Cable Set-up & Panel chart, pm, k4 (6, 8, 8, 12, 12, 14, 14), pm for cable panel, work Row 1 of the Cable Set-up & Panel chart, pm, knit to end of row.

NOTE: Continue working the Cable Set-up & Panel chart between the cable panel markers and the stitches outside of the markers in reverse stockinette stitch (purl RS rows, knit WS rows) as established, slipping markers as you come to them.

Short-rows 1 and 2: Work to last 20 (21, 22, 24, 25, 25, 25, 25) sts, w&t.

Short-rows 3 and 4: Work to wrapped st, work 7 sts, w&t—92 (96, 100, 104, 110, 110, 112, 112) sts.

Short-row 5: Work to end of second cable panel, then purl to last 7 sts, w&t.

Short-row 6: Work to end of second cable panel, then knit to last 7 sts, w&t.

After the last turn, work to end of the row. Work 11 rows over all sts, ending with Row 19 of the Cable Set-up & Panel chart. Cut yarn and place sts on a holder or waste yarn.

Right Front

NOTE: Neck shaping is incorporated in the Right Front Cable and Left Front Cable charts. The stitches on the armhole edge are worked in reverse stockinette stitch. Once the collar stitches have been joined to the front, work the edge stitch next to the front stitches in reverse stockinette stitch and continue the front edge stitch in garter stitch (knit every row).

Return held 32 collar sts to cir needle. With RS facing and collar sts at left end of the needle, beg at held sts of right saddle and pick up and k25 (26, 27, 29, 30, 30, 30, 30) sts evenly along the long edge to collar, pm, work next row of the Collar chart to end *(figure 5, page 43)*—57 (58, 59, 61, 62, 62, 62, 62) sts.

Shape shoulder

Set-up row (WS): Work to m in established patt, work Row 1 of the Right Front Cable chart, pm, knit to end.

Short-row 1 (RS): Purl to m, work Row 2 of the Right Front Cable chart to m, then work to end in established patt.

Short-row 2: Work 37 sts in established patt, w&t.

Short-row 3: Work in established patt to front edge and inc 1 st as indicated in the Right Front Cable chart—58 (59, 60, 62, 63, 63, 63, 63) sts.

Short-row 4: Work in established patt to wrapped st, work 6 sts, w&t.

Short-row 5: Work in established patt to front edge.

Short-row 6: Work in established patt to last wrapped st, work to last 7 sts, w&t.

Shape neckline

Inc row (RS): Work to collar m and inc 1 st as indicated in the Right Front Cable chart, sl m, work to end—1 st inc'd.

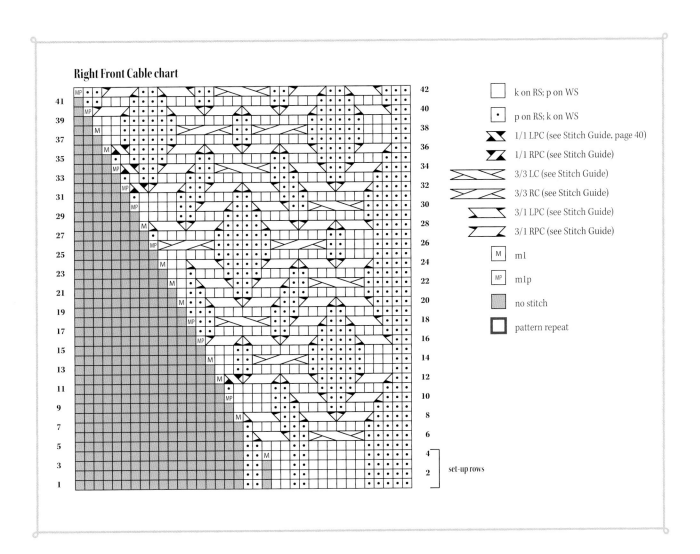

Right Front Cable chart

	k on RS; p on WS
	p on RS; k on WS
	1/1 LPC (see Stitch Guide, page 40)
	1/1 RPC (see Stitch Guide)
	3/3 LC (see Stitch Guide)
	3/3 RC (see Stitch Guide)
	3/1 LPC (see Stitch Guide)
	3/1 RPC (see Stitch Guide)
M	m1
MP	m1p
	no stitch
	pattern repeat

set-up rows

Work 11 more rows in established patt, ending with Row 19 of the Right Front Cable chart—64 (65, 66, 68, 69, 69, 69, 69) sts.

Cut yarns and place sts on a holder or waste yarn.

Left Front

Return held 32 collar sts to cir needle. With RS facing, work next row of the Collar chart, pm, pick up and k25 (26, 27, 29, 30, 30, 30, 30) sts evenly along the long edge of left saddle to holder (*figure 5, page 43*)—57 (58, 59, 61, 62, 62, 62, 62) sts.

Shape shoulder

Set-up row (WS): K8 (9, 10, 12, 13, 13, 13, 13) sts, pm,

work Row 1 of the Left Front Cable chart to m, work to end in established patt.

Short-row 1 (RS): Work 37 sts in established patt, w&t.

Short-row 2: Work to front edge in established patt.

Short-row 3: Work in established patt to wrapped st, work 7 sts, w&t—58 (59, 60, 62, 63, 63, 63, 63) sts.

Short-row 4: Work to front edge in established patt.

Short-row 5: Work in established patt to last wrapped st, purl to last 7 sts, w&t.

Short-row 6: Rep Short-row 4.

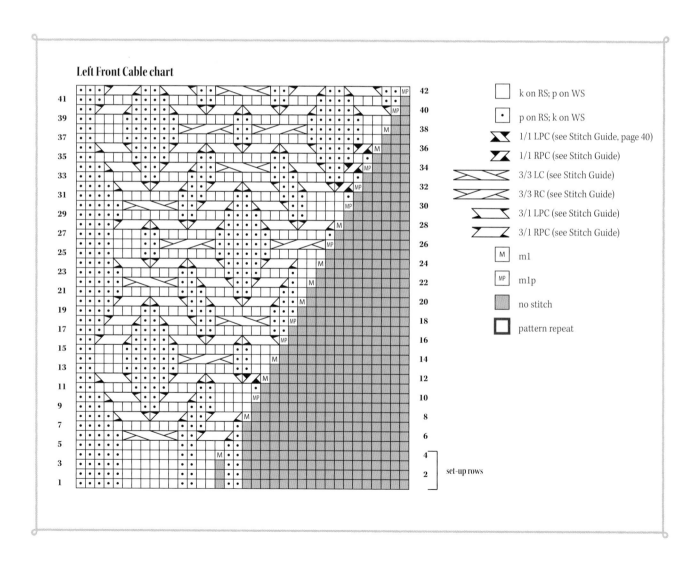

Left Front Cable chart

☐	k on RS; p on WS
•	p on RS; k on WS
⟋	1/1 LPC (see Stitch Guide, page 40)
⟍	1/1 RPC (see Stitch Guide)
⟋	3/3 LC (see Stitch Guide)
⟍	3/3 RC (see Stitch Guide)
⟍	3/1 LPC (see Stitch Guide)
⟋	3/1 RPC (see Stitch Guide)
M	m1
MP	m1p
▨	no stitch
☐	pattern repeat

set-up rows

Shape neckline

Inc row: Work to collar m in established patt, sl m, work next row of the Left Front Cable chart—1 st inc'd.

Work 11 more rows in established patt, ending with Row 19 of the Left Front Cable chart—64 (65, 66, 68, 69, 69, 69, 69) sts.

Yoke

With RS facing, return all held sts to cir needle as foll: left front, left saddle, back, right saddle, and right front (*figure 3, page 43*)—268 (274, 280, 288, 296, 296, 298, 298) sts.

Add sleeves

With RS facing, work left collar and front sts in established patt pm for armhole, pick up and k8 sts evenly along side edge of left front to saddle sts, pm, p2tog, work in established patt to last 2 saddle sts, p2tog, pm, pick up and k8 sts evenly along side edge of back, pm for armhole, work 92 (96, 100, 104, 110, 110, 112, 112) back sts, pm for armhole, pick up and k8 sts evenly along side edge of back to saddle sts, pm, p2tog, work in established patt to last 2 saddle sts, p2tog, pm, pick up and k8 sts evenly along side edge of right front, pm for armhole, work to end in established patt—298 (304, 310, 318, 326, 326, 328, 328) sts; 65 (66, 67, 69, 70, 70, 70, 70) sts for each front, 38 sts for each sleeve, and 92 (96, 100, 104, 110, 110, 112, 112) sts for the back.

Next row (WS): [Work in established patt to armhole m, knit to m, sl m, work next 22 sts in established patt, sl m, knit to next armhole m] 2 times, work in patt to end.

Increase sleeve and neck stitches

Inc row (RS): [Work in established patt to armhole m, sl m, RLI-P, work to next armhole m, LLI-P, sl m] 2 times, work in patt to end—6 sts inc'd.

Work WS 1 row even.

Rep last 2 rows 10 more times—364 (370, 376, 384, 392, 392, 394, 394) sts; 76 (77, 78, 80, 81, 81, 81, 81) sts for each front and collar, 60 sts for each sleeve, and 92 (96, 100, 104, 110, 110, 112, 112) sts for the back.

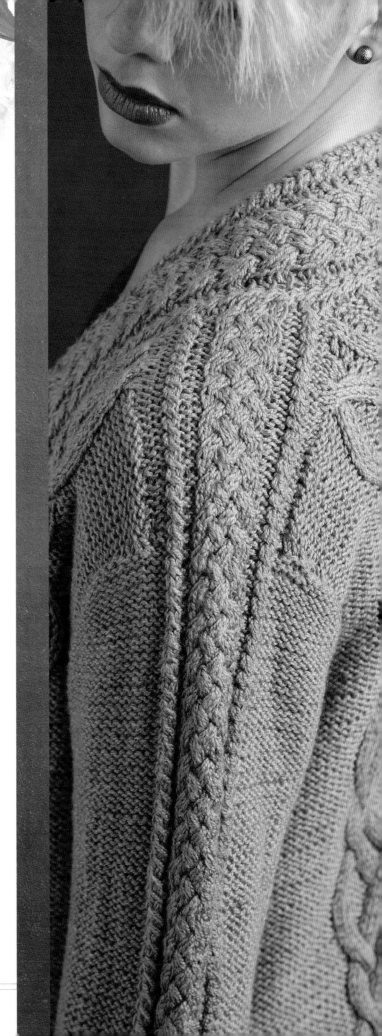

Sizes 39 (42, 44¾, 47¾, 50¾, 53½)" (99 [106.5, 113.5, 121.5, 129, 136] cm) only:

Inc row (RS): Work to first m, sl m, m1p, [work to armhole m, sl m, RLI-P, work to next armhole m, LLI-P, sl m] 2 times, work to last m, m1p, sl m, work to end of row—6 sts inc'd.

Work 1 WS row even.

Rep last 2 rows 1 (3, 5, 5, 6, 6) more time(s)—388 (408, 428, 428, 436, 436) sts; 80 (84, 87, 87, 88, 88) sts for each front and collar, 64 (68, 72, 72, 74, 74) sts for each sleeve; and 100 (104, 110, 110, 112, 112) sts for the back.

Shape neck and armholes
Sizes 33¼ (36, 39)" (84.5 [91.5, 99] cm) only:

Inc row (RS): Work to first m, sl m, m1p, [work in patt to armhole m, RLI-P, sl m, work to next armhole m, sl m, LLI-P] 2 times, work to last m, m1p, sl m, work to end of row—6 sts inc'd.

Work 1 WS row even.

Rep last 2 rows 1 (2, 1) more time(s)—376 (388, 400) sts; 80 (83, 84) sts for each front and collar, 60 (60, 64) sts for each sleeve, and 96 (102, 104) sts for the back.

Mark the last row worked on the Saddle/Side/Sleeve chart for the sleeves.

Sizes 39 (42, 44¾, 47¾, 50¾, 53½)" (99 [106.5, 113.5, 121.5, 129, 136] cm) only:

Inc row (RS): [Work to armhole m, LLI-P, sl m, RLI-P, work to next armhole m, LLI-P, sl m, RLI-P] 2 times, work to end of row—8 sts inc'd.

Work 1 WS row even.

Rep last 2 rows 0 (2, 2, 3, 4, 5) more times—408 (432, 452, 460, 476, 484) sts; 85 (87, 90, 91, 93, 94) sts for each front and collar, 66 (74, 78, 80, 84, 86) sts for each sleeve, and 106 (110, 116, 118, 122, 124) sts for the back.

Mark the last row worked on the Saddle/Side/Sleeve chart for the sleeves.

Body
Divide body and sleeves
Sizes 33¼ (36, 39)" (84.5 [91.5, 99] cm) only:

Dividing row (RS): Removing armhole m as you go, work 76 (80, 84) sts in established patt, pm for side cable panel, p4 (3, 1), place next 60 (60, 66) sts on a holder or waste yarn for left sleeve, CO 14 (16, 20) sts, p4 (3, 1), pm for side cable panel, work 88 (96, 102) back sts, pm for side cable panel, p4 (3, 1), place next 60 (60, 66) sts on a holder or waste yarn for right sleeve, CO 14 (16, 20) sts, p4 (3, 1), pm for side cable panel, work to end—284 (300, 316) sts.

Sizes 42 (44¾, 47¾, 50¾, 53½)" (106.5 [113.5, 121.5, 129, 136] cm) only:

Dividing row (RS): Removing armhole m as you go, work to armhole m, place next 74 (78, 80, 84, 86) sts on a holder or waste yarn for left sleeve, CO 1 (2, 5, 7, 10) st(s), pm for side cable panel, CO 22 sts, pm for side cable panel, CO 1 (2, 5, 7, 10) st(s), work 110 (116, 118, 122, 124) back sts, place next 74 (78, 80, 84, 86) sts on a holder or waste yarn for right sleeve, CO 1 (2, 5, 7, 10) st(s), pm for side cable panel, CO 22 sts, pm for side cable panel, CO 1 (2, 5, 7, 10) st(s), work to end—332 (348, 364, 380, 396) sts.

All sizes:

Next row (WS): [Work in established patt to side cable panel m, sl m, work Row 1 of the Saddle/Side/Sleeve chart, sl m] 2 times, work to end.

Cont in established patt until piece measures 11 (11½, 11½, 12, 12, 12, 12½, 12½)" (28 [29, 29, 30.5, 30.5, 30.5, 31.5, 31.5] cm) from armhole, ending with a WS row.

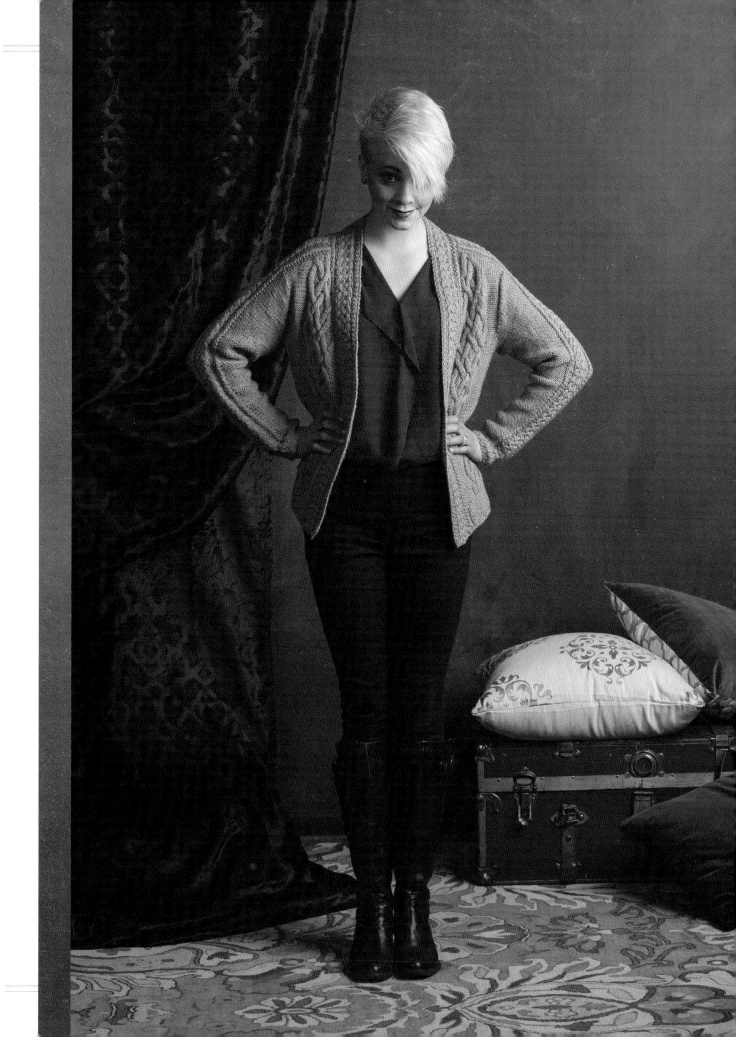

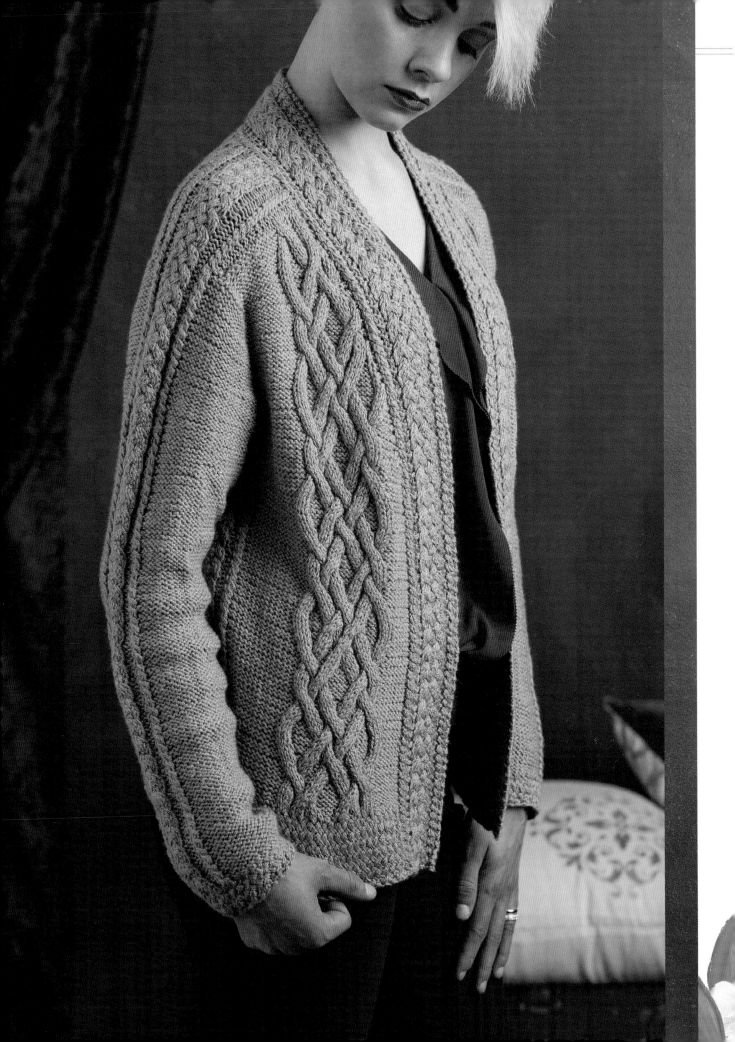

Bottom Band

NOTE: In the set-up row, work stitches as they appear, knitting the knit stitches and purling the purl stitches. Increase using the make 1 method (Techniques, page 144), spacing the new stitches evenly across the reverse stockinette–stitch sections and the front and back cable panels. Remove the markers as you come to them, except the collar markers.

Set-up row (RS): Work in established patt to collar m, sl m, purl to cable panel m and inc 1 (1, 2, 2, 3, 3, 4, 5) st(s) evenly spaced, work 3 sts, m1, [work 10 sts, m1] 3 times, work 3 sts, purl to side cable m and inc 3 (5, 7, 9, 10, 12, 14, 16) sts evenly spaced, work next 22 sts in established patt, purl to cable panel m and inc 3 (5, 7, 9, 10, 12, 14, 16) sts evenly, work 3 sts, m1, [work 10 sts, m1] 3 times, work 3 sts, purl to next cable panel m and inc 1 (3, 3, 5, 5, 7, 7, 7) st(s) evenly spaced, work 3 sts, m1, [work 10 sts, m1] 3 times, work 3 sts, purl to side cable m and inc 3 (5, 7, 9, 10, 12, 14, 16) sts evenly spaced, work next 22 sts in established patt, purl to cable panel m and inc 3 (5, 7, 9, 10, 12, 14, 16) sts evenly spaced, work 3 sts, m1, [work 10 sts, m1] 3 times, work 3 sts, sl m, purl to last m and inc 1 (1, 2, 2, 3, 3, 4, 5) st(s) evenly spaced, sl m, work to end of row—315 (341, 366, 393, 415, 441, 467, 493) sts.

Row 1 (WS): Work in established patt to m, sl m, p2, *RT; rep from * to 1 st before last m, p1, work to end of row.

Row 2: Work in established patt to m, sl m, k2, *LT; rep from * to 1 st before last m, k1, work to end of row.

Rep last 2 rows until bottom band measures 2½" (6.5 cm), ending with a RS row.

Next row (WS): K2tog, p2tog, lift first st over second st and off needle, cont BO after each st, work as foll: k2tog, p2tog, k2tog, [p3tog, k3tog] 2 times, [p2tog, k2tog] 2 times, p2tog, *k2tog, p2tog; rep from * to 1 st before last m, k1, p2tog, [k2tog, p2tog] 2 times, [k3tog, p3tog] 2 times, k2tog, [p2tog, k2tog] 2 times.

Sleeves

With dpn and RS facing, beg at center of underarm CO sts and pick up and k7 (8, 10, 12, 13, 16, 18, 21) sts evenly along CO edge, work held 60 (60, 66, 74, 78, 80, 84, 86) sleeve sts in established patt, pick up and k7 (8, 10, 12, 13, 16, 18, 21) sts along rem CO edge—74 (76, 86, 98, 104, 112, 120, 128) sts.

Pm for beg of rnd and join for working in rnds.

Work 9 (8, 6, 5, 4, 4, 4, 3) rows in established patt, working picked up sts in rev St st.

Dec rnd: P1, p2tog, work to last 2 sts, ssp—2 sts dec'd.

Rep dec rnd every 10 (9, 7, 6, 5, 5, 5, 4) rnds 3 (9, 8, 10, 19, 4, 7, 24) more times, then every 9 (8, 6, 5, 4, 4, 4, 3) rnds 8 (3, 9, 11, 5, 24, 22, 9) more times—50 (50, 50, 54, 54, 54, 60, 60) sts rem.

Cont even until sleeve measures 17 (17, 17¾, 18¼, 18¼, 18¼, 19¼, 19¼)" (43 [43, 45, 46.5, 46.5, 46.5, 49, 49] cm) from armhole, ending with an odd-numbered rnd of the chart and inc 14 (14, 14, 18, 18, 18, 20, 20) sts on last rnd in rev St st section—64 (64, 64, 72, 72, 72, 80, 80) sts.

Cuff

Rnd 1: *LT; rep from * to end.

Rnd 2: Sl 1 wyib, *RT; rep from * to last st, remove beg-of-rnd m, RT and replace beg-of-rnd m between twist sts.

Rep last 2 rnds until cuff measures 1¼" (3.2 cm).

Next rnd: K2tog, *p2tog, lift first st over second st and off needle, k2tog, lift first st over second st and off needle; rep from * to last 2 sts, p2tog, lift first st over second st and off needle, fasten off the rem st.

Finishing

Weave in loose ends. Block to finished measurements.

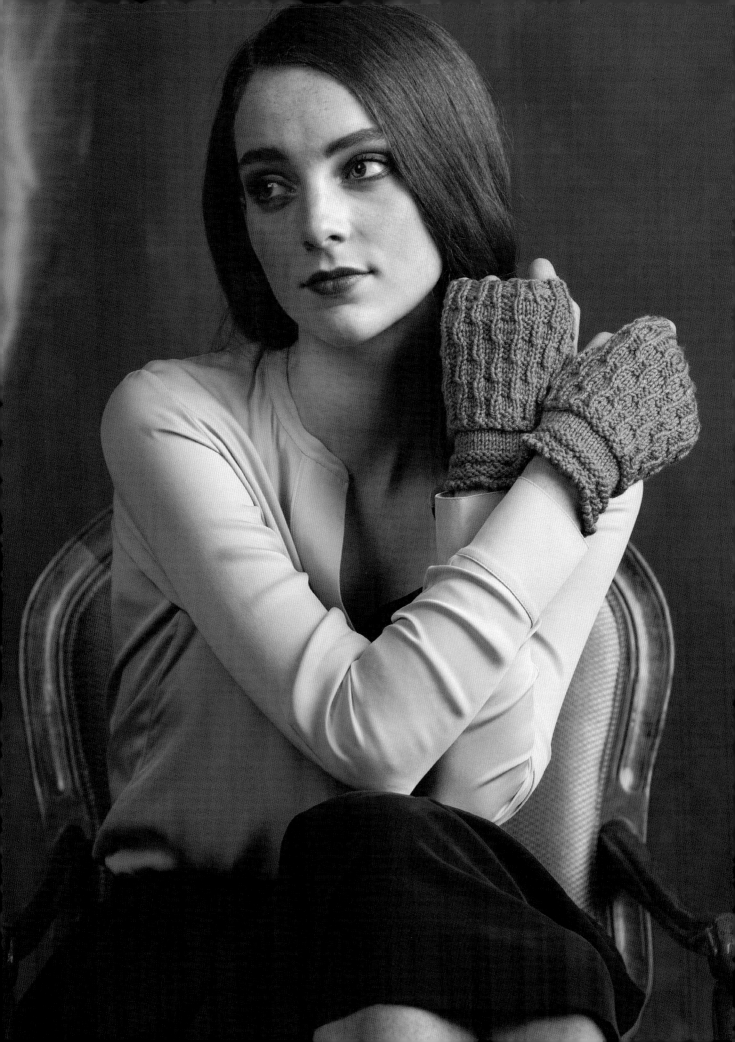

FINISHED SIZE

About 7" (18 cm) hand circumference and 6½" (16.5 cm) long.

YARN

Sportweight (#2 Fine).

Shown here: Lorna's Laces Sportmate (70% superwash merino wool, 30% Outlast viscose; 270 yd [247 m]/3½ oz [100 g]), patina, 1 skein or 113 yd (103 m) of similar yarn.

NEEDLES

Size U.S. 4 (3.5 mm).

Adjust needle size if necessary to obtain the correct gauge.

NOTIONS

Locking markers (m); tapestry needle.

GAUGE

24 sts and 28 rows = 4" (10 cm) in St st.

26½ sts and 30 rows = 4" (10 cm) in patt, blocked.

Elodie
WAVING RIB MITTS

These pretty mitts are sophisticated enough for high society. Elodie means foreign riches, making it a fitting name. Mitts may be practical, but they do not have to be plain—they are a great canvas for playing with pretty stitch designs.

These mitts start out with a flirty picot edge that has knots and purl ridges for decoration and move into a wavy rib that gives a high relief pattern like a cable. They are deceptively easy to knit. Elodie works up quite quickly once you get past the picot cast-on. This, combined with the uncomplicated stitch pattern, makes them a good project for novice knitters who want to learn to knit decorative stitches.

I used something special: Lorna's Laces Sportmate, a blend of superwash merino wool and Outlast, which is a viscose fiber that interacts with the body's microclimate to moderate temperature. Wearing these mitts, your hands won't get too hot or too cold.

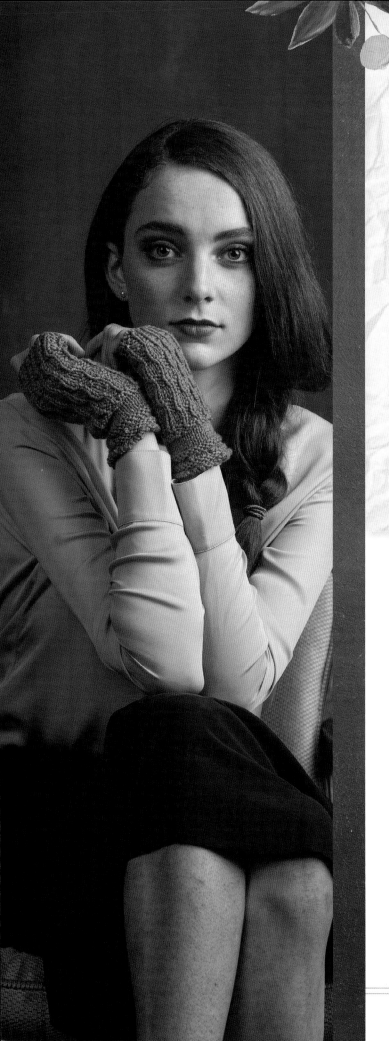

 Knot: Knit the next st, [sl the st just worked back onto the LH needle and knit it again tbl] 3 times *(figures 1–6)*.

Turn to the Glossary on page 144 to learn how to work these stitches:
K1f&b
P2tog

A word about construction:
These mitts are worked flat and then seamed, leaving a hole for the thumb (Invisible Vertical Seam, page 152).

WAVING RIB MITTS

Cuff

Work the picot edge. CO 36 sts using the cable method (Techniques, page 144) as foll: CO 3 sts, BO 1, *CO 2, BO 1; rep from * until there are 35 sts, CO 1 more st.

Knit 2 rows.

Purl 2 rows.

Next row (RS): K1, knot, [k3, knot] 8 times, k2.

Purl 2 rows.

Knit 1 row.

Beg with a RS row, work 8 rows in St st (knit RS rows, purl WS rows).

Purl 1 row.

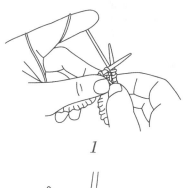

1

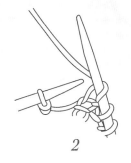

2

3

4

5

6

Hand

Inc row (WS): [K1, k1f&b] 3 times, [k2, k1f&b] 7 times, [k1, k1f&b] 4 times, k1—50 sts.

Row 1 (RS): P2, *k4, p2; rep from * to end of row.

Row 2: K2, *p4, k2; rep from * to end.

Row 3: K3, p2, *k4, p2; rep from * to the last 3 sts, k3.

Row 4: P3, k2, *p4, k2; rep from * to the last 3 sts, p3.

Rows 5 and 6: Rep Rows 3 and 4.

Rows 7 and 8: Rep Rows 1 and 2.

Rep Rows 1–8 two more times, then work Rows 1–4 once more.

Ribbed Band

Dec row (RS): K1, p1, k1, [p2tog, k1, p2, k1] 7 times, p2tog, k1, p1, k1—42 sts rem.

Next row: P1, [k1, p1] 2 times, [k2, p1, k1, p1] 7 times, k1, p1.

Next row: [K1, p1] 2 times, [k1, p2, k1, p1] 7 times, k1, p1, k1.

Rep last 2 rows once more.

BO all sts loosely in patt.

Finishing
Seam Sides

Wrap one mitt around your hand and use a locking m to mark top and bottom of thumb hole. Sew sides of the mitt tog above and below m, leaving space between m open for thumb hole.

Weave in loose ends. Block to finished measurements.

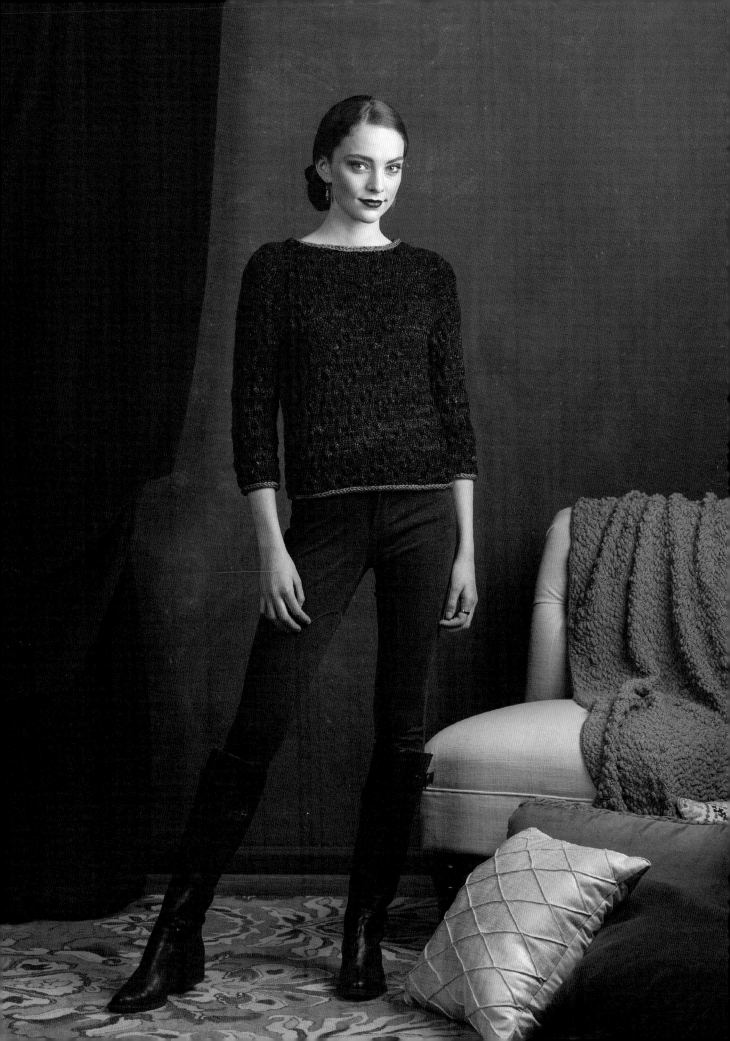

FINISHED SIZE

About 32¾ (37, 41½, 45¾, 50¼, 54½)" (83 [94, 105.5, 116, 127.5, 138.5] cm bust circumference and 21½ (22¾, 24¼, 25½, 26½, 27¼)" (54.5 [58, 61.5, 65, 67.5, 69] cm) long.

Pullover shown measures 32¾" (83 cm).

YARN

Bulky weight (#5).

Shown here: SweetGeorgia Superwash Six (100% superwash merino wool; 115 yd [105 m]/4 oz [115 g]), MC: mink, CC: wasabi.

MC: 8 (9, 10, 11, 12, 13) skeins or 856 (969, 1,083, 1,198, 1,311, 1,426) yd (782 [886, 990, 1,095, 1,199, 1,304] m) of similar yarn.

CC: 1 skein or 37 (43, 46, 52, 57, 63) yds (34 [39, 42, 47, 52, 57] m) of similar yarn.

NEEDLES

Size U.S. 9 (5.5 mm): 16" (40 cm) and 24" (60 cm) circular (cir) and set of 4 or 5 double-pointed (dpn).

Adjust needle size if necessary to obtain the correct gauge.

NOTIONS

Stitch markers (m); stitch holders or waste yarn; tapestry needle.

GAUGE

22 sts and 23 rnds = 4" (10 cm) in cable patt, blocked.

Ada
REVERSIBLE PULLOVER

Just as some stitch patterns look like cables without having cable stitches, some stitch patterns are cables without looking like it. Because of the way the cables are arranged in Ada, they get lost in the honeycomb texture of the stitch pattern. On the right side, the cables form circles, and, on the wrong side, they form a pretty diamond shape.

With a contrasting I-cord binding on the neck, bottom edge, and cuffs, Ada is fully reversible. A reversible name for a reversible sweater—Ada means nobility, reflected in the purple yarn and the diamond shapes formed on the wrong side.

I knitted Ada in SweetGeorgia Superwash Six. It is a bulky, soft, 100 percent merino wool that gives good stitch definition.

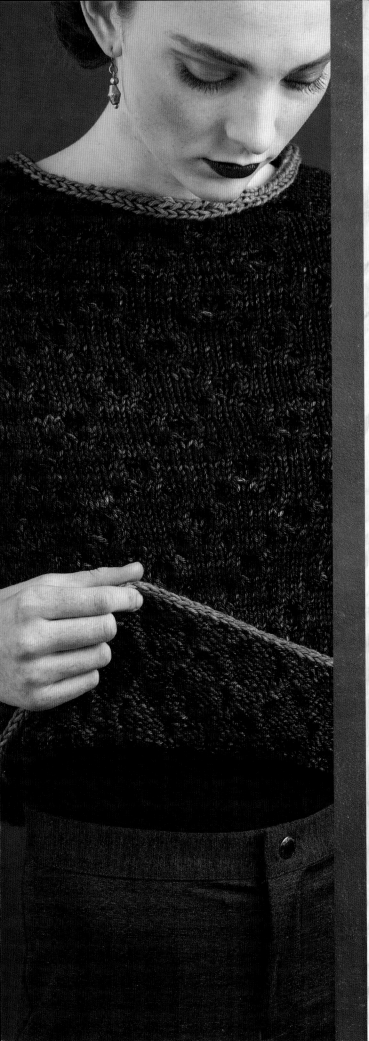

STITCH GUIDE

- ❦ **2/2 LC (2 over 2 left cross):** Sl 2 sts onto cn and hold in front, k2, k2 from cn.
- ❦ **2/2 RC (2 over 2 right cross):** Sl 2 sts onto cn and hold in back, k2, k2 from cn.
- ❦ **I-cord BO:** With CC, CO 3 sts in front of sts on LH needle using provisional method (Techniques, page 144). *K2 *(figure 1, page 61)*, ssk *(figure 2, page 61)*—1 st dec'd from sts on LH needle. Slip 3 sts from RH needle back to LH needle *(figure 3, page 61)*; rep from * until 3 sts rem. Place 3 provisionally CO sts onto LH needle and, using the Kitchener st, graft the sts from both needles together.

Turn to the Glossary on page 144 to learn how to work these stitches:

Inc 2
K1f&b
K2tog
Kitchener
LLI
RLI
Ssk

A word about construction:

This sweater is a compound raglan constructed in one piece from the top down. The compound raglan allows for a more flattering fit. The rate of increase varies to accurately follow the shape of the body; it increases more rapidly between the neck and shoulders and at the end to curve around the underarm, but more gradually in the yoke.

When working the cable chart stitches at the raglan armholes and on the sleeves, work the cable crosses only when there are enough stitches to cross the cable.

REVERSIBLE PULLOVER

Collar

With shorter cir needle and MC, CO 90 (90, 110, 110, 110, 110) sts using long-tail method (Techniques, page 144). Place marker (pm) for beg of rnd and join for working in rnds, being careful not to twist sts.

Rnd 1: [K3, k1f&b, k2, k1f&b, k3] 9 (9, 11 11, 11, 11) times—108 (108, 132, 132, 132, 132) sts.

Work Rows 1–5 of the Cable chart.

Yoke

NOTE: The set-up round is worked as row 6 of the Cable chart. Place the locking markers on the first stitch of the first full repeat in each section to remind you how to work the chart for each section; move the locking markers as you add stitches. Place a marker between each repeat in each section.

The sleeves are labeled in this section as left sleeve and right sleeve. These labels will not be used until you work the sleeves after dividing the body, but they need to be marked when you work the next section.

Set-up rnd: Work 1 (1, 6, 6, 6, 6) st(s), place marker (pm) for raglan (new beg-of-rnd m), k1, pm for sleeve, work 14 (14, 16, 16, 16, 16) sts for left sleeve and place locking m on 11th (11th, 6th, 6th, 6th, 6th) st for beg of chart rep, pm after sts just worked for raglan and locking m in sts just worked for left sleeve, k1, pm, work 38 (38, 48, 48, 48, 48) sts for front and place locking m on 8th (8th, 1st, 1st, 1st, 1st) st for beg of chart rep, pm after sts just worked for raglan, k1, pm, work 14 (14, 16, 16, 16, 16) sts for right sleeve and place locking m on 5th (5th, 12th, 12th, 12th, 12th) st for beg of chart rep, pm after sts just worked for raglan and locking m in sts just worked for right sleeve, k1, pm, work 38 (38, 48, 48, 48, 48) sts for back and place locking m on 2nd (2nd, 7th, 7th, 7th, 7th) st for beg of chart rep—14 (14, 16, 16, 16, 16) sts for each sleeve, 38 (38, 48, 48, 48, 48) sts each for the front and the back, and 4 raglan sts.

Increase body and sleeve stitches

Inc rnd 1: [Inc 2, work next row of the Cable chart to next raglan m] 4 times—8 sts inc'd.

Next rnd: [K1, sl m, work next row of the Cable chart to next raglan m, sl m] 4 times.

Rep last 2 rnds 3 (4, 4, 4, 5, 5) more times—140 (148, 172, 172, 180, 180) sts; 22 (24, 26, 26, 28, 28) sts for each sleeve, 46 (48, 58, 58, 60, 60) sts each for the front and back, and 4 raglan sts.

Rep inc rnd every 4 rnds 5 times, then every other rnd

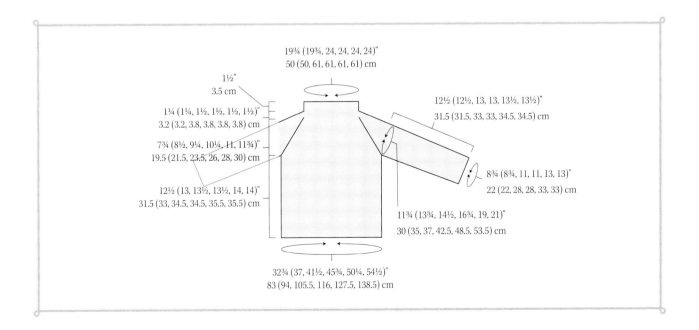

1½"
3.5 cm

19¾ (19¾, 24, 24, 24, 24)"
50 (50, 61, 61, 61, 61) cm

12½ (12½, 13, 13, 13½, 13½)"
31.5 (31.5, 33, 33, 34.5, 34.5) cm

1¼ (1¼, 1½, 1½, 1½, 1½)"
3.2 (3.2, 3.8, 3.8, 3.8, 3.8) cm

7¾ (8½, 9¼, 10¼, 11, 11¾)"
19.5 (21.5, 23.5, 26, 28, 30) cm

8¾ (8¾, 11, 11, 13, 13)"
22 (22, 28, 28, 33, 33) cm

12½ (13, 13½, 13½, 14, 14)"
31.5 (33, 34.5, 34.5, 35.5, 35.5) cm

11¾ (13¾, 14½, 16¾, 19, 21)"
30 (35, 37, 42.5, 48.5, 53.5) cm

32¾ (37, 41½, 45¾, 50¼, 54½)"
83 (94, 105.5, 116, 127.5, 138.5) cm

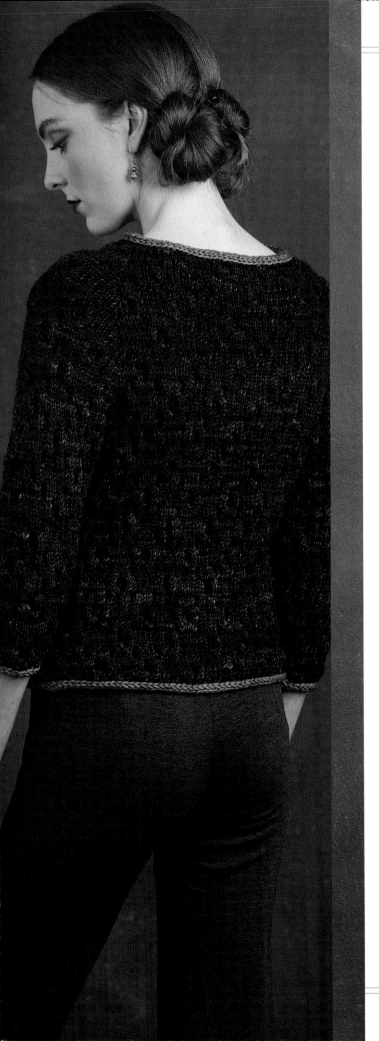

6 (9, 11, 14, 15, 17) times—228 (260, 300, 324, 340, 356) sts; 44 (52, 58, 64, 68, 72) sts for each sleeve, 68 (76, 90, 96, 100, 104) sts each for the front and the back, and 4 raglan sts.

Mark last chart rnd worked for sleeves.

Body
Divide body and sleeves

Dividing rnd: Removing m as you go, sl raglan st to RH needle, place next 44 (52, 58, 64, 68, 72) on a holder or waste yarn for the left sleeve, CO 10 (12, 11, 14, 18, 22) sts, pm for beg of rnd, CO 10 (12, 11, 14, 18, 22) sts, work raglan st and 68 (76, 90, 96, 100, 104) front sts, work raglan st, place next 44 (52, 58, 64, 68, 72) sts on a holder or waste yarn for the right sleeve, CO 20 (24, 22, 28, 36, 44) sts, work raglan st and 68 (76, 90, 96, 100, 104) back sts, then work to end—180 (204, 228, 252, 276, 300) sts rem.

Next rnd: Remove beg-of-rnd m, work to the end of first rep of the chart patt, pm for new beg of rnd, work to end of rnd.

Cont in established patt until piece measures 12 (12½, 13, 13, 13½, 13½)" (30.5 [31.5, 33, 33, 34.5, 34.5 cm) from

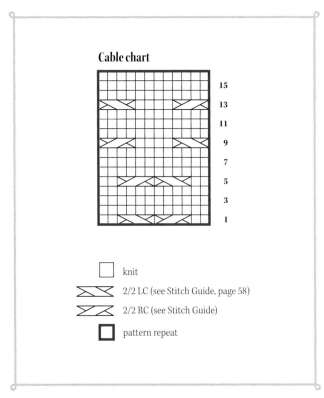

Cable chart

15
13
11
9
7
5
3
1

☐ knit

⬛ 2/2 LC (see Stitch Guide, page 58)

⬛ 2/2 RC (see Stitch Guide)

☐ pattern repeat

armhole or ½" (1.3 cm) less than desired length, ending with Rnd 1, 5, 9, or 13 of chart rep.

Dec rnd: *K2tog, k2, ssk; rep from * to end—120 (136, 152, 168, 184, 200) sts rem.

Work I-cord BO using CC *(figures 1–3)*.

Sleeves

Place held 44 (52, 58, 64, 68, 72) sleeve sts on dpn. With MC and RS facing, beg at center of underarm and pick up and k10 (12, 11, 14, 18, 22) sts evenly along the CO edge, work sleeve sts in established patt, pick up and k10 (12, 11, 14, 18, 22) sts evenly along rem CO edge to center of underarm—66 (74, 80, 84, 90, 98, 108, 110) sts.

Pm for beg of rnd and join for working in rnds.

Left sleeve

Set-up rnd: Begin the Cable chart on st #2 (8, 12, 6, 12, 6) of next row of chart, work 1 rnd even.

Right sleeve

Set-up rnd: Begin the Cable chart on st #8 (2, 6, 12, 6, 12) of next row of chart, work 1 rnd even.

Both sleeves

Work 7 (3, 5, 3, 3, 2) rnds even in established patt.

Dec rnd: K1, k2tog, work to last 2 sts, ssk—2 sts dec'd.

Rep dec rnd every 8 (4, 6, 4, 4, 3) rnds 7 (13, 9, 15, 15, 21) more times—48 (48, 60, 60, 72, 72) sts rem.

NOTE: If the last decrease round is a cable row, adjust the decreases so you work them on either side of the cables.

Next rnd: Work to end of first chart rep, pm for new beg of rnd, work to end of rnd.

Work even until sleeve measures 12 (12, 12½, 12½, 13, 13)" (30.5 [30.5, 31.5, 31.5, 33, 33] cm) or about ½" (1.3 cm) less than desired length.

Dec rnd: *K2tog, k2, ssk; rep from * to end—32 (32, 40, 40, 48, 48) sts rem.

Work I-cord BO using CC.

Finishing
Work neckband

With dpn and the CC, CO 3 sts using the provisional method (Techniques, page 144). Do not turn work.

*K2, sl 1 pwise, yo, pick up and k1 st in CO edge of neck, sl yo and slipped st over picked up st and off needle (3 sts rem), sl rem 3 sts back to LH needle; rep from * until all CO sts have been worked—3 sts rem.

Place 3 provisionally CO sts onto LH needle. Use Kitchener st to graft sts from both needles together.

Weave in loose ends. Block to finished measurements.

WORKING THE I-CORD BIND OFF

1

2 *3*

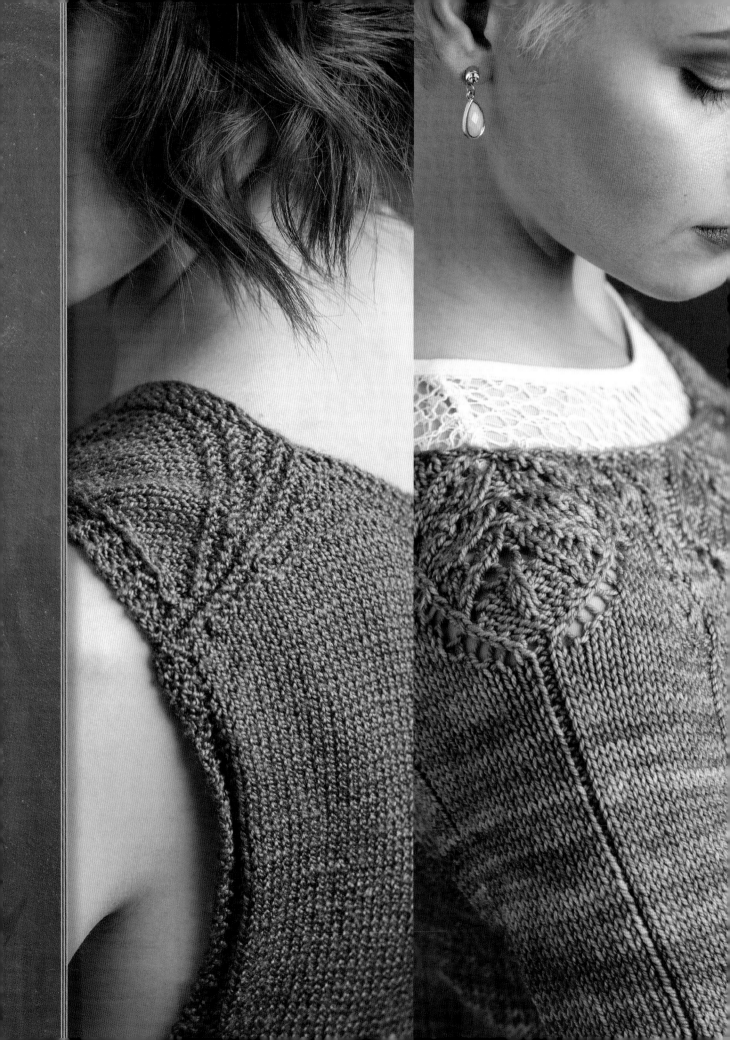

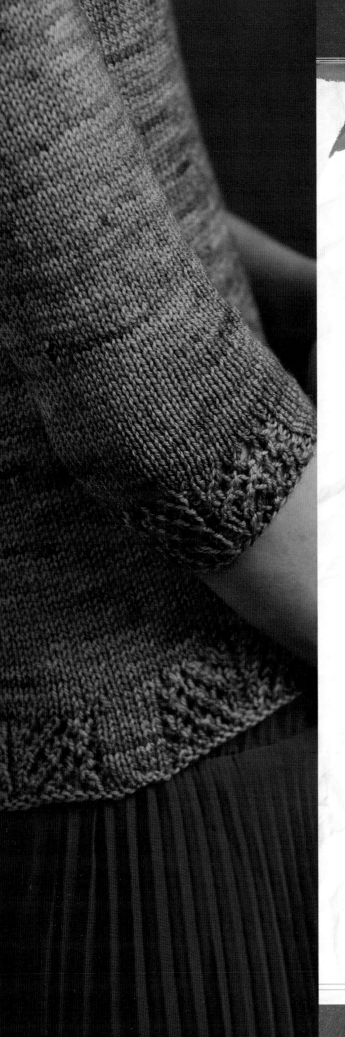

TIMELESS
Lace

I love these words of an old prayer, "Lord, let me grow old like beautiful lace, cherished and treasured and cared for with grace."

That you can make something as pretty as lace with a ball of yarn and two needles is amazing. Lace knitting has both rhythm and grace simply through working yarnovers and decreases.

Like cables, lace can be used in many ways to elevate a garment. As either an all-over pattern, as in Shayla (page 78), or merely adorning a neckline, as in Victoria (page 64) and Camelia (page 96), lace can make a sweater stylishly jaunty or effortlessly chic. A lace pattern may be open and airy, as with Anwen (page 90), or a field of uncomplicated eyelets on a background of knit stitches. The possibilities are endless.

Join the enchanting world of lace and create unique clothing that is as wearable as it is breathtaking.

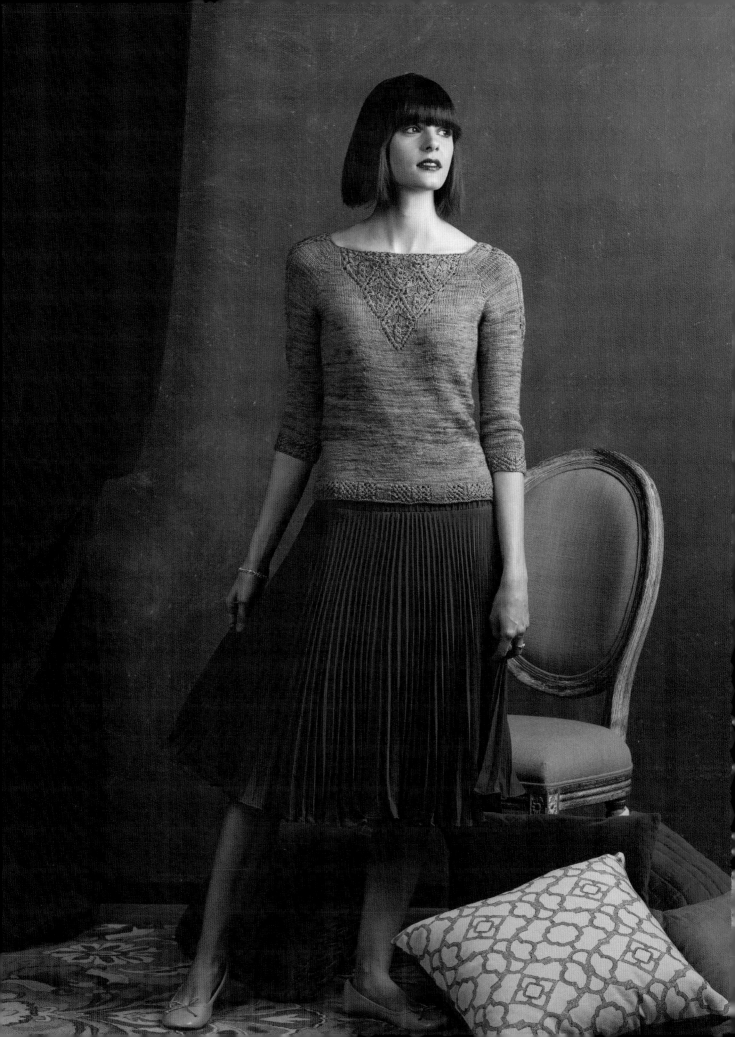

FINISHED SIZE:
About 30¾ (34¼, 37, 40, 43, 46, 49, 52)" (78 [87, 94, 101.5, 109, 117, 124.5, 132] cm) bust circumference and 20 (21, 21¼, 22¾, 23¾, 24¾, 26, 26)" (51 [53.5, 54, 58, 60.5, 63, 66, 66] cm) long.

Pullover shown is size 34¼" (87 cm).

YARN
Fingering weight (#1 Super Fine).

Shown here: Sweet Paprika Messa di Voce (100% superwash merino wool; 460 yd [421 m]/ 3½ oz [100 g]), chimney smoke, 2 (2, 3, 3, 3, 3, 3, 3) skeins or 795 (890, 960, 1,037, 1,115, 1,193, 1,271, 1,349) yd (727 [814, 878, 948, 1,019, 1,091, 1,162, 1,233] m) of similar yarn.

NEEDLES
Size U.S. 3 (3.25 mm): 24" (60 cm) circular (cir) and set of 4 or 5 double-pointed (dpn).

Adjust needle size if necessary to obtain the correct gauge.

NOTIONS
Stitch markers (m); stitch holders or waste yarn; tapestry needle.

GAUGE
24 sts and 36 rows = 4" (10 cm) in St st.

17-st sleeve panel = 2" (5 cm) wide, blocked.

49-st front/back lace panel = 6¾" (17 cm) wide at neck edge, blocked.

Victoria
DIAMOND PULLOVER

I found a version of this lace pattern in one of my favorite Japanese stitch dictionaries. I adapted it by making the diamonds adjacent and altering the center stitches to form a beautiful lace V down the center of the front and back of this lightweight pullover. Because the sleeves needed an elegant touch to match, I added a single column of lace V's—"V" for Victoria!

Like this sweater, Victoria is a graceful and elegant name. And you will feel victorious after you knit the lacework! The lace pattern is worked on every row, but the sweater is worked in the round, so you don't work lace stitches on the wrong side. Once you finish the lace top, you work the body in simple stockinette stitch with easy body shaping.

I used Sweet Paprika Messa di Voce. It is a light fingering weight yarn that is 100 percent merino and soft with great stitch definition.

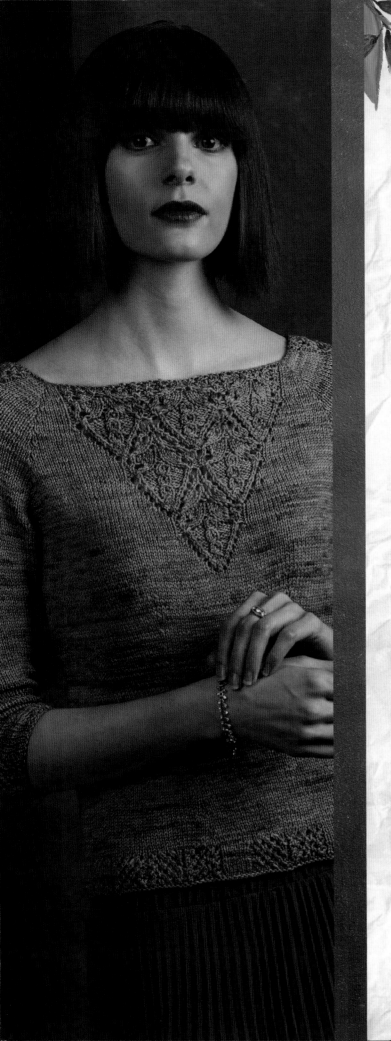

STITCH GUIDE

Turn to the Glossary on page 144 to learn how to work these stitches:
Inc 2
K2tog
Ssk
S2kp

A word about construction:
This sweater is a compound raglan constructed in one piece from the top down. The compound raglan allows for a more flattering fit because the rate of increase varies to accurately follow the shape of your body. It increases rapidly between the neck and shoulders and at the end to curve around the underarm, but gradually in the section in between. The length of the body and sleeves can be easily adjusted.

There are a lot of markers used in this pattern to make the instructions clearer; you certainly do not have to use them all. I recommend using three different color markers: one unique color for the beginning of the round, a second color for the raglans and bust darts, and a third color for the lace panels.

DIAMOND PULLOVER

Yoke

NOTE: Markers are used to indicate the raglans and lace panels on the front, back, and sleeves. When you increase stitches, the new stitches are always worked as knit stitches. Once the lace panel charts are complete, remove the lace panel markers and work all stitches in stockinette st (knit every round).

Sizes 30¾ (34¼, 37, 40, 43)" (78 [87, 94, 101.5, 109] cm) only: The charts will not be completed before the work is divided for the body and sleeves. Mark the last chart row worked on the Sleeve chart when dividing.

With a cir needle, CO 152 (156, 156, 164, 172, 188, 196, 196) sts using the long-tail method (Techniques, page 144).

Place marker (pm) for beg of rnd and join for working in rnds, being careful not to twist sts.

Set-up rnd: [K1, pm for raglan, p3 (4, 3, 4, 5, 7, 8, 8), pm for sleeve lace panel, p17, pm for sleeve lace panel, p3 (4, 3, 4, 5, 7, 8, 8) sts, pm for raglan, k1, pm for body, p1 (1, 2, 3, 4, 6, 7, 7) sts, pm for lace panel, p49, pm for lace panel, p1 (1, 2, 3, 4, 6, 7, 7) sts, pm for raglan] 2 times—23 (25, 23, 25, 27, 31, 33, 33) sts for each sleeve, 51 (51, 53, 55, 57, 61, 63, 63) sts each for the front and the back, and 4 raglan sts.

Increase body and sleeve stitches

Inc rnd: [Inc 2, knit to sleeve lace panel m, work Row 1 of the Sleeve Lace chart over next 17 sts, sl m, knit to next raglan m, inc 2, knit to lace panel m, work Row 1 of the Yoke Lace chart over next 49 sts, knit to next raglan m, sl m] 2 times—8 sts inc'd.

Next rnd: Slipping m as you come to them, knit to lace panels, work next row of appropriate chart between lace panel m, then knit to end of rnd.

Rep last 2 rnds 3 (3, 4, 4, 4, 5, 5) more times—184 (188, 196, 204, 212, 228, 244, 244) sts; 31 (33, 33, 35, 37, 41, 45, 45) sts for each sleeve, 59 (59, 63, 65, 67, 71, 75, 75) sts each for the front and the back, and 4 raglan sts.

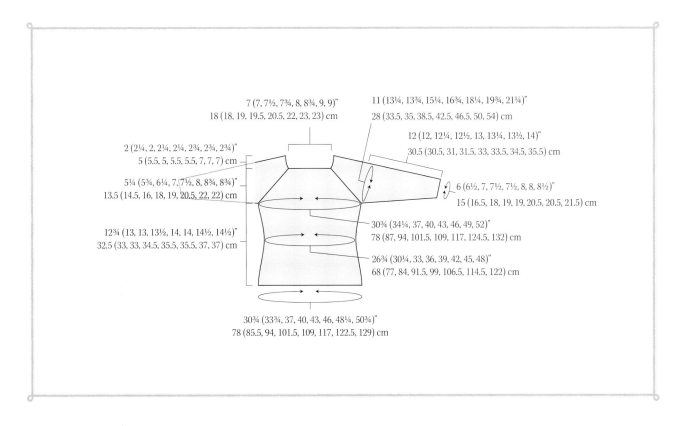

7 (7, 7½, 7¾, 8, 8¾, 9, 9)"
18 (18, 19, 19.5, 20.5, 22, 23, 23) cm

11 (13¼, 13¾, 15¼, 16¾, 18¼, 19¾, 21¼)"
28 (33.5, 35, 38.5, 42.5, 46.5, 50, 54) cm

2 (2¼, 2, 2¼, 2¼, 2¾, 2¾, 2¾)"
5 (5.5, 5, 5.5, 5.5, 7, 7, 7) cm

12 (12, 12¼, 12½, 13, 13¼, 13½, 14)"
30.5 (30.5, 31, 31.5, 33, 33.5, 34.5, 35.5) cm

5¼ (5¾, 6¼, 7, 7½, 8, 8¾, 8¾)"
13.5 (14.5, 16, 18, 19, 20.5, 22, 22) cm

6 (6½, 7, 7½, 7½, 8, 8, 8½)"
15 (16.5, 18, 19, 19, 20.5, 20.5, 21.5) cm

12¾ (13, 13, 13½, 14, 14, 14½, 14½)"
32.5 (33, 33, 34.5, 35.5, 35.5, 37, 37) cm

30¾ (34¼, 37, 40, 43, 46, 49, 52)"
78 (87, 94, 101.5, 109, 117, 124.5, 132) cm

26¾ (30¼, 33, 36, 39, 42, 45, 48)"
68 (77, 84, 91.5, 99, 106.5, 114.5, 122) cm

30¾ (33¾, 37, 40, 43, 46, 48¼, 50¾)"
78 (85.5, 94, 101.5, 109, 117, 122.5, 129) cm

Rep inc rnd every 4 rnds 6 times, then every 2 rnds 7 (9, 11, 14, 16, 19, 21, 21) times—288 (308, 332, 364, 388, 428, 460, 460) sts; 57 (63, 67, 75, 81, 91, 99, 99) sts for each sleeve, 85 (89, 97, 105, 111, 121, 129, 129) sts each for the front and the back, and 4 raglan sts.

Body
Divide body and sleeves

Dividing rnd: Removing raglan m as you work, place raglan st, place next 57 (63, 67, 75, 81, 91, 99, 99) sts and next raglan st on a holder or waste yarn for left sleeve, CO 4 (7, 7, 8, 9, 9, 9, 14) sts, pm for new beg of rnd, CO 3 (7, 7, 7, 9, 8, 9, 13) sts, work back sts in established patt to next raglan m, place raglan st, place next 57 (63, 75, 81, 91, 99, 99) sts and next raglan st on a holder or waste yarn for right sleeve, CO 3 (7, 7, 7, 9, 8, 9, 13) sts, pm for side, CO 4 (7, 7, 8, 9, 9, 9, 14) sts, work across front sts in established patt, then knit to end of rnd—184 (206, 222, 240, 258, 276, 294, 312) sts rem; 93 (103, 111, 121, 129, 139, 147, 157) sts for the front and 91 (103, 111, 119, 129, 137, 147, 155) sts for the back.

Work 22 rnds even in established patt.

Shape waist
Set-up rnd: K30 (36, 40, 44, 49, 53, 58, 62) sts, pm for bust dart, k31, pm for bust dart, k61 (72, 80, 89, 98, 107, 116, 125) sts and remove side m, pm for bust dart, k31, pm for bust dart, knit to end.

Dec rnd: [Knit to 2 sts before bust dart m, ssk, sl m, knit to next bust dart m, sl m, k2tog] 2 times, knit to end—4 sts dec'd.

Rep dec rnd every 5 rnds 5 more times—160 (182, 198, 216, 234, 252, 270, 288) sts rem.

Work 12 rnds even.

Inc rnd: [Knit to bust dart m, LLI, sl m, knit to next bust dart m, sl m, RLI] 2 times, knit to end—4 sts inc'd.

Rep inc rnd every 8 (9, 8, 8, 8, 8, 10, 10) rnds 5 (4, 5, 5, 5, 5, 4, 4) more times—184 (202, 222, 240, 258, 276, 290, 308) sts.

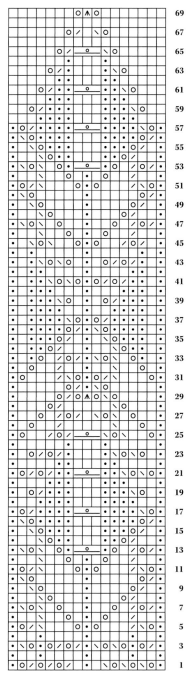

Sleeve chart

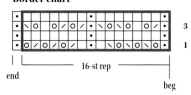

Border chart

Yoke chart

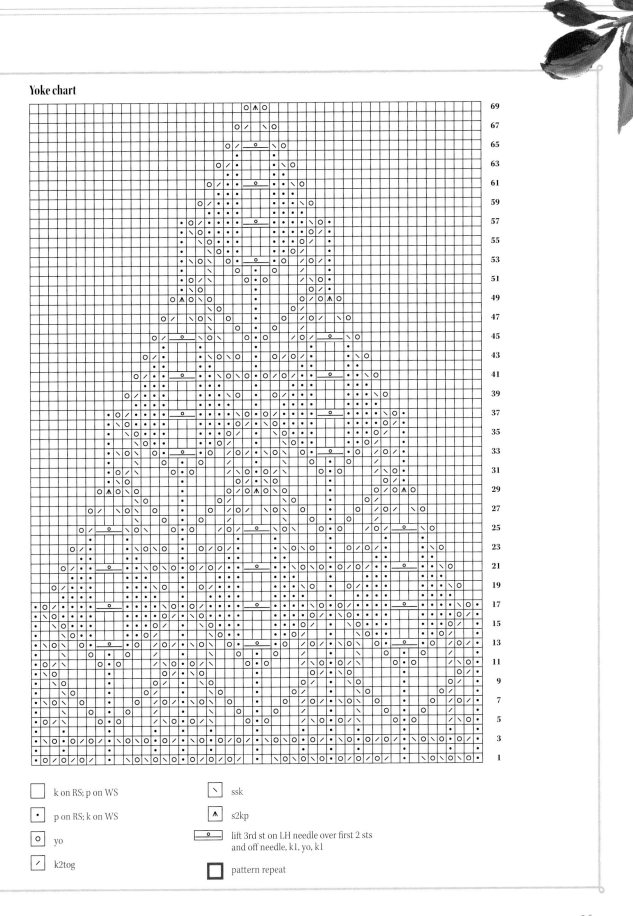

k on RS; p on WS

• p on RS; k on WS

○ yo

╱ k2tog

╲ ssk

⋀ s2kp

⎯○⎯ lift 3rd st on LH needle over first 2 sts and off needle, k1, yo, k1

☐ pattern repeat

69

Remove bust dart m and cont evenly until piece measures 11½ (11¾, 11¾, 12¼, 12¾, 12¾, 13¼, 13¼)" (29 [30, 30, 31, 32.5, 32.5, 33.5, 33.5] cm) or 1¼" (3.2 cm) less than desired length from armhole.

Bottom Band

Set-up rnd: K1 (3, 2, 3, 5, 6, 5, 6) sts, pm for lace border, k33, pm, k3 (6, 4, 7, 10, 13, 10, 13) sts, pm for lace border, k17 (17, 33, 33, 33, 33, 49, 49) sts, pm, [k3 (6, 4, 7, 10, 13, 10, 13) sts, pm for lace border, k33, pm] 2 times, k3 (6, 4, 7, 10, 13, 10, 13) sts, pm for lace border, k17 (17, 33, 33, 33, 33, 49, 49) sts, pm, k3 (6, 4, 7, 10, 13, 10, 13) sts, pm for lace border, k33, pm, knit to end.

Next rnd: [Knit to lace border m, work Row 1 of the Border chart to m] 6 times, knit to end.

Work Rows 2–4 of the Border chart, then work Rows 1–4 two more times.

BO all sts pwise.

Sleeves

NOTE: If necessary, continue working the Sleeve Lace chart between the lace panel markers through the end of the chart. After you've completed the charts, remove the markers and work stitch over all stitches.

With dpn and RS facing, beg at center of underarm CO and pick up and k4 (7, 7, 8, 9, 9, 9, 14) sts evenly along CO edge, work held 59 (65, 69, 77, 83, 93, 101, 101) sleeve sts, then pick up and k3 (7, 7, 7, 9, 8, 9, 13) sts evenly along rem CO edge—66 (79, 83, 92, 101, 110, 119, 128) sts. Pm for beg of rnd and join for working in rnds.

Work 7 (5, 5, 4, 4, 4, 3, 3) rnds even.

Dec rnd: K1, k2tog, work to last 2 sts, ssk—2 sts dec'd.

Rep dec rnd every 8 (6, 6, 5, 5, 5, 4, 4) rnds 9 (10, 14, 17, 14, 2, 13, 10) more times, then every 0 (5, 0, 0, 4, 4, 3, 3) rnds 0 (4, 0, 0, 5, 20, 14, 20) times—46 (49, 53, 56, 61, 64, 63, 66) sts rem.

Work even until sleeve measures 10¼ (10¼, 10½, 10¾, 11¼, 11½, 11¾, 12¼)" (26 [26, 26.5, 27.5, 28.5, 29, 30, 31] cm) or 1¾" (4.5 cm) less than desired length, and dec 4 (5, 5, 4, 7, 7, 6, 6) sts evenly across last rnd—42 (44, 48, 52, 54, 57, 57, 60) sts rem.

Cuffs

Next rnd: [Work Row 1 of the Border chart over next 17 sts, pm, k4 (5, 7, 9, 1, 2, 2, 3) sts, pm] 1 (1, 1, 1, 2, 2, 2, 2) time(s), work Row 1 of the Border chart over next 17 sts, pm, knit to end.

Work Rows 2–4 of the Border chart, then work Rows 1–4 four more times.

BO all sts pwise.

Finishing

Weave in loose ends. Block to finished measurements.

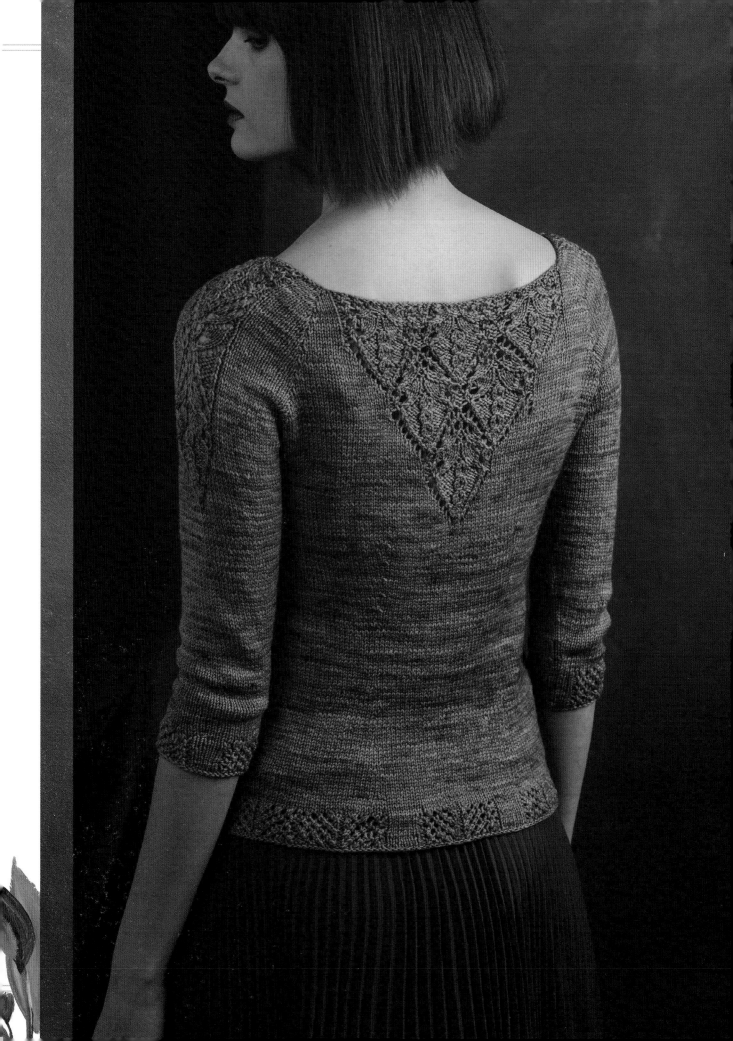

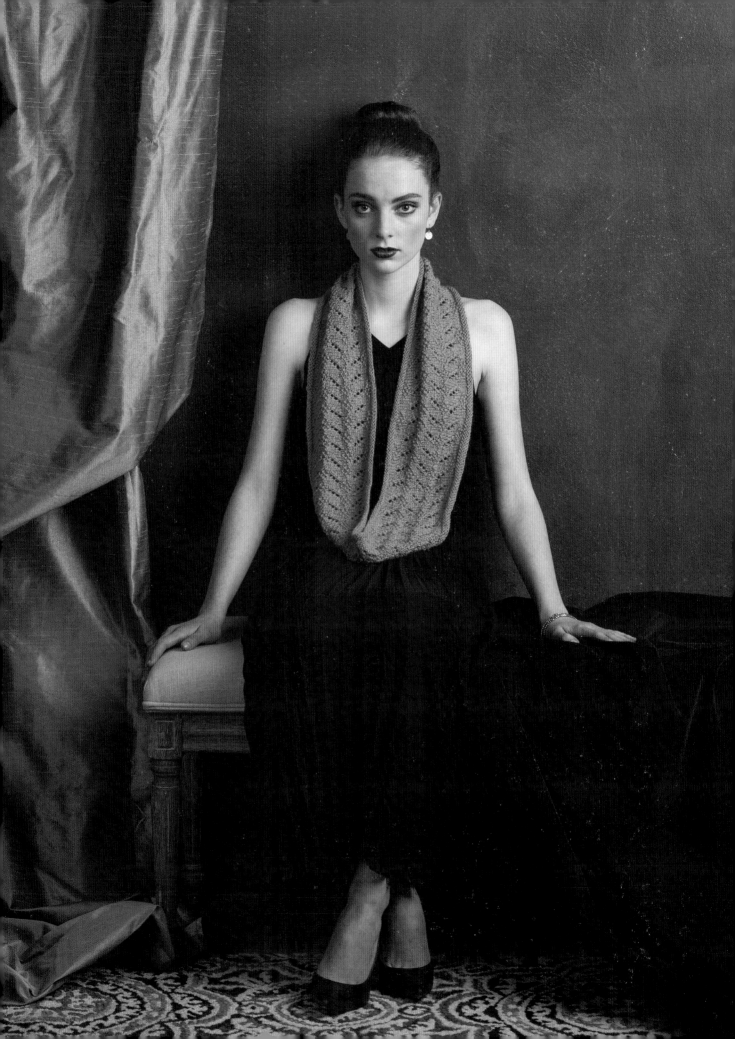

FINISHED SIZE

About 48" (122 cm) circumference and 6½" (16.5 cm) wide.

YARN

Light worsted weight (#3 Light).

Shown here: The Fibre Company Knightsbridge (65% llama, 25% alpaca, 10% silk; 120 yd [110 m]/1¾ oz [50 g]), poole, 3 skeins or 290 yd (265 m) of similar yarn.

NEEDLES

Size U.S. 7 (4.5 mm): 24" (60 cm) circular (cir) needle.

Adjust needle size if necessary to obtain the correct gauge.

NOTIONS

Stitch marker (m); tapestry needle.

GAUGE

20 sts and 28 rnds = 4" (10 cm) in St st.

20 sts and 29 rnds = 4" (10 cm) in lace pattern, blocked.

Gauge is not critical.

Louisa
COWL

Sometimes all it takes is a mixture of plain knit and purl stitches to make a pretty, yet practical, pattern. Add a simple lace stitch and you get a sweet, old-fashioned design perfect for a cozy cowl. Worked in the round with an easy lace stitch, this pattern is suitable for new lace knitters or a good social knit for a seasoned knitter who wants to catch up with friends rather than focus on stitches.

Louisa is a vintage name for a cowl with a vintage feel, and its namesake is one of my favorite classic novelists, Louisa May Alcott. Louisa means renowned warrior, and this cowl will work like a warrior to keep you warm.

I used The Fibre Company's Knightsbridge to knit Louisa. It is a lush heather yarn that blends baby llama, merino and silk—soft and warm, perfect for a cowl.

STITCH GUIDE

Turn to the Glossary on page 144 to learn how to work these stitches:
K2tog
Ssk

❧

A word about construction:
Louisa is worked in the round. If you desire a wider cowl, work additional rounds in the lace pattern. If you prefer a longer or shorter cowl, add or subtract stitches in increments of 10, which will result in a difference of 2" (5 cm) in the lace pattern. See Doing the Math on page 76.

❧

COWL

CO 240 sts using the long-tail method (Techniques, page 144). Place marker (pm) and join for working in rnds, taking care to not twist sts.

Purl 3 rnds.

Knit 1 rnd.

Work Rows 1–6 of the Lace Border chart.

Work Rows 1–24 of the Lace chart, then work Rows 1–6 of the Lace chart again.

Work Rows 1–6 of the Lace Border chart.

Purl 3 rnds.

BO all sts pwise.

Weave in loose ends. Block to finished measurements.

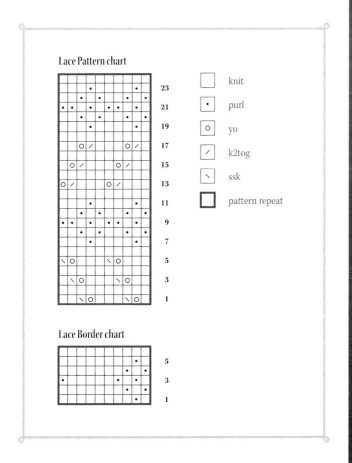

Lace Pattern chart

knit	□			
purl	•			
yo	○			
k2tog	/			
ssk	\			
pattern repeat	□			

Lace Border chart

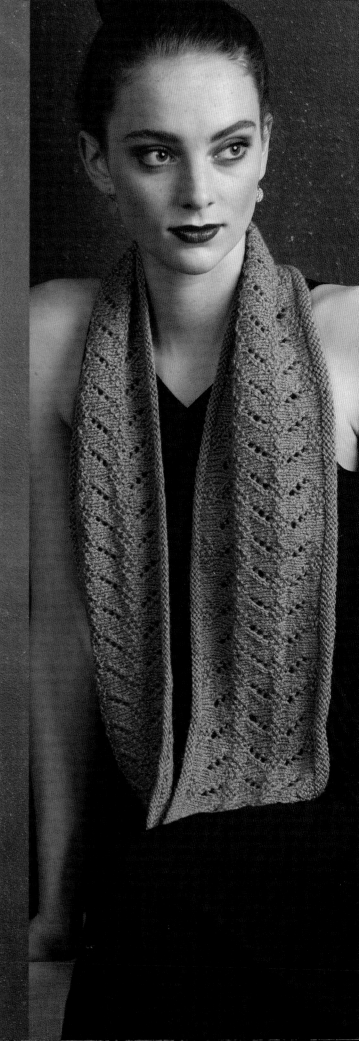

DOING *the* MATH

. .

Some women love a wide cowl that can be wrapped around their necks twice and pulled up over their noses, offering extra warmth against a snowy winter. But if you live in warmer climes, you might prefer a shorter cowl in a lightweight yarn that is more decorative layer than protection against the elements. With some simple math, you can alter Louisa to make it fit your wardrobe perfectly.

KNIT A WIDER COWL
Work Rows 7–18 of the Lace chart (page 75) again, maintaining the pattern. That would add 1½" (3.8 cm), and your cowl would be 8" (20.5 cm) wide.

KNIT A SHORTER COWL
Divide the length you want to make your cowl by the length of each pattern repeat. The Louisa lace pattern is a 10-stitch repeat that is 2" (5 cm) long.

So, if you want to make a cowl that is 24" (61 cm) long, divide 24 by 2—that equals 12. You will knit 12 repeats of the lace pattern.

To figure out how many stitches to cast on, multiply the number of repeats by the number of stitches in each repeat. In this case, multiply 12 by 10 for 120 stitches to cast on.

KNIT WITH YARN YOU ALREADY HAVE
Determine first how much yarn you have to make this cowl, then figure out how long it can be.

Let's say you have only 200 yd (183 m) of the yarn you want to use to make Lousia. It takes 300 yd (274 m) to make a 48" (122 cm) long cowl.

First, divide the length by 2 to get the number of repeats; so, 48" divided by 2 is 24 repeats of the lace pattern.

Second, divide the yardage by the number of repeats; so, 300 divided by 24 is 12½ yd (11.4 m) of yarn per pattern repeat.

Last, divide the yardage of the yarn you want to use by the repeat yardage to determine how many pattern repeats you can knit; so, 200 divided by 12½ equals 16 repeats of the lace pattern at the width it is written.

For safety's sake, I would work just 15 repeats—I'd hate to get almost finished and run out of yarn!

To figure out how many stitches to cast on, multiply the number of repeats by the number of stitches in each repeat. In this case, 15 multiplied by 10 is 150 stitches to cast on.

To determine the size of the cowl, multiply the number of repeats by the length of each repeat; so, 15 multiplied by 2 is 30. With 200 yd (183 m) of your favorite worsted yarn, you could knit a Lousia cowl that is 6" (15 cm) wide and 30" (76 cm) long.

To work out the numbers with yarn from your stash, try this equation:

_____ *repeats* × _____ *inches/cm for each repeat* = _____ *inches/cm long cowl*

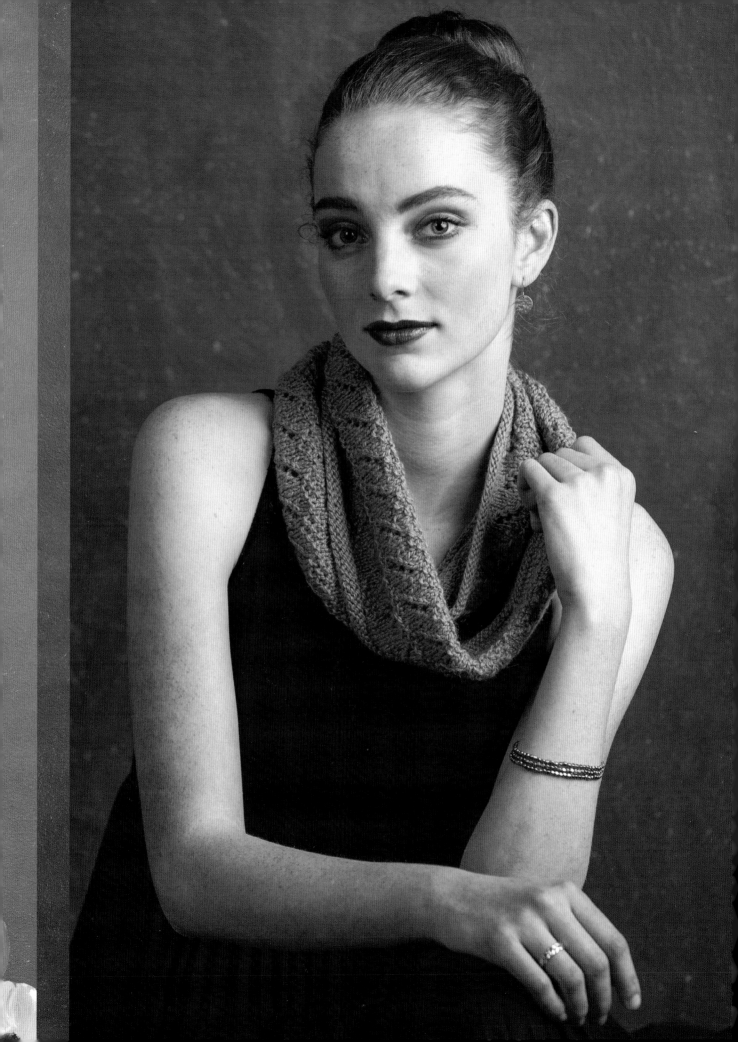

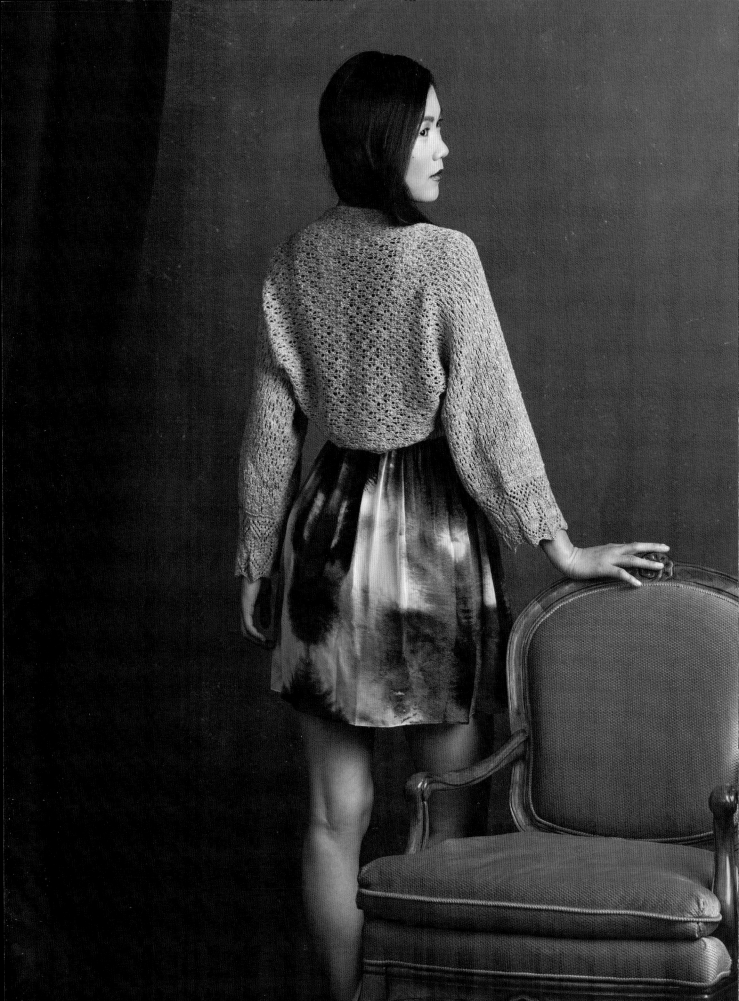

FINISHED SIZE

About 50½" (128.5 cm) long and 18½" (47 cm) wide with an 11" (28 cm) circumference at the center of the cuff.

YARN

Fingering weight (#1 Super Fine).

Shown here: Crave Yarn Filigree (75% merino wool, 25% silk; 410 yd [375 m]/3½ oz [100 g]), sullen sunbeams, 2 skeins or 767 yd (701 m) of similar yarn.

NEEDLES

Size U.S. 2 and 4 (2.75 mm and 3.5 mm): 24" (60 cm) circular (cir).

Adjust needle sizes if necessary to obtain the correct gauge.

NOTIONS

Stitch holders; tapestry needle.

GAUGE

24½ sts and 31 rows = 4" (10 cm) of body chart on larger needles, blocked.

32 sts and 34 rows of cuff chart = 4" (10 cm) on smaller needles, blocked.

Shayla
SHRUG

This shrug is cross-cultural, incorporating Estonian lace in the cuff and a traditional Japanese pattern in the body for a modern look. From Estonia's rich and long history of beautiful lace knitting patterns, I chose one that creates an elegant pattern evoking images of royalty from the Medieval period. This inspired the name of the shrug, which means fairy princess of the field.

Both lace patterns are knitted only on the right side, making it suitable for less-experienced lace knitters. Work the cuffs first, then complete the body section second.

For Shayla, I used Crave Yarn Filigree, a merino and silk combination. It has a nice drape, a slight sheen, and is very soft, which gives it a luxuriousness that is very fitting for this light and airy shrug.

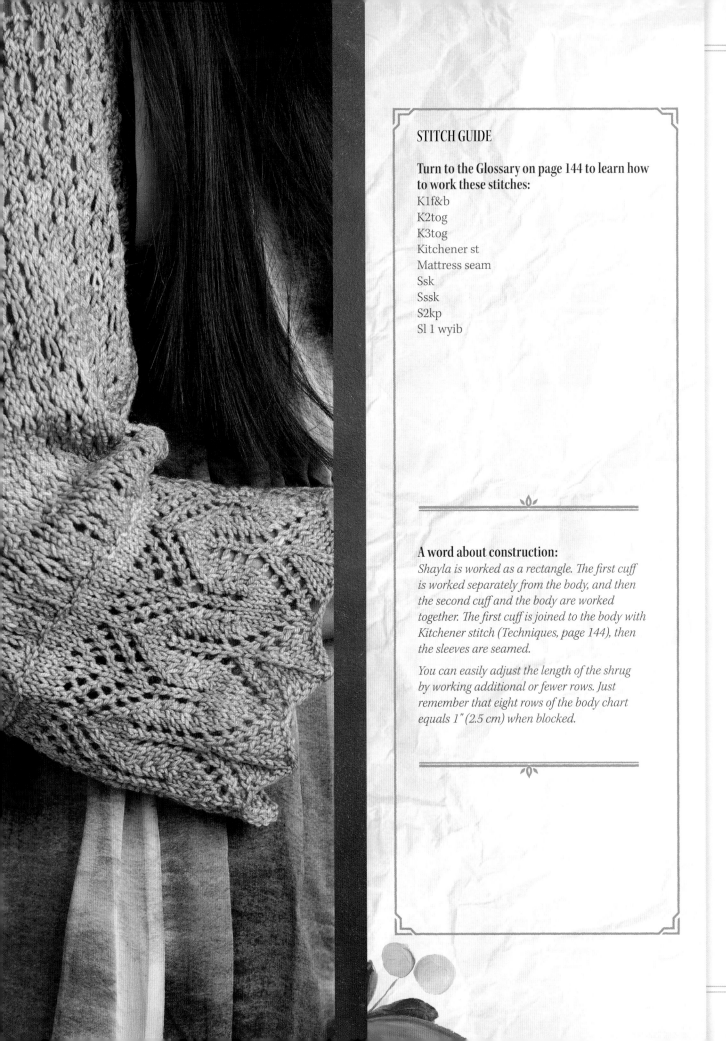

STITCH GUIDE

Turn to the Glossary on page 144 to learn how to work these stitches:
K1f&b
K2tog
K3tog
Kitchener st
Mattress seam
Ssk
Sssk
S2kp
Sl 1 wyib

A word about construction:

Shayla is worked as a rectangle. The first cuff is worked separately from the body, and then the second cuff and the body are worked together. The first cuff is joined to the body with Kitchener stitch (Techniques, page 144), then the sleeves are seamed.

You can easily adjust the length of the shrug by working additional or fewer rows. Just remember that eight rows of the body chart equals 1" (2.5 cm) when blocked.

SHRUG

First Cuff

With smaller cir needle, CO 87 sts using the long-tail method (Techniques, page 144). Do not join.

Knit 1 WS row.

Work Rows 1–34 of the Cuff chart.

Next row (RS): Knit. Break yarn and slip sts to a holder or waste yarn.

Second Cuff

With smaller cir needle, CO 87 sts using the long-tail method.

Knit 1 WS row.

Work Rows 1–34 of the Cuff chart.

Work 3 rows in St st (knit RS rows, purl WS rows).

Inc row (WS): K3, [k1f&b, k2] 3 times, *k1f&b, k3, [k1f&b, k2] 4 times; rep from * 3 more times, [k1f&b, k2] 3 times, k2—113 sts.

Work 2 rows in St st.

Body

Change to larger cir needle. Rep Rows 1–8 of the Body chart until the piece measures 40½" (103 cm) from the inc row, ending on either Row 4 or Row 8 of the chart.

Work 1 row in St st.

Dec row (WS): K3, [k2tog, k2] 3 times, *k2tog, k3, [k2tog, k2] 4 times; rep from * 3 more times, [k2tog, k2] 3 times, k2—87 sts rem.

Next row: Knit.

Cut yarn, leaving a tail about 94" (239 cm) long.

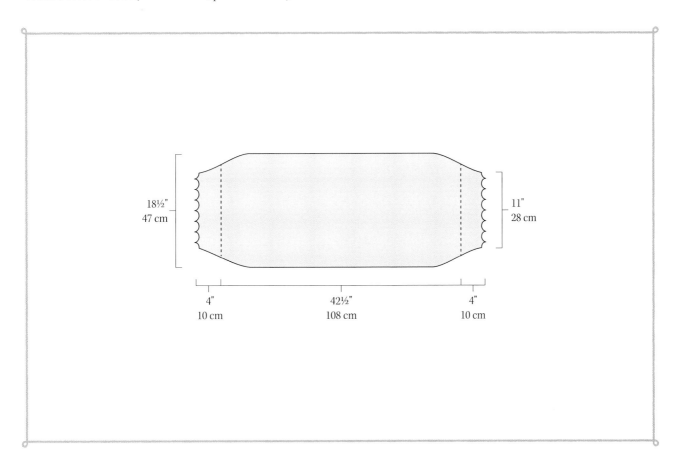

18½" / 47 cm

11" / 28 cm

4" / 10 cm 42½" / 108 cm 4" / 10 cm

Finishing
Graft cuff
Place 87 held sts from first cuff onto smaller cir needle. Thread tail onto the tapestry needle, then graft first cuff to body using Kitchener st.

Weave in loose ends. Block to finished measurements.

Starting at cuff, sew tog 15" (38 cm) along side edges using mattress stitch (Techniques, page 144). Rep on rem end of shrug.

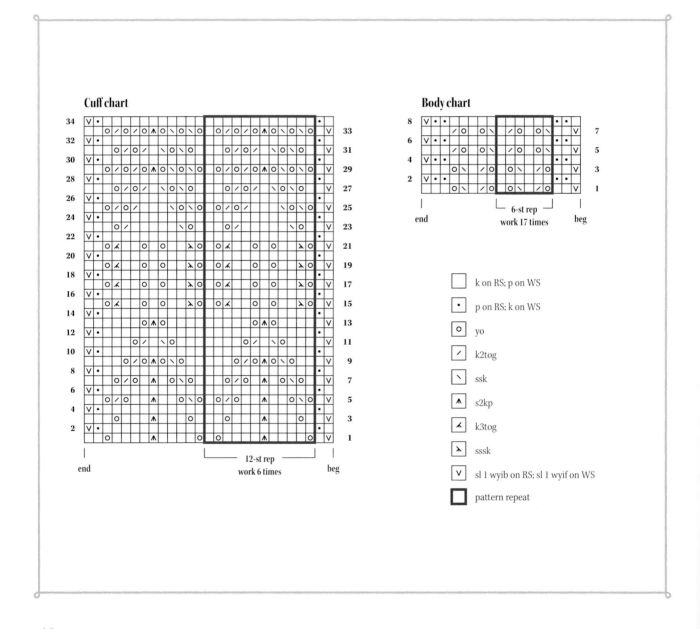

Cuff chart

Body chart

□ k on RS; p on WS

• p on RS; k on WS

○ yo

╱ k2tog

╲ ssk

⋀ s2kp

⤞ k3tog

⤝ sssk

V sl 1 wyib on RS; sl 1 wyif on WS

▢ pattern repeat

FIVE TIPS FOR READING
Lace Charts

· ·

I prefer charts to written directions. They help me visualize what my knitting should look like because the chart symbols resemble the pattern that the stitches will make. It's easier to learn the rhythm of the stitch pattern from the picture of a chart, rather than a line of knitting directions. Plus, I always seem to lose my place in a long line of written directions, but a chart keeps me knitting happily away.

Charts only look complicated. These tips should make it easier to read them, no matter which lace design you're knitting:

1 If the lace pattern is worked on both sides of your knitting, highlight the right-side rows to make it easier to read the charts. Look for this in the charts for Victoria (page 64), Vivian (page 84), Camelia (page 96), Dwyn (page 104), and Billie (page 126).

2 As you first start knitting the chart, study your knitting as you finish each row. Compare your knitting to the chart, so you learn where you are in the chart. This helps you to figure out which row to knit next when you inevitably forget.

For example, Rows 1–4 and Rows 11–14 of Dywn are identical. This makes the rows easier to learn, but it also can make it harder to discern whether you are on Row 1 or Row 11. You have to look carefully at the way the decreases are leaning on the rows directly below. Looking at the right half of the shawl, if they are leaning to the left toward

the center of the shawl, you are working Row 1. If they are leaning to the right and to the edge of the shawl, you are working Row 11.

3 Also study the pattern that the yarnovers and the decreases make on the chart. This will help you learn the chart and discern where you are in the chart.

4 Symmetrical charts have areas that can make it easier to learn the pattern. Look for areas where the number of stockinette stitches changes on each row but is the same at each side within a row.

For example, in the charts for Dwyn and Billie, there is always the same number of stockinette stitches between the two purl columns at each edge and on each side of the center purl column.

5 Some charts have areas that have a consistent number of stockinette stitches or reverse stockinette stitches between an edge and a yarnover or between a yarnover and a decrease. These can be helpful in learning the pattern.

For example, in the oval shape in the charts for Corinne (page 110), there are always three stockinette stitches between the purl background and the yarnovers or the decreases that form the oval. Look for this, too, in the charts for Shayla (page 78), Vivian, Anwen (page 90), Camelia, and Dywn.

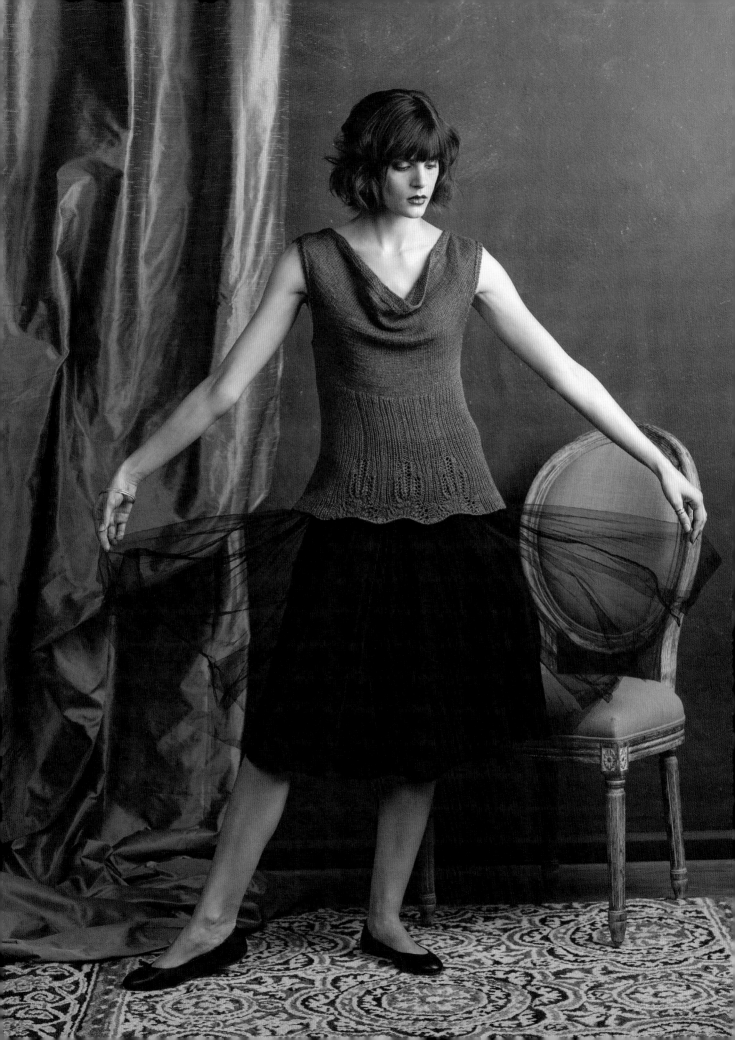

FINISHED SIZE:
About 29½ (32, 34½, 37, 39, 41½, 45½, 48)" (75 [81.5, 87.5, 94, 99, 105.5, 115.5, 122] cm) bust circumference and 20½ (21¼, 22¼, 23½, 24¾, 26, 27, 28¼)" (52 [54, 56.5, 59.5, 63, 66, 68.5, 72] cm) long.

Pullover shown is size 29½" (75 cm).

YARN
Fingering weight (#1 Super Fine).

Shown here: Shibui Staccato (70% superwash merino wool, 30% silk; 195 yd [178 m]/1¾ oz [50 g]), #2012 fjord, 5 (5, 6, 6, 6, 7, 7, 8) skeins or 807 (905, 979, 1,064, 1,119, 1,205, 1,318, 1,419) yd (738 [827, 895, 973, 1,023, 1,102, 1,205, 1,297] m) of similar yarn.

NEEDLES
Size U.S. 3 (3.25 mm): 24" (60 cm) circular (cir) needle.

Adjust needle size if necessary to obtain the correct gauge.

NOTIONS
Stitch markers (m); stitch holders or waste yarn; locking markers; tapestry needle.

GAUGE
25 sts and 33 rows = 4" (10 cm) in St st.

35 sts and 33 rnds = 4" (10 cm) in k1, p1 rib, blocked.

Vivian
SLEEVELESS PULLOVER

This sweater has a Roaring Twenties aspect to it, an era when the name Vivian peaked in popularity. With its cowl neck, this sleeveless sweater has a retro feel to match the vintage Frost Flower stitch.

Vivian is worked from the top down, so the Frost Flower stitch pattern is inverted. I also embedded it in a rib stitch, giving this popular stitch pattern new life. I love the way it starts small and then fans out to the full flower at the bottom of the sweater. The lace is knitted on every row. It is a simple pattern worked in the round, so there is no wrong side.

I used Shibui Staccato, a merino and silk blend. It has a wonderful drape and a beautiful sheen, giving even a retro sweater a contemporary feel.

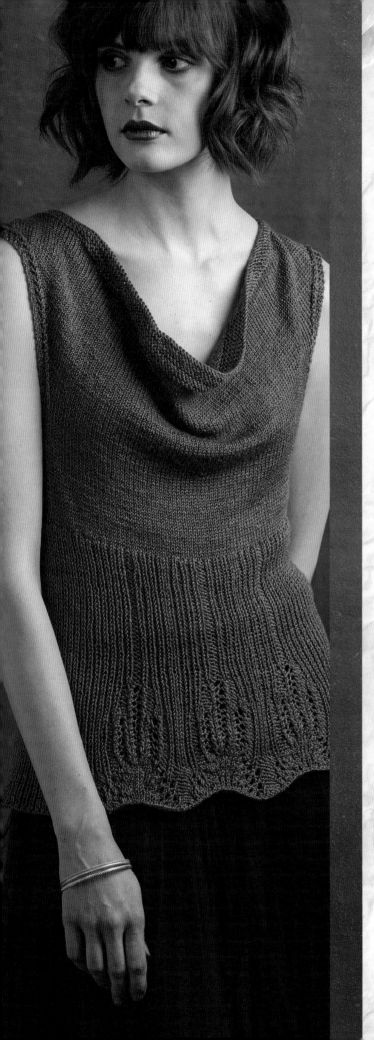
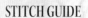

STITCH GUIDE

Turn to the Glossary on page 144 to learn how to work these stitches:
K2tog
P2tog
RLI
Ssk
SSPLI
WYIB
W&t

A word about construction:

Vivian is constructed from the top down with short-row shoulder shaping. All of the short-rows are worked in garter stitch, so there is no need to hide the wraps. The front and back are worked flat to the underarm and then joined for working in the round. Garter-stitch edging is worked at the neck and armhole edges.

The armholes are designed with a looser, more comfortable fit. Check the armhole-depth measurement on the schematic before beginning, in case you desire a more fitted armhole or if you are using a yarn that tends to stretch or grow. The armhole depth may be adjusted by taking out the even rows on the front before the armhole shaping begins; some or all of the rows can be eliminated. Be sure to take out the same numbers of rows when working the back piece.

SLEEVELESS PULLOVER

Back

NOTE: The first 2 rows are worked in garter st (knit every row). You also work 3 garter sts on each armhole edge on the back.

CO 86 (92, 98, 98, 100, 100, 100, 102) sts using the long-tail method (Techniques, page 144). Do not join.

Next row (RS): Knit.

Shape shoulders
Next row (WS): K24 (27, 29, 27, 28, 27, 27, 27) sts for shoulder, place marker (pm), k38 (38, 40, 44, 44, 46, 46, 48) sts for neck, pm, knit to end of the row.

Short-rows 1 and 2: Knit to 5 sts past second m, w&t.

Short-rows 3–6: Knit to wrapped st, k5 (6, 6, 6, 6, 6, 6, 6) more sts, w&t.

After last turn, knit to end of row.

Next row (WS): K3, sl 1 wyib, purl to last 4 sts, sl 1 wyib, k3.

Next row: Knit.

Work 55 (59, 65, 71, 75, 77, 79, 81) more rows in established patt, removing m as you come to them.

Shape armholes
Inc row (RS): K4, RLI, knit to last 4 sts, LLI, k4—2 sts inc'd.

Work 1 WS row even.

Rep inc row every RS row 0 (0, 1, 2, 3, 4, 6, 8) more time(s)—88 (94, 102, 104, 108, 110, 114, 120) sts.

6 (6, 6½, 7, 7, 7¼, 7¼, 7¾)"
15 (15, 16.5, 18, 18, 18.5, 18.5, 19.5) cm

3¾ (4¼, 4¾, 4¼, 4½, 4¼, 4¼, 4¼)"
9.5 (11, 12, 11, 11.5, 11, 11, 11) cm

front 1" (2.5 cm)
back ½" (1.3 cm)

7¼ (7¾, 8¾, 9¾, 10½, 11, 11¾, 12½)"
18.5 (19.5, 22, 25, 26.5, 28, 30, 31.5) cm

29½ (32, 34½, 37, 39, 41½, 45½, 48)"
75 (81.5, 87.5, 94, 99, 105.5, 115.5, 122) cm

13½ (14, 14¼, 14½, 15, 15½, 15¾, 15¾)"
34.5 (35.5, 36, 37, 38, 39.5, 40, 40) cm

25¾ (29, 31¼, 34, 36, 38¾, 42¼, 45½)"
65.5 (73.5, 79.5, 86.5, 91.5, 98.5, 107.5, 115.5) cm

35 (38¼, 40½, 43¼, 45, 47¾, 51½, 54½)"
89 (97, 103, 110, 114.5, 121.5, 132, 138.5) cm

Lace chart

[Chart with rows numbered 1, 3, 5, 7, 9, 11, 13, 15, 17, 19, 21, 23, 25, 27, 29, 31, 33, 35]

16-st rep,
inc to 22-st rep
Work 3 times for front;
work once for back.

☐	knit
•	purl
o	yo
╱	k2tog
╲	ssk
M	m1
MP	m1p
▨	no stitch
☐	pattern repeat

Piece should measure 7¼ (7¾, 8½, 9¼, 9¾, 10, 10¼, 10½)" (18.5 [19.5, 21.5, 23.5, 24.75, 25.5, 26, 26.5] cm) from beg along armhole edge.

Cut yarn and place sts on a holder or waste yarn. Place locking m at each end of CO row for shoulder.

Front

With CO edge of back at top and RS facing, pick up and k24 (27, 29, 27, 28, 27, 27) sts (1 st in each CO st), turn, using cable method (Techniques, page 144) CO 59 (59, 60, 66, 68, 71, 71) sts for first half of neck, pm for center of neck, CO 59 (59, 60, 66, 68, 71, 71, 72) sts for second half of neck, turn, skip center 38 (38, 40, 44, 44, 46, 46, 48) sts of back for neck, pick up and k24 (27, 29, 27, 28, 27, 27) sts along rem back CO edge—166 (172, 178, 186, 192, 196, 196, 198) sts.

Work 1 WS row even.

Shape shoulders
Short-rows 1 and 2: Knit to 16 (16, 17, 17, 19, 19, 19, 19) sts past center neck m, w&t.

Short-rows 3–8: Knit to wrapped st, k16 (16, 16, 18, 18, 19, 19, 19) more sts, w&t.

Short-rows 9–12: Knit to wrapped st, k5 (6, 6, 6, 6, 6, 6, 6) more sts, w&t.

Next row (RS): Knit to end of row.

Next row (WS): K3, sl 1 wyib, purl to last 4 sts, sl 1 wyib, k3.

Shape yoke
Dec row 1 (RS): K4, ssk, knit to last 6 sts, k2tog, k4—2 sts dec'd.

Dec row 2 (WS): K3, sl 1 wyib, p2tog, purl to last 6 sts, ssp, sl 1 wyib, k3—2 sts dec'd.

Rep last 2 rows 14 (12, 12, 12, 13, 15, 15, 15) more times—106 (120, 126, 134, 136, 132, 132, 134) sts rem.

Rep Dec Row 1—2 sts dec'd.

Work 1 WS row even.

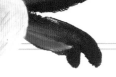

Rep last 2 rows 9 (13, 13, 17, 17, 15, 15, 15) more times—86 (92, 98, 98, 100, 100, 100, 102) sts rem.

Work 6 (6, 12, 10, 12, 14, 16, 18) rows even.

Shape armholes
Inc row: K4, RLI, knit to last 4 sts, LLI, k4—2 sts inc'd.

Work 1 WS row even.

Rep last 2 rows 0 (0, 1, 2, 3, 4, 6, 8) more time(s)—88 (94, 102, 104, 108, 110, 114, 120) sts.

Join front and back
With RS facing, return held 88 (94, 102, 104, 108, 110, 114, 120) back sts to left end of the same cir needle with front sts—176 (188, 204, 208, 216, 220, 228, 240) sts.

Next row (RS): Work front sts, CO 2 (3, 3, 6, 7, 10, 14, 15) sts, pm for side, CO 2 (3, 3, 6, 7, 10, 14, 15) sts, knit back sts, CO 2 (3, 3, 6, 7, 10, 14, 15) sts, pm for beg of rnd, CO 2 (3, 3, 6, 7, 10, 14, 15) sts—184 (200, 216, 232, 244, 260, 284, 300) sts.

Join for working in rnds.

Next rnd: Knit to end of rnd.

Next rnd: P4, knit to 4 sts before side m, p4, sl m, p4, knit to last 4 sts, p4.

Next rnd: Knit.

Next rnd: P3, knit to 3 sts before side m, p3, sl m, p3, knit to the last 3 sts, p3.

Knit 20 (20, 22, 22, 24, 28, 30, 30) rnds even.

Lower Body

NOTE: Try on the pullover to make sure you've knitted enough rounds to reach under your bust. If necessary, work additional rounds before beginning the ribbed section.

Set-up rnd: Remove beg-of-rnd m and side m as you come to them, k22 (26, 30, 34, 37, 41, 47, 51) sts, pm for new beg of rnd, k48 sts, pm for front lace panel, knit to end of rnd and inc 42 (54, 58, 66, 70, 78, 86, 98) sts evenly across these sts (about every 2 or 3 sts across)—226 (254, 274, 298, 314, 338, 370, 398) sts.

NOTE: The beginning-of-round marker also denotes the start of the lace panel on the front.

Next rnd: [(K1, p1) 4 times, (p1, k1) 4 times] 3 times, sl m, [p1, k1] 40 (47, 52, 58, 62, 68, 76, 83) times, p1, pm for back lace panel, (k1, p1) 4 times, (p1, k1) 4 times, pm for back lace panel, [p1, k1] to last st, p1.

Next rnd: [(K1, p1) 4 times, (p1, k1) 4 times] 3 times, [p1, k1] to 1 st before back lace panel m, p1, (k1, p1) 4 times, (p1, k1) 4 times, [p1, k1] to last st, p1.

Cont in established rib until piece measures 9¼ (9¾, 10, 10¼, 10¾, 11¼, 11½, 11½)" (23.5 [25, 25.5, 26, 27.5, 28.5, 29, 29] cm) from underarm or 4¼" (11 cm) less than desired length.

Lace Border
Next rnd: Work 16-st rep of the Lace chart Row 1 three times over 48 sts, work in established rib to back lace panel m, work 16-st rep of the Lace chart Row 1 once over next 16 sts, work in established rib to end.

Cont as established through Row 35 of the Lace chart—250 (278, 298, 322, 338, 362, 394, 422) sts.

Next rnd: BO all sts, working sts kwise or pwise as they appear, and each yo kwise.

Finishing
Weave in loose ends. Block to finished measurements.

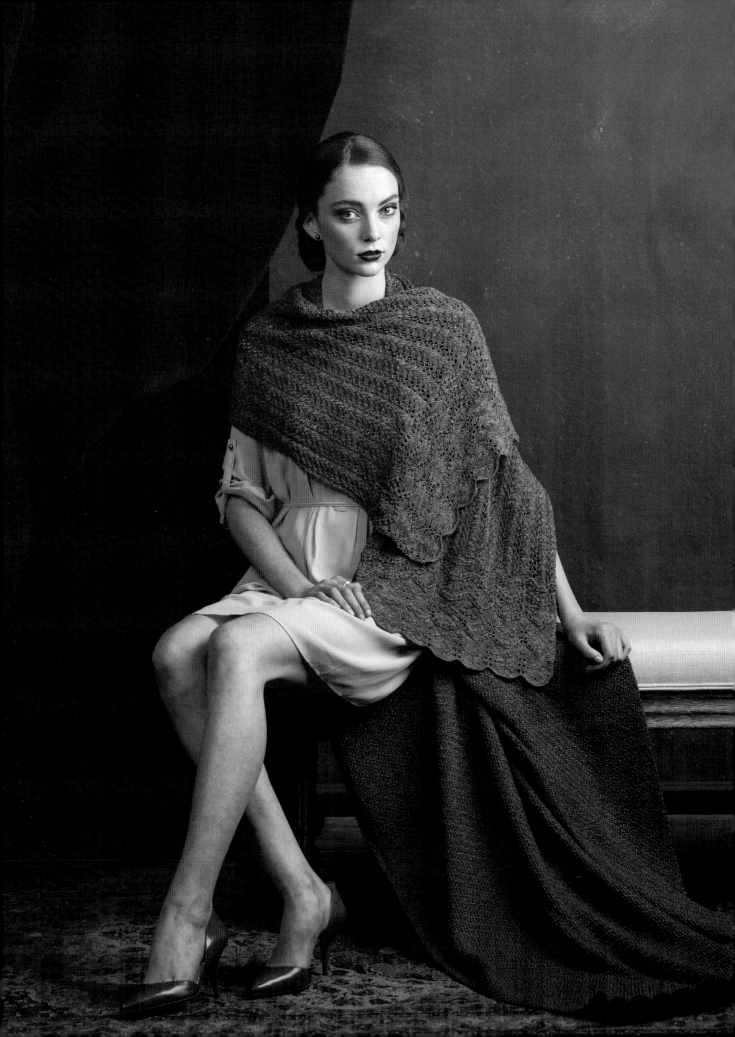

FINISHED SIZE

About 61" (155 cm) long and 17" (43 cm) wide.

YARN

Fingering weight (#1 Super Fine).

Shown here: Ella Rae Lace Merino (100% superwash merino; 460 yd (421 m)/3½ oz [100 g], #08 taupe, 3 skeins or 1,205 yd (1,102 m) of similar yarn.

NEEDLES

Size U.S. 3 and 4 (3.25 and 3.5 mm).

Adjust needle sizes if necessary to obtain the correct gauge.

NOTIONS

Stitch holder or waste yarn; tapestry needle.

GAUGE

28 sts and 40 rows = 4" (10 cm) in St st using smaller needles.

28½ sts and 32 rows = 4" (10 cm) in lace pattern using smaller needles, blocked.

Anwen
RECTANGULAR SHAWL

Anwen is a feminine, ethereal name that means very fair and beautiful. It captures the essence of this shawl, a collection of three old stitch patterns: a little Frost Flower stitch, a bit of old shale stitch, and a lot of fern lace stitch. This combination makes Anwen a beautifully intricate shawl, as well as a study of arrangements of decreases and yarnovers.

Anwen is made in two pieces worked from the ends, then invisibly seamed at the center. The center design of mirrored ripples made from seaming the two pieces together is definitely worth the effort of grafting—I was thrilled with the results.

I used Ella Rae Lace Merino, a wonderfully soft, springy fingering-weight yarn that is great for shawl knitting. It comes in a gorgeous array of solid and variegated colors.

A word about construction:
The long edges of Anwen curl in on themselves, giving the shawl a rolled edge, as shown. If you prefer flat edges along the length of the shawl, work the Lace D, Flat Edging chart.

RECTANGULAR SHAWL

Border

With larger needle, CO 122 sts using the long-tail method (Techniques, page 144). Change to smaller needles.

Knit 2 rows.

Rows 3–18: Work Rows 1–4 of the Lace A chart 4 times.

Rows 19–24: Work Rows 1–6 of the Lace B chart once.

Rows 25–36: Work Rows 1–4 of the Lace A chart 3 times.

Rows 37–42: Work Rows 1–6 of the Lace B chart once.

Rows 43–62: Work Rows 1–4 of the Lace C chart once, then work Rows 1–8 twice.

Row 63: Knit.

Row 64: K2, purl to last 2 sts, k2.

Body

Work Rows 1–4 of the Lace D, Flat Edging chart or the Lace D, Rolled Edging chart until piece measures 25" (63.5 cm) from beg, unblocked.

Work Rows 3–6 of the Lace B chart once.

Work Rows 1–8 of the Lace C chart once, rep Rows 1–4 once more, then rep Rows 1–3 once more.

Next row (WS): K2, purl to last 2 sts, k2. Cut the yarn, then place sts on a holder or waste yarn.

Work second half of shawl same as first half, leaving sts on needle.

Finishing
Graft shawl together

Return sts for first half of shawl onto smaller needle. Graft sts together using Kitchener st (Techniques, page 144).

Weave in loose ends. Block to finished measurements.

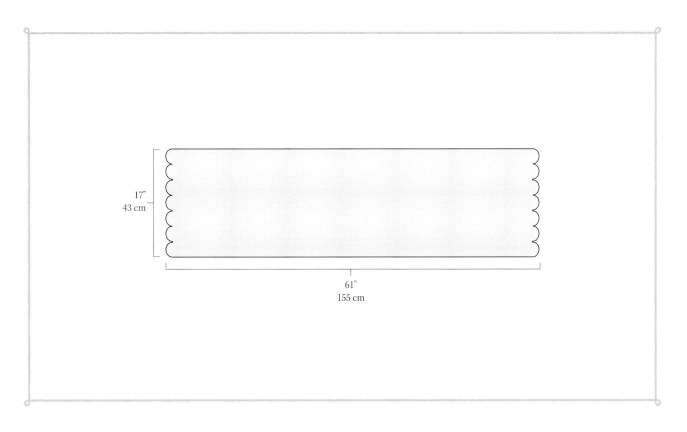

17"
43 cm

61"
155 cm

Lace A chart

4
2

3
1

17-st rep
Work 6 times.

end

beg

Lace B chart

6
4
2

5
3
1

17-st rep
Work 6 times.

end

beg

Lace C chart

8
6
4
2

7
5
3
1

17-st rep
Work 6 times.

end

beg

Lace D, Flat Edging chart

4
2

3
1

9-st rep
Work 12 times.

end

beg

Lace D, Rolled Edging chart

4
2

3
1

9-st rep
Work 12 times.

end

beg

	k on RS; p on WS
•	p on RS; k on WS
o	yo
/	k2tog on RS; p2tog on WS
\	ssk on RS; ssp on WS
	pattern repeat

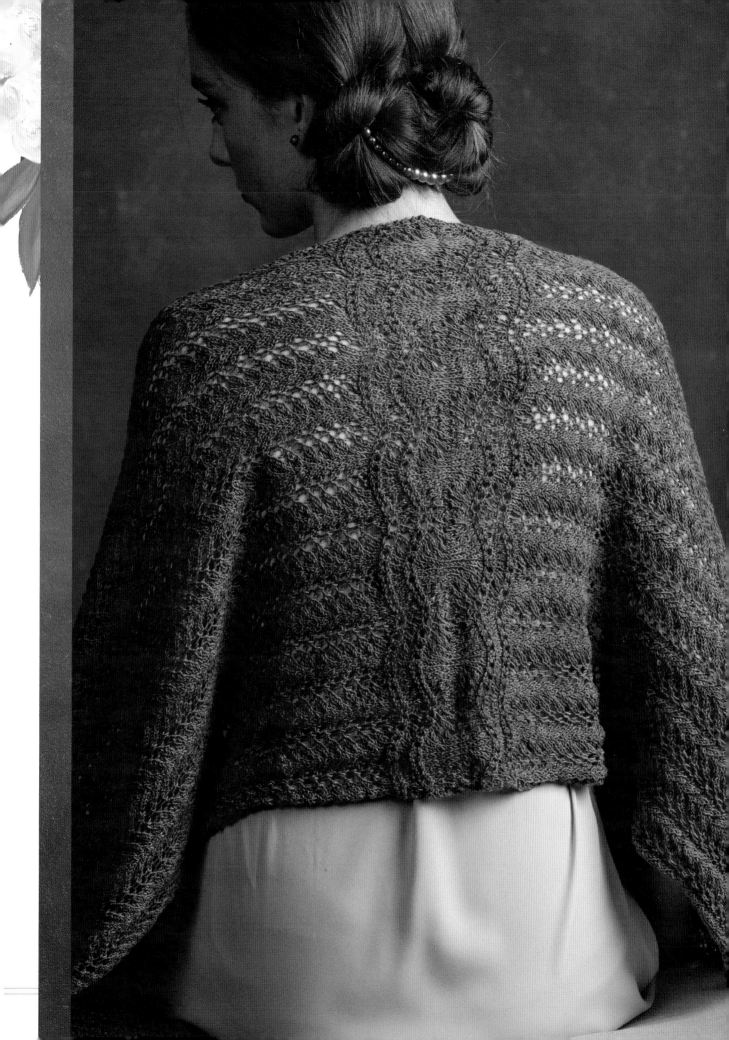

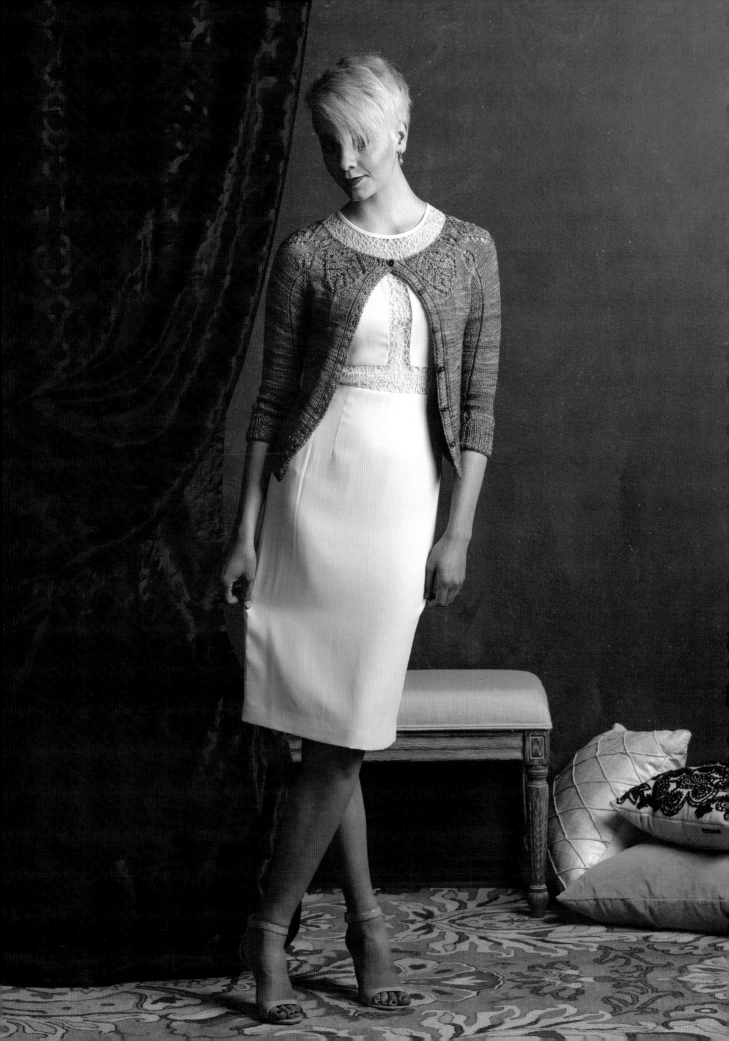

FINISHED SIZE

About 28¾ (31½, 34½, 36¼, 39¼, 42, 44¼, 47)" (73 [80, 87.5, 92, 99.5, 106.5, 112.5, 119.5] cm) bust circumference, buttoned with 1" (2.5 cm) overlap and 18¼ (19¼, 19¾, 20¼, 21¼, 21½, 21¾, 21¾)" (46.5 [49, 50, 51.5, 54, 54.5, 55, 55] cm) long.

Cardigan shown is size 28¾" (73 cm).

YARNS

DK weight (#3 Light).

Shown here: Anzula Cricket (80% superwash merino wool, 10% cashmere, 10% nylon; 250 yd [229 m]/4 oz [114 g]), Olivia, 4 (4, 4, 4, 5, 5, 5, 5) skeins or 790 (858, 926, 970, 1,047, 1,117, 1,167, 1,235) yd (722 [784, 846, 887, 957, 1,021, 1,067, 1,129] m) of a similar yarn.

NEEDLES

Size U.S. 4 (3.5 mm): 24" (60 cm) circular (cir) and set of 4 or 5 double-pointed (dpn).

Adjust needle size if necessary to obtain the correct gauge.

NOTIONS

Stitch markers (m); stitch holders or waste yarn; cable needle (cn); tapestry needle; seven to twelve ½" (1.3 cm) buttons.

GAUGE

23 sts and 29 rows = 4" (10 cm) in St st.

Camelia
PINECONE CARDIGAN

I found this pattern in a Japanese stitch dictionary when I was looking for a stitch pattern to use for a rounded-yoke cardigan. The shape was perfect and reminded me of pinecones. Camelia, which means evergreen in Italian, is a pretty feminine name that perfectly matches the pinecones that drop from evergreen trees.

I placed the center of the stitch pattern between the pinecone repeats to balance the design, and then I carried the purl ridges down the sweater, adding the center part to the bottom for a pretty detail. This lace pattern is somewhat complex; I recommend knitters have some lace experience before tackling it.

I used Anzula Cricket, a blend of superwash merino, cashmere, and a little bit of nylon. This very soft yarn has great stitch definition and makes a fabric with a comfortable weight.

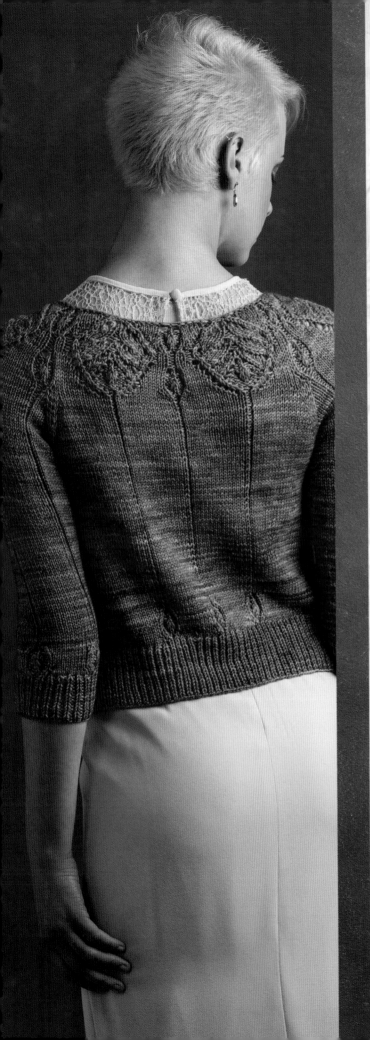

STITCH GUIDE

- **Left twist (LT):** Sl 1 st onto cn and hold in front, k1, k1 from cn.
- **Right twist (RT):** Sl 1 st onto cn and hold in back, k1, k1 from cn.

Buttonhole band (8 sts):

- **Row 1 (RS):** P1, k1 tbl, k2tog, [yo] 2 times, ssk, k1 tbl, k1.
- **Row 2 (WS):** K1, p1 tbl, p1, [k1, k1 tbl] of double yo, p1, p1 tbl, k1.
- **Row 3:** P1, k1 tbl, LT, RT, k1 tbl, k1.
- **Row 4:** K1, p1 tbl, k1, p2, k1, p1 tbl, k1.

Turn to the Glossary on page 144 to learn how to work these stitches:

Hide wrap	M1	RT
K1 tbl	M1P	Sk2p
K2tog	M1R	S2kp
K3tog	P1 tbl	Ssk
LLI	P2tog	Ssp
LT	RLI	W&t

A word about construction:

This cropped, rounded-yoke cardigan is constructed in one piece from the top down. Raglan increases shape the bodice. To create a flattering fit, short-rows are used to shape the back neckline.

The buttonhole band creates more holes than will be needed for the number of buttons, so when sewing on the buttons, make sure to evenly space them along the buttonband to line up with the chosen holes.

Camelia is designed to be form fitting. If you desire a looser fit, work one size bigger or omit some of the waist shaping.

PINECONE CARDIGAN

Body

With cir needle, CO 93 (93, 93, 103, 103, 103, 103, 103) sts using the long-tail method (Techniques, page 144). Do not join.

Purl 1 RS row.

Next row (WS): K1, p1 tbl, m1, p2, m1, p1 tbl, m1 for buttonhole band, place marker (pm) for yoke, work Row 1 of the Yoke chart for your size, pm for buttonband, k1, [p1 tbl, k4] 2 times—114 (114, 114, 124, 124, 124, 124, 124) sts.

Next row: [P4, k1 tbl] 2 times, p1, work Row 2 of the Yoke chart to m, work Row 1 of buttonhole band.

Work Rows 3–28 of Yoke chart and cont buttonhole and buttonbands as established—188 (188, 188, 198, 198, 198, 198, 198) sts.

Shape raglan yoke

NOTE: Work the reverse stockinette stitches from the last row of the yoke in twisted reverse stockinette stitch (p1 tbl on RS rows, k1 tbl on WS rows). These stitches continue down the body to the bottom ribbed band.

Cont button and buttonhole bands and twisted rev St sts (purl tbl on RS, knit tbl on WS) in established patt, and cont in St st (knit on RS, purl on WS) over rem sts as foll:

Set-up row (WS): Work 8 sts for buttonhole band as established, work next 22 (22, 22, 23, 23, 23, 23, 23) sts for right front, pm for raglan, work next 35 (35, 35, 37, 37, 37, 37, 37) sts for right sleeve, pm for raglan, work next 55 (55, 55, 59, 59, 59, 59, 59) sts for back, pm for raglan, work next 35 (35, 35, 37, 37, 37, 37, 37) sts for left sleeve, pm for raglan, work next 22 (22, 22, 23, 23, 23, 23, 23) sts for left front, work next 11 sts for buttonband.

Increase sleeve and body stitches

Short-row 1 (RS): [Work to 1 st before raglan m, LLI, k1, sl m, work to next raglan m, sl m, k1, RLI] 2 times, k1, w&t (see Techniques)—4 sts inc'd.

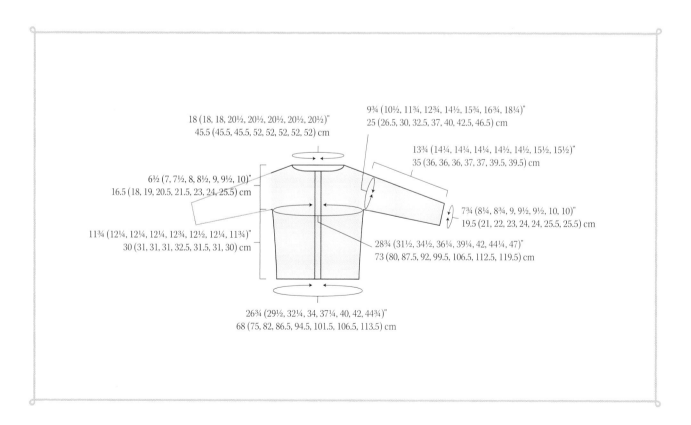

18 (18, 18, 20½, 20½, 20½, 20½, 20½)"
45.5 (45.5, 45.5, 52, 52, 52, 52, 52) cm

9¾ (10½, 11¾, 12¾, 14½, 15¾, 16¾, 18¼)"
25 (26.5, 30, 32.5, 37, 40, 42.5, 46.5) cm

13¾ (14¼, 14¼, 14¼, 14½, 14½, 15½, 15½)"
35 (36, 36, 36, 37, 37, 39.5, 39.5) cm

6½ (7, 7½, 8, 8½, 9, 9½, 10)"
16.5 (18, 19, 20.5, 21.5, 23, 24, 25.5) cm

7¾ (8¼, 8¾, 9, 9½, 9½, 10, 10)"
19.5 (21, 22, 23, 24, 24, 25.5, 25.5) cm

11¾ (12¼, 12¼, 12¼, 12¾, 12½, 12¼, 11¾)"
30 (31, 31, 31, 32.5, 31.5, 31, 30) cm

28¾ (31½, 34½, 36¼, 39¼, 42, 44¼, 47)"
73 (80, 87.5, 92, 99.5, 106.5, 112.5, 119.5) cm

26¾ (29½, 32¼, 34, 37¼, 40, 42, 44¾)"
68 (75, 82, 86.5, 94.5, 101.5, 106.5, 113.5) cm

Short-row 2: Work to 3 sts past last raglan m, w&t.

Short-row 3: [Work to 1 st before raglan m, LLI, k1, sl m, work to next raglan m, sl m, k1, RLI] 2 times, work to wrapped st, hide wrap, work 3 more sts, w&t—4 sts inc'd.

Short-row 4: Work to wrapped st, hide wrap, work 3 more sts, w&t.

Short-rows 5–8: Rep Short-rows 3 and 4 two more times—8 sts inc'd.

Inc Row: [Work to 1 st before raglan m, LLI, k1, sl m, work to next raglan m, sl m, k1, RLI] 2 times, work to wrapped st, hide wrap, work to end—208 (208, 208, 218, 218, 218, 218, 218) sts; 27 (27, 27, 28, 28, 28, 28, 28) sts for each front, 35 (35, 35, 37, 37, 37, 37, 37) sts for each sleeve, 65 (65, 65, 69, 69, 69, 69, 69) sts for the back, 8 sts for the buttonhole band, and 11 sts for the buttonband.

Work 1 WS row, hiding rem wrap.

Inc Row: [Work to 1 st before raglan m, LLI, k1, sl m, work to next raglan m, sl m, k1, RLI] 2 times, work to end—4 sts inc'd.

Work 1 WS row even.

Rep last 2 rows 0 (2, 2, 1, 1, 1, 1, 1) more time(s)—212 (220, 220, 226, 226, 226, 226, 226) sts; 28 (30, 30, 30, 30, 30, 30, 30) sts for each front, 35 (35, 35, 37, 37, 37, 37, 37) sts for each sleeve, 67 (71, 71, 73, 73, 73, 73, 73) sts for back, 8 sts for buttonhole band, and 11 sts for buttonband.

Increase sleeve and body stitches

Inc Row: [Work to 1 st before raglan m, LLI, k1, sl m, k1, RLI] 4 times, work to end—8 sts inc'd.

Work 1 WS row even.

Rep last 2 rows 2 (2, 4, 6, 8, 10, 12, 14) more times—236 (244, 260, 282, 298, 314, 330, 346) sts; 31 (33, 35, 37, 39, 41, 43, 45) sts for each front, 41 (41, 45, 51, 55, 59, 63, 67) sts for each sleeve, 73 (77, 81, 87, 91, 95, 99, 103) sts for back, 8 sts for buttonhole band, and 11 sts for buttonband.

Lace Border chart

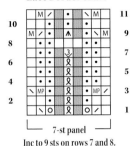

7-st panel

Inc to 9 sts on rows 7 and 8.

NOTE: When working back and forth, read RS rows from right to left and WS rows from left to right. When working in the round, read all chart rows from right to left.

☐ k on RS; p on WS

• p on RS; k on WS

○ yo

⅄ k1 tbl on RS; p1 tbl on WS

⅄ p1 tbl on RS; k1 tbl on WS

╱ k2tog on RS; p2tog on WS

╲ ssk on RS; ssp on WS

⋋ k3tog

⅄ sk2p

⋀ s2kp

Ⓜ m1

MP m1p

⬇ (k1, p1, k1) in st 3 rows below, letting the 2 sts above ravel

▨ no stitch

☐ pattern repeat

Small Yoke chart, sizes 28¾ (31½, 34½)" (73 [80, 87.5] cm)

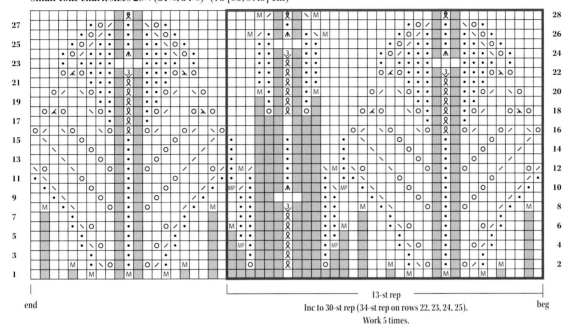

end

beg

13-st rep

Inc to 30-st rep (34-st rep on rows 22, 23, 24, 25).
Work 5 times.

Large Yoke chart, sizes 36¼ (39¼, 42, 44¼, 47)" (92 [99.5, 106.5, 112.5, 119.5] cm)

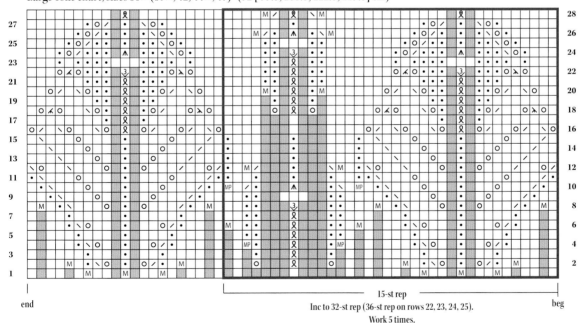

end

beg

15-st rep

Inc to 32-st rep (36-st rep on rows 22, 23, 24, 25).
Work 5 times.

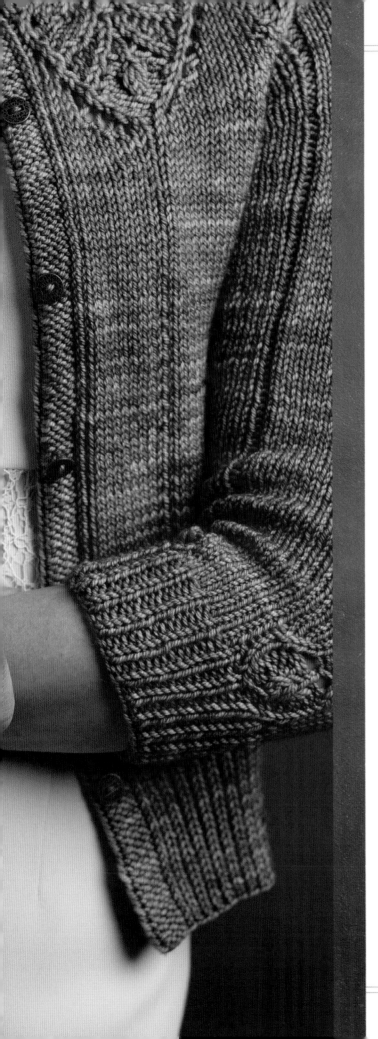

Body
Divide body and sleeves
Dividing row (RS): Removing raglan m as you go, work to raglan m, place next 41 (41, 45, 51, 55, 59, 63, 67) sts on a holder or waste yarn for the left sleeve, CO 15 (19, 23, 23, 28, 32, 34, 38) sts, work 73 (77, 81, 87, 91, 95, 99, 103) back sts, place next 41 (41, 45, 51, 55, 59, 63, 67) sts on a holder or waste yarn for right sleeve, CO 34, 38) sts, work to end—184 (200, 216, 226, 244, 260, 272, 288) sts.

Working CO sts in St st, work 20 rows even in established patt, ending with a RS row.

Shape waist
Set-up row (WS): Work 25 (29, 30, 32, 32, 34, 36, 38) sts in established patt, pm for dart, work 43 (43, 49, 50, 59, 63, 65, 69) sts, pm for dart, work 45 (53, 55, 59, 59, 63, 67, 71) sts, pm for dart, work 43 (43, 49, 50, 59, 63, 65, 69) sts, pm for dart, work rem 28 (32, 33, 35, 35, 37, 39, 41) sts.

Dec row: [Work to dart m, sl m, k2tog, work to 2 sts before next dart m, ssk, sl m] 2 times, work to end—4 sts dec'd.

Work 5 rows even.

Rep last 6 rows 2 more times—172 (188, 204, 214, 232, 248, 260, 276) sts rem.

Remove dart m and work evenly until piece measures 9¼ (9¾, 9¾, 9¾, 10 , 10, 10, 10¼)" (23.5 [24.75, 24.75, 24.75, 25.5, 25.5, 25.5, 26] cm) or 2½" (6.5 cm) less than the desired length from armhole, ending with a WS row.

Bottom Lace Band
Set-up row (RS): [Work to 3 sts before twisted rev St st, pm, work Row 1 of the Lace Band chart over next 7 sts, pm] 5 times, work to end of row.

Cont as established through Row 11 of the Lace Band chart.

Ribbed Band
Set-up row (WS): Removing lace band m as you go, work buttonband in established patt, sl m, [k1, p1] to 1 st before buttonhole band m and dec 1 st where necessary to maintain the center st of Lace Band as a knit st, k1, sl m, work buttonhole band in established patt.

Set-up row (WS): Removing Lace Band m as you go, work buttonband in established patt, sl m, [p1, k1] to 1 st before buttonhole band m and dec 1 st as necessary to maintain the center st of the Lace Band as a knit st, k1 sl m, work buttonhole band in established patt.

Next row (RS): Work buttonband in established patt, sl m, [k1, p1] to 1 st before buttonhole band m, k1, work buttonhole band in established patt.

Cont in established rib patt until rib measures about 2½" (6.5 cm).

BO all sts loosely in patt.

Sleeves

With dpn and RS facing, beg at center of underarm, pick up and k8 (10, 12, 12, 14, 16, 17, 19) sts evenly along CO edge, work held 41 (41, 45, 51, 55, 59, 63, 67) sleeve sts from holder and cont twisted rev St sts in patt as established, pick up and k7 (9, 11, 11, 14, 16, 17, 19) sts evenly along rem CO edge to center of underarm—56 (60, 68, 74, 83, 91, 105) sts.

Pm for beg of rnd and join for working in rnds.

Work 8 (9, 5, 4, 3, 2, 2, 2) rnds even.

Dec rnd: K1, k2tog, work to last 2 sts, ssk—2 sts dec'd.

Rep dec rnd every 9 (10, 6, 5, 4, 3, 3, 2) rnds 5 (5, 8, 10, 13, 17, 19, 23) more times—44 (48, 50, 52, 55, 55, 57, 57) sts rem.

Cont evenly until piece measures 9½ (10, 10, 10, 10¼, 10¼, 11¼, 11¼)" (24 [25.5, 25.5, 25.5, 26, 26, 28.5, 28.5] cm) from armhole.

Cuff

Set-up rnd: [Knit to 3 sts before twisted rev St st, pm, work Row 1 of the Lace Band chart over next 7 sts, pm] 3 times, knit to end of rnd.

Cont in established patt through Row 11 of the Lace Band chart.

Ribbed Band
**Sizes 28¾ (31½, 34½)"
(73 [80, 87.5] cm) only:**
Set-up rnd: Knit to first chart m (becomes new beg-of-rnd m), [(k1, p1) 3 times, k1, remove m, p1, k1, p2tog, (k1, p1) 5 times, remove m] 2 times, [k1, p1] to new end of rnd and remove old beg-of-rnd m—42 (46, 48) sts rem.

Size 36¼" (92 cm) only:
Set-up rnd: Knit to first chart m (becomes new beg-of-rnd m), [k1, p1] to new beg-of-rnd m, and removing chart m and old beg-of-rnd m—52 sts rem.

**Sizes 39¼ (42, 44¼, 47)"
(99.5 [106.5, 112.5, 119.5] cm) only:**
Set-up rnd: Knit to first chart m (becomes new beg-of-rnd m), [k1, p1] to 2 sts before new beg-of-rnd m, and remove chart m and old beg-of-rnd m, p2tog—54 (54, 56, 56) sts rem.

All sizes:
Next rnd: [K1, p1] around.

Cont in established rib patt until the rib measures 2½" (6.5 cm).

BO all sts loosely in patt.

Finishing
Weave in loose ends. Block to finished measurements.

Work buttonband
With RS facing, fold 4 purled edge sts to WS along first line of twisted sts. Sew band to inside along knit st before second twisted st.

Sew buttons to buttonband opposite buttonholes.

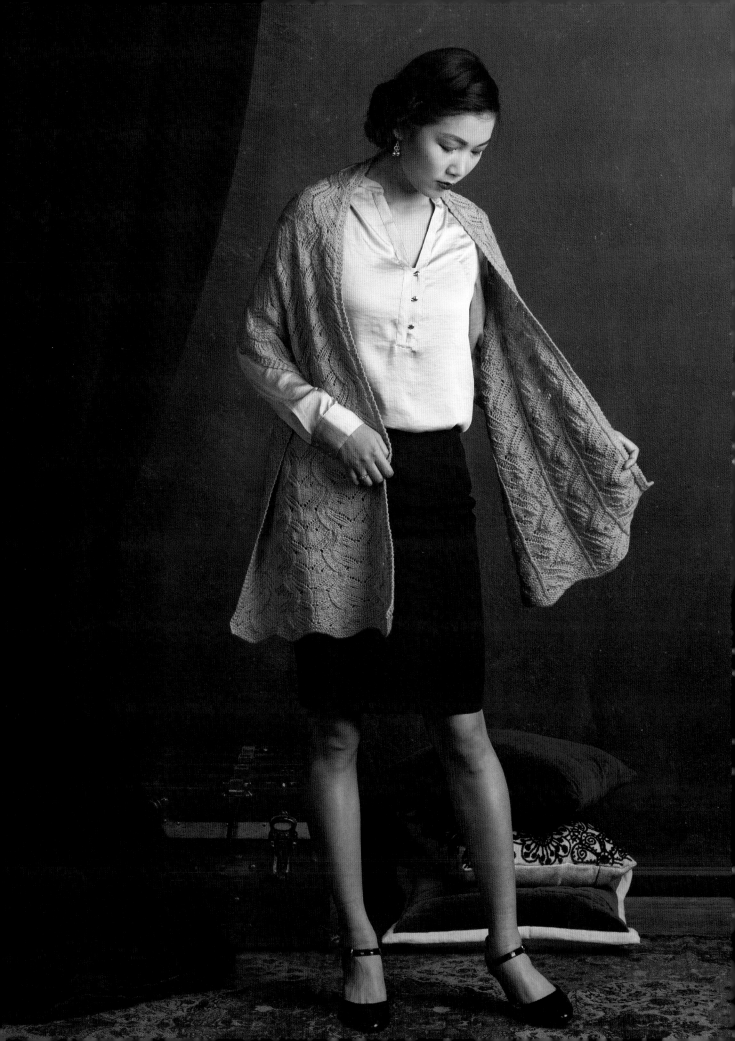

Dwyn
SHAWL

The name of this shawl is pronounced "doo-IN." Dwyn is an ancient-sounding Welsh name that means wave. I chose it for the way the raised stitches wave in and out in this lace-stitch pattern, which mimics the look of cables without actually crossing stitches.

I found this stitch pattern in one of my Japanese stitch dictionaries. I rearranged it to create the undulating waves with the pretty lace stitches in between. This is one of those rare designs where the finished project surpasses my expectations. This uncomplicated lace pattern is worked on both sides of the shawl.

This design requires yarn with good stitch definition; the stitches will look sloppy without it. I used Lorna's Laces Shepherd Worsted, a 100 percent superwash wool that is a very soft, hard-wearing yarn.

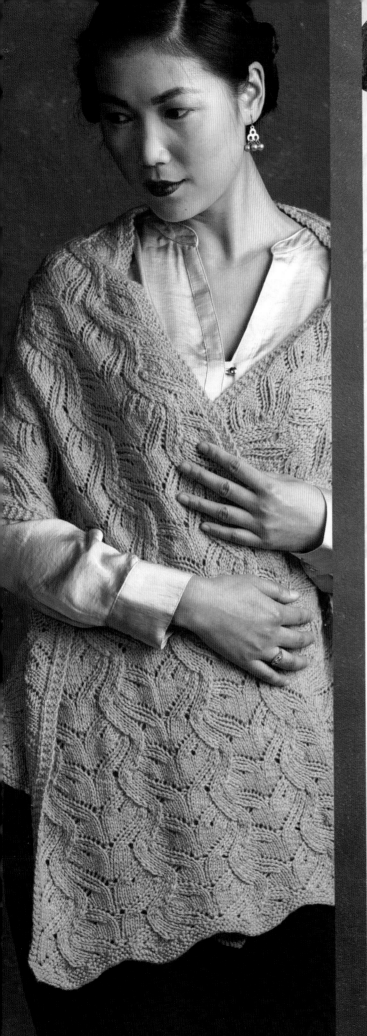

SHAWL

CO 95 sts using the long-tail method (Techniques, page 144).

Work 5 rows in garter st (knit every row).

Next row (RS): Work Row 1 of the right half of the Lace chart, pm, work Row 1 of the left half of the Lace chart.

Cont in patt as estab, working Rows 1–20 of the Lace chart 21 times.

Work Rows 1–4 of the Lace chart once more.

Work 5 rows in garter st, removing m.

BO all sts kwise.

Finishing
Weave in loose ends. Block to finished measurements.

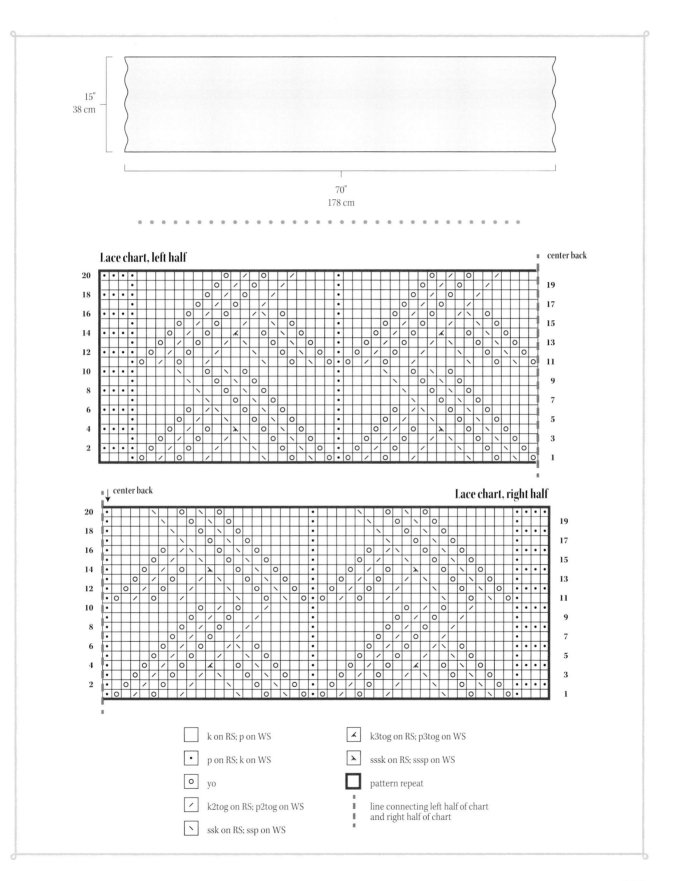

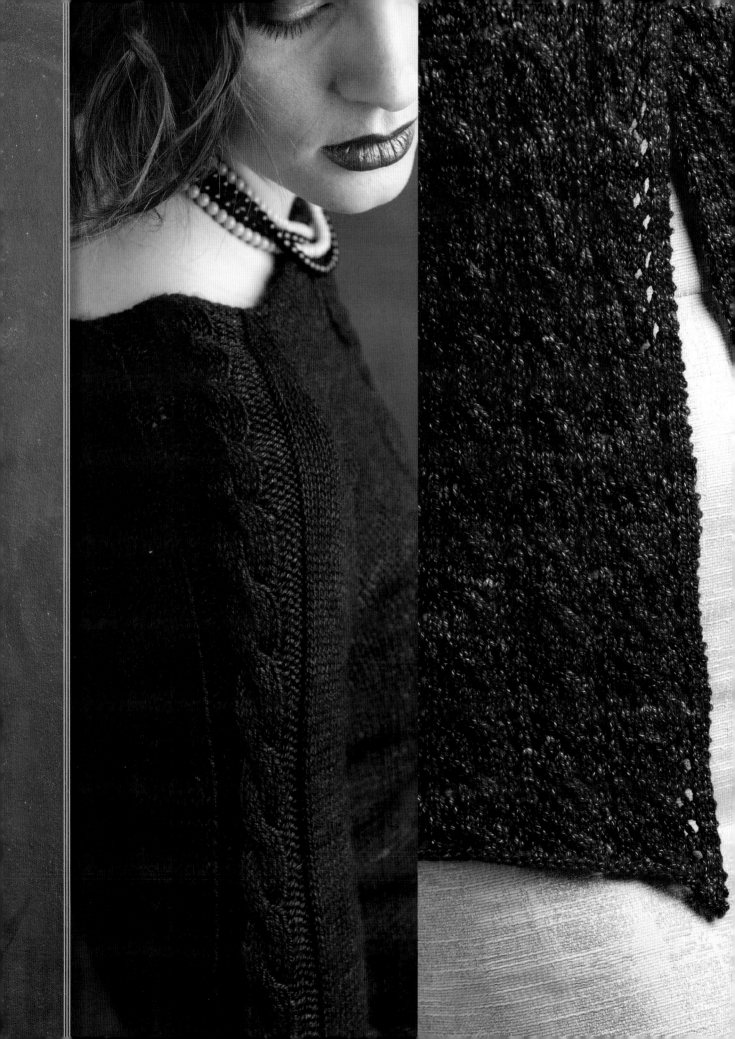

ELEGANT
Aran Lace

Alone, cable knitting and lace patterns are thrilling to knit. But together? Nothing is more wonderful than the joining of my two favorite techniques.

Combining cables and lace is like uniting structure and beauty, strength and grace, fortitude and elegance. Oh the beauty that can be created! Naturally, the two can be used together in a host of ways—balanced equally, as in Maisie (page 138), or complementing a large cable with a few delicate eyelets, as in Keavy (page 118). Lace can gracefully melt into cables, a perfect blend of knitted magic in a sweater such as Corinne (page 110).

With Aran lace, there is no limit to creative knitting.

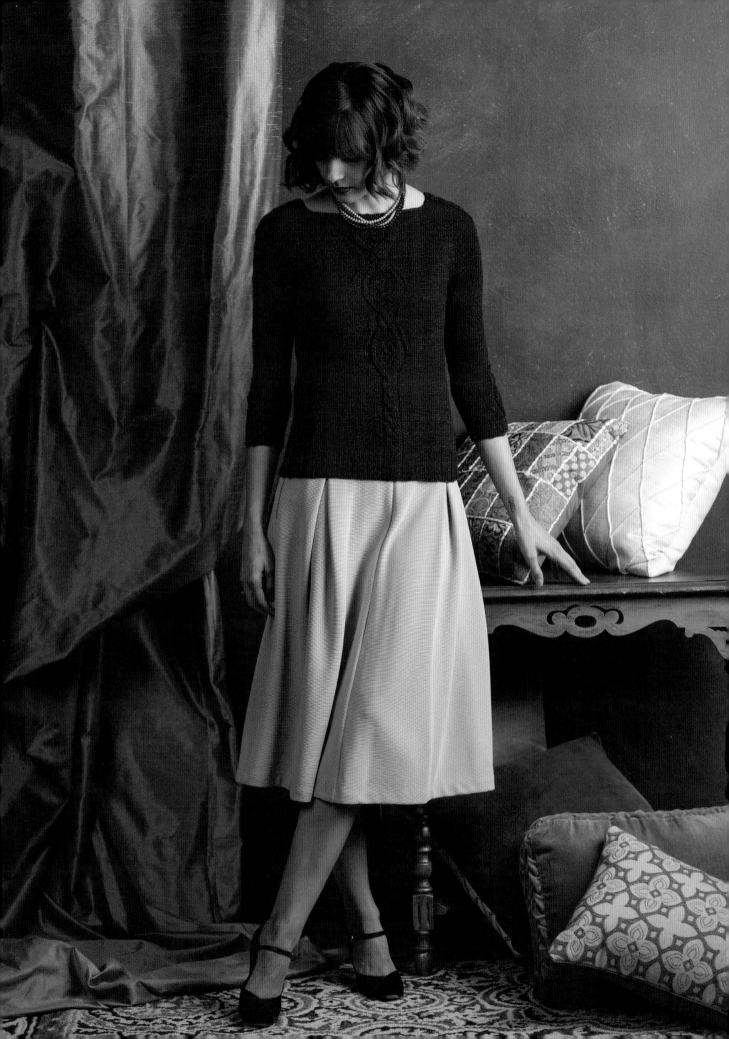

FINISHED SIZE

About 28 (30½, 33¼, 35¾, 38½, 41½, 44, 46½)"
(71 [77.5, 84.5, 90.5, 98, 105.5, 112, 118] cm)
bust circumference and 21½ (22, 22½, 24¼, 25,
25¾, 27, 27½)" (54.5 [56, 57, 61.5, 63.5, 65.5, 68.5,
70] cm) long.

Pullover shown is size 30½" (77.5 cm).

YARN

Sportweight (#2 Fine).

Shown here: Madelinetosh Pashmina (75%
superwash merino, 15% silk, 10% cashmere;
360 yd [329 m]/3½ oz [100 g]), tart, 3 (3, 3, 4,
4, 4, 5, 5) skeins or 904 (982, 1,060, 1,137, 1,215,
1,303, 1,381, 1,458) yd (826 [898, 969, 1,039, 1,111,
1,191, 1,263, 1,333] m) of similar yarn.

NEEDLES

Size U.S. 5 (3.75 mm): 24" (60 cm) circular (cir)
and set of 4 or 5 double-pointed (dpn).

Adjust needle size if necessary to obtain the
correct gauge.

NOTIONS

Stitch markers (m); cable needle (cn); stitch
holders or waste yarn; tapestry needle.

GAUGE

24½ sts and 32 rows = 4" (10 cm) in St st.

29-st front cable panel = 4" (10 cm) wide,
blocked.

59-st back cable panel = 8" (20.5 cm) wide,
blocked.

Corinne
OVAL PULLOVER

*This lace pattern is from one of Barbara Walker's stitch
dictionaries. Although it was originally an all-over
pattern worked in a laceweight yarn, I decided to try
a single repeat of it in a sportweight yarn. I altered the
oval pattern to stand alone, slightly shrinking it, and
carried the cable from it down the sweater. This pattern,
alone and grouped on the back of the sweater, creates a
delightfully elegant pullover.*

*Even though Corinne is worked in the round, you must
keep track of many lace stiches and cable crosses on
the back.*

*Such a beautiful sweater needs beautiful yarn and
a lovely name to match. Madelinetosh Pashmina's
luxurious blend of merino, silk, and cashmere fit the
bill with great stitch definition and drape. The name
Corinne means beautiful maiden, mirroring the
qualities of this pullover.*

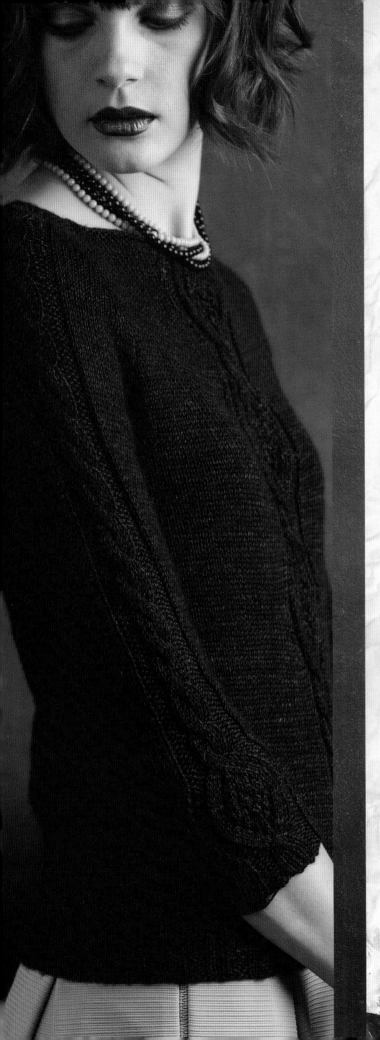

STITCH GUIDE

- **3/1/3 LC (3 over 1 over 3 left cross):** Sl 4 sts onto cn and hold in front, k3, sl purl st back to LH needle, p1, then k3 from cn.

Turn to the Glossary on page 144 to learn how to work these stitches:
K2tog
LLI
M1
M1p
RLI
Sk2p
S2kp
Ssk

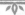

A word about construction:

This pullover is a compound raglan constructed in one piece from the top down. The compound raglan allows for a flattering fit because the rate of increase varies to accurately follow the shape of the body. It increases rapidly between the neck and shoulders and at the end to curve around the underarm. It gradually increases in the section in between.

You can easily adjust the length of the body and sleeves. If you adjust the body or sleeve size, make sure you use a multiple of 6 stitches + 3 for the bottom band and the cuff in the stockinette stitch sections.

I used a lot of markers in this pattern to make the instructions clearer, but you certainly do not have to use them all. Try using different color markers for the different lace panels.

OVAL PULLOVER

Yoke

NOTE: Markers are used to indicate raglan increases, the front and back lace panels, and the cable on the sleeve. Always work the increase sts in St st (knit RS rows, purl WS rows).

In the set-up round, work the St sts as rev St sts (purl on RS rows, knit on WS rows). Work the 36-row rep of the Front chart 3 times. For the Back chart, work Rows 1–47 once, then work Rows 4–47 once more, working the charted gray sts in St st.

Slip markers as you come to them unless instructed otherwise.

With cir needle, CO 126 (126, 126, 134, 142, 150, 154, 166) sts using the long-tail method (Techniques, page 144).

Place marker (pm) and join for working in rnds, being careful not to twist sts.

Set-up rnd: [P2 (2, 2, 3, 4, 5, 5, 7), pm for sleeve cable, work Row 1 of the Sleeve Cable chart over next 13 sts, pm, p2 (2, 2, 3, 4, 5, 5, 7)] for left sleeve, pm for raglan, [p2 (2, 2, 3, 4, 5, 6, 7), pm for back lace panel, work Row 1 of the Back chart over next 45 sts, pm, p2 (2, 2, 3, 4, 5, 6, 7) sts] for back, pm for raglan, [p2 (2, 2, 3, 4, 5, 5, 7), pm for sleeve cable, work Row 1 of the Sleeve Cable chart over next 13 sts, pm, p2 (2, 2, 3, 4, 5, 5, 7)] for right sleeve, pm for raglan, [p7 (7, 7, 8, 9, 10, 11, 12), pm for front lace panel, work Row 1 of the Front chart over next 29 sts, pm, p7 (7, 7, 8, 9, 10, 11, 12) sts] for front—17 (17, 17, 19, 21, 23, 23, 27) sts for each sleeve, 49 (49, 49, 51, 53, 55, 57, 59) sts for the back, and 43 (43, 43, 45, 47, 49, 51, 53) sts for the front.

Next rnd: K2 (2, 2, 3, 4, 5, 5, 7), work Row 2 of the Sleeve Cable chart over next 13 sts, k2 (2, 2, 3, 4, 5, 5, 7), sl raglan m, k2 (2, 2, 3, 4, 5, 6, 7), work Row 2 of the Back chart over next 59 sts, k2 (2, 2, 3, 4, 5, 6, 7), sl raglan m, k2 (2, 2, 3, 4, 5, 5, 7), work Row 2 of the Sleeve Cable chart over next 13 sts, k2 (2, 2, 3, 4, 5, 5, 7), sl raglan m, k7 (7, 7, 8, 9, 10, 11, 12), work Row 2 of the Front chart over next 29 sts, k7 (7, 7, 8, 9, 10, 11, 12).

18¼ (18¼, 18¼, 19½, 20¾, 22, 22¾, 24¾)"
46.5 (46.5, 46.5, 49.5, 52.5, 56, 58, 63) cm

9¾ (11¼, 12½, 13¾, 15, 16½, 17½, 19¼)"
25 (28.5, 31.5, 35, 38, 42, 44.5, 49) cm

1¼ (1¼, 1¼, 1½, 1¾, 1¾, 1¾, 2¼)"
3.2 (3.2, 3.2, 3.8, 4.5, 4.5, 4.5, 5.5) cm

11½ (13, 13½, 13½, 14, 14¼, 14½, 14½)"
29 (33, 34.5, 34.5, 35.5, 36, 37, 37) cm

6¼ (6¾, 7¼, 8¼, 8¾, 9½, 10¼, 10¼)"
16 (17, 18.5, 21, 22, 24, 26, 26) cm

14 (14, 14, 14½, 14½, 14½, 15, 15)"
35.5 (35.5, 35.5, 37, 37, 37, 38, 38) cm

7 (7, 7, 7¾, 8¾, 8¾, 8¾, 9¾)"
18 (18, 18, 19.5, 22, 22, 22, 25) cm

28 (30½, 33¼, 35¾, 38½, 41½, 44, 46½)"
71 (77.5, 84.5, 91, 98, 105.5, 112, 118) cm

NOTE: In the first increase section through Row 15 of the Back chart, move the back lace markers 1 stitch toward the sleeves as shown on the chart to include stitches in the back cable panel and work these stitches according to the chart.

Increase body and sleeve stitches

Inc rnd: Working next row of each chart and sl cable m as you come to them, *k1, RLI, work to 1 st before raglan m, LLI, k1, sl m; rep from * 3 more times—8 sts inc'd.

Working new sts in St st, work 1 rnd even.

Rep last 2 rnds 7 more times.

Rep inc rnd every 4 rnds 5 times, then every other rnd 6 (8, 10, 14, 16, 19, 22, 22) times—278 (294, 310, 350, 374, 406, 434, 446) sts; 55 (59, 63, 73, 79, 87, 93, 97) sts for each sleeve, 87 (91, 95, 105, 111, 119, 127, 129) sts for the back, and 81 (85, 89, 99, 105, 113, 121, 123) sts for the front.

Make a note of the last row worked on the Sleeve Cable chart so you know which row to start with when you work the sleeves.

Divide body and sleeves

Next rnd: Removing all raglan m, place next 55 (59, 63, 73, 79, 87, 93, 97) sts on a holder or waste yarn for left sleeve, CO 4 (6, 8, 7, 8, 9, 9, 12) sts, pm for new beg of rnd, CO 5 (7, 9, 8, 9, 9, 9, 12) sts, work back sts in established patt, place next 55 (59, 63, 73, 79, 87, 93, 97) sts on a holder or waste yarn for right sleeve, CO 9 (13, 17, 15, 17, 18, 18, 24) sts, knit to beg-of-rnd m—186 (202, 218, 234, 250, 268, 284, 300) sts rem.

Body

NOTE: When you finish the second repeat of the Back chart Rows 4–47, move the cable markers 8 stitches in on each side and repeat Rows 48–55 over the center 43 stitches of the back to the ribbed band.

When you finish the third repeat of the Front chart Rows 1–36, move the cable markers 8 stitches in on each side and repeat Rows 37–44 over the center 13 sts of the front to the ribbed band.

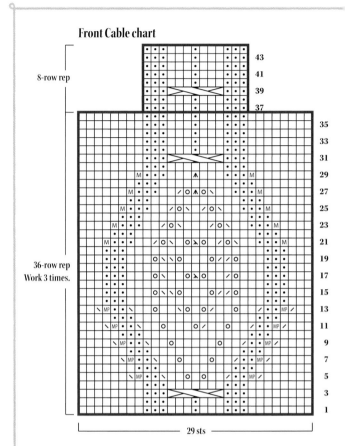

Front Cable chart

8-row rep

36-row rep
Work 3 times.

29 sts

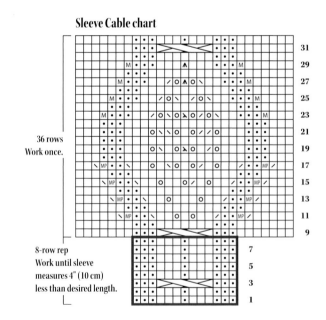

Sleeve Cable chart

36 rows
Work once.

8-row rep
Work until sleeve measures 4" (10 cm) less than desired length.

Back Cable chart

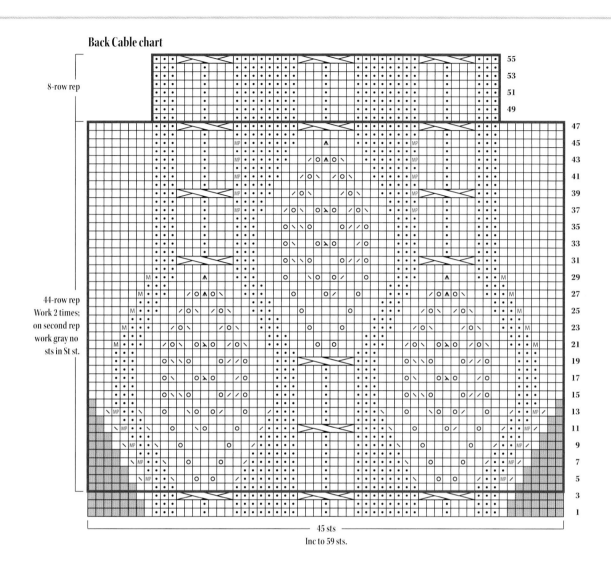

8-row rep

44-row rep
Work 2 times;
on second rep
work gray no
sts in St st.

45 sts
Inc to 59 sts.

	k on RS; p on WS			sk2p
•	p on RS; k on WS		M	m1
o	yo		MP	m1p
∕	k2tog			3/1/3 LC (see Stitch Guide, page 112)
∖	ssk			no stitch
⋀	s2kp			pattern repeat
⋋	sk2p			

Work in established patt until piece measures 12 (12, 12, 12½, 12½, 12½, 13, 13)" (30.5 [30.5, 30.5, 31.5, 31.5, 31.5, 33, 33] cm) or 2" (5 cm) short of the desired length from armhole, and dec 2 (4, 0, 2, 4, 1, 3, 5) st(s) evenly in each side St st section on last rnd—182 (194, 218, 230, 242, 266, 278, 290) sts.

Ribbed Band

Set-up rnd: Knit to back cable m, p3, [k1, ssk, p1, k2tog, k1, p3, k2, p3] 2 times, k1, ssk, p1, k2tog, k1, p3, sl m, (k3, p3) to 3 sts before front cable m, k3, p3, k1, ssk, p1, k2tog, k1, p3, sl m, [k3, p3] to end, remove beg-of-rnd m, cont in k3, p3 rib to 3 sts before back cable m, k3—174 (186, 210, 222, 234, 258, 270, 282) sts rem.

Rnds now beg at back cable m.

Next rnd: P3, [k2, p1, k2, p3, k2, p3] 2 times, k2, p1, k2, p3, remove m, (k3, p3) to 3 sts before front cable m, k3, remove m, p3, k2, p1, k2, p3, remove m, (k3, p3) to last 3 sts, k3.

Cont in established rib patt until band measures 2" (5 cm).

BO all sts loosely in patt.

Sleeves

With dpn and RS facing, beg at center of underarm CO sts, pick up and k5 (7, 9, 8, 9, 9, 9, 12) sts evenly along CO edge, work held 55 (59, 63, 73, 79, 87, 93, 97) sleeve sts in established patt, then pick up and k4 (6, 8, 7, 8, 9, 9, 12) sts evenly along rem CO edge—64 (72, 80, 88, 96, 105, 111, 121) sts.

Pm for beg of rnd and join to work in rnds.

Cont the Sleeve Cable chart over center 13 sts and working rem sts in St st, work 5 (4, 4, 5, 6, 4, 6, 6) rnds even.

Dec rnd: K1, k2tog, work to last 2 sts, ssk—2 sts dec'd.

Rep dec rnd every 9 (8, 7, 6, 5, 5, 4, 4) rnds 8 (11, 7, 11, 18, 10, 24, 14) times, then every 0 (0, 6, 5, 0, 4, 0, 3) rnds 0 (0, 7, 5, 0, 11, 0, 13) times. At the same time, when sleeve measures 7½ (9, 9½, 9½, 10, 10¼, 10½, 10½)" (19 [23, 24, 24, 25.5, 26, 26.5, 26.5] cm) from armhole, move cable m out 7 sts to the right and to the left and work Rows 9–31 of the Sleeve chart—46 (48, 50, 54, 58, 61, 61, 65) sts rem.

Next rnd: Work Row 32 of the Sleeve chart and dec 0 (2, 4, 2, 0, 3, 3, 1) st(s) evenly across St st section—46 (46, 46, 52, 58, 58, 58, 64) sts rem.

Next rnd: Knit to cable m, remove m, k7, pm, p3, k1, ssk, p1, k2tog, k1, p3, [k3, p3] to end, remove beg-of-rnd m, cont in k3, p3 rib to 3 sts before next m, k3.

Rnds beg at new m.

Next rnd: P3, k2, p1, k2, [p3, k3] to end.

Rep last rnd 6 more times.

BO all sts loosely in patt.

Finishing

Weave in loose ends. Block to finished measurements.

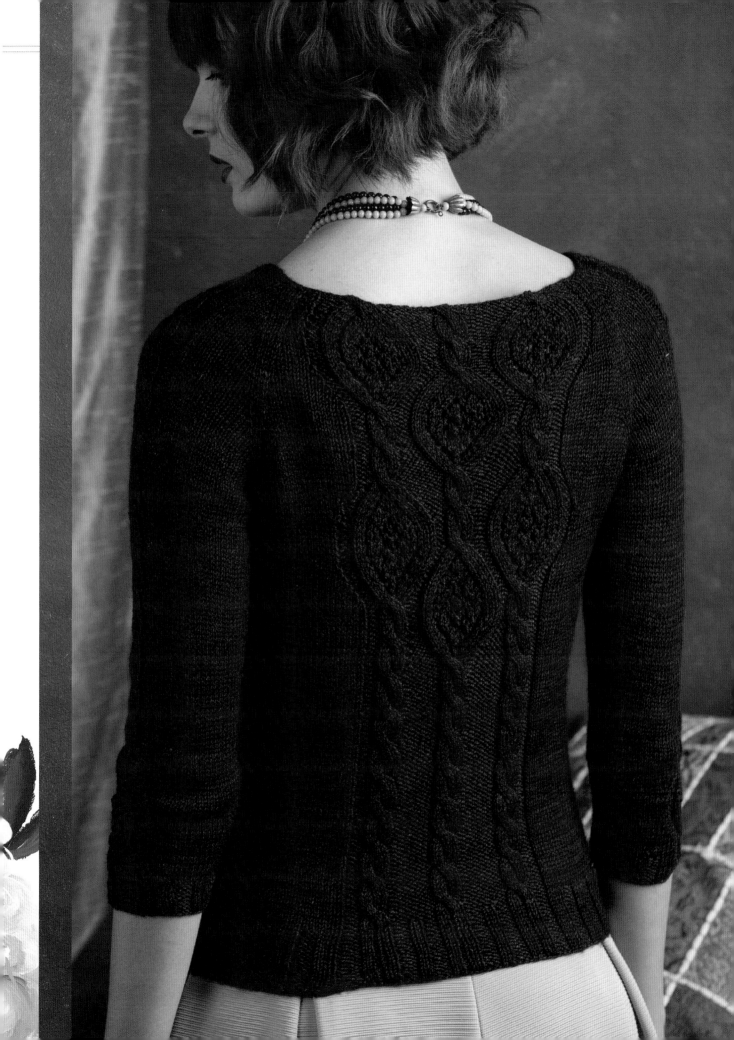

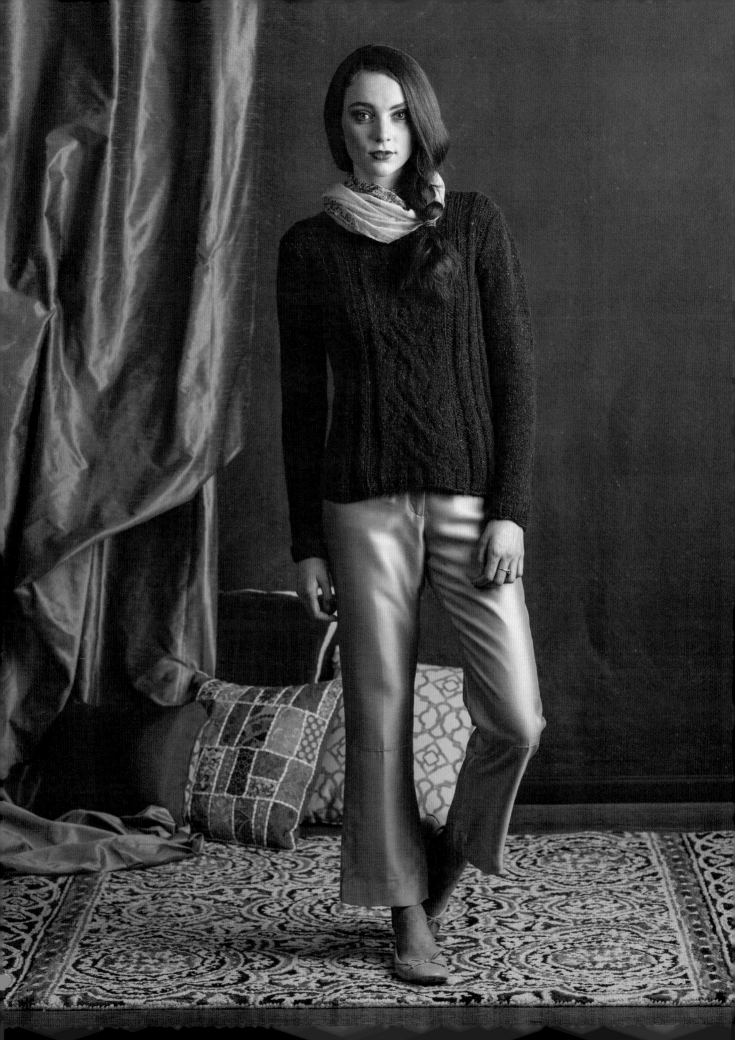

FINISHED SIZE

About 31¼ (35½, 39½, 43¾, 49, 53¼, 58¾, 63)"
(79.5 [90, 100.5, 111, 124.5, 135.5, 149, 160] cm)
bust circumference and 22¼ (22¾, 23½, 24¼,
24¾, 26, 26½, 27¼)" (56.5 [58, 59.5, 61.5, 63, 66,
67.5, 69] cm] long.

Pullover shown is size 35½" (90 cm).

YARN

Aran weight (#4 Medium).

Shown here: Rowan Felted Tweed Aran (50%
merino wool, 25% rayon, 25% alpaca; 95 yd
[87 m]/1¾ oz [50 g]), #734 mahogany, 8 (9, 10,
11, 12, 13, 14, 15) skeins or 697 (785, 872, 959,
1,069, 1,157, 1,265, 1,353) yd (637 [718, 797, 877,
977, 1,058, 1,156, 1,237] m) of similar yarn.

NEEDLES

Size U.S. 8 (5 mm): 24" (60 cm) circular (cir) and
set of 4 or 5 double-pointed (dpn).

Adjust needle size if necessary to obtain the
correct gauge.

NOTIONS

Stitch markers (m); locking marker; stitch
holders or waste yarn; tapestry needle; cable
needle (cn) (optional).

GAUGE

15 sts and 20 rows = 4" (10 cm) in St st.

24-st center cable pattern = 6" (15 cm) wide,
blocked.

Keavy
SIMPLE PULLOVER

*This contemporary, simple, feminine version of an Aran
pullover is just the thing for the Lover's Knot cable. I
love the warm and inviting contrast between the rustic
tweed yarn and the quaintness of the simple eyelet
cable pattern. This is a fairly straightforward design
and a good choice if you are new to cables and lace.*

*This sweater is kin to an Aran pullover, so I wanted to
go with an Irish name. Keavy means gentle, beautiful,
and precious, all of which reflect the feminine aspect of
the sweater.*

*I used Rowan Felted Tweed Aran, a mixture of merino,
rayon, and alpaca. It is a "sticky" yarn, meaning that
the stitches do not readily ravel, which makes it
good for practicing crossing six-stitch cables without
a cable needle.*

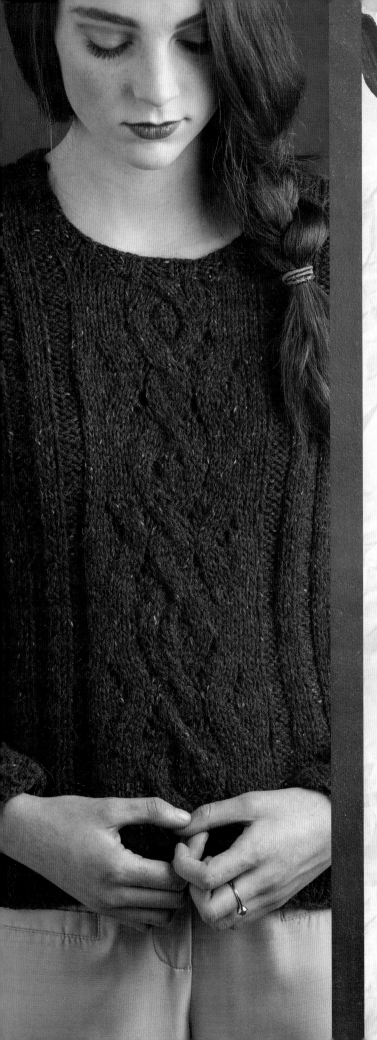

STITCH GUIDE

- **3/3 LC (3 over 3 left cross):** Sl 3 sts onto cn and hold in front, k3, k3 from cn.

Turn to the Glossary on page 144 to learn how to work these stitches:
Hide wrap
K2tog
LLI
M1
M1L
M1R
RLI
Ssk
W&t

❦

A word about construction:

Keavy is constructed in one piece from the top down with set-in sleeves. The shoulders are shaped using short-rows. The fronts and back are worked separately until the sleeves are started. The top of the sweater is worked flat until the fronts are joined, and then it is worked in the round. There is no body shaping below the armholes; the cabled panel and ribs add some natural shaping.

Slip markers as you come to them unless instructed otherwise.

For helpful hints about construction, see Willa Explained on page 10.

SIMPLE PULLOVER

Back

With cir needle, CO 16 (17, 20, 20, 22, 21, 22, 22) sts for shoulder, place a locking marker at edge, CO 26 (26, 28, 28, 28, 30, 30, 30) sts for neck, place a locking marker at edge, CO 16 (17, 20, 20, 22, 21, 22, 22) sts for shoulder—58 (60, 68, 68, 72, 72, 74, 74) sts.

Shape shoulders

Set-up row (WS): P2 (3, 1, 1, 3, 3, 4, 4), place marker (pm) for cable panel, working Row 1 of the Cable Panel chart, work 3 sts at left side of chart, work 6-st rep 2 (2, 3, 3, 3, 3, 3, 3) times, work next 24 sts once, work 6-st rep 2 (2, 3, 3, 3, 3, 3, 3) times, then work 3 sts at right side of chart, pm for cable panel, purl to end.

NOTE: Continue to work the Cable Panel chart between markers, working the next row of the chart and working the stitches outside of the markers in stockinette stitch (knit RS rows, purl WS rows) as established. If the short-row wrap stitch falls in a reverse stockinette–stitch section, you don't need to hide the wrap on the following row.

Short-rows 1 and 2: Work to last 13 (14, 16, 16, 16, 16, 16, 16) sts, w&t.

Short-rows 3–6: Work to wrapped st, hide the wrap, work 3 (3, 4, 4, 4, 4, 4, 4) more sts, w&t.

After last turn, work to end of row. Work 13 more rows over all sts in established patt, hiding the last wraps as you come to them, ending with Row 21 of the chart.

Cut yarn and place sts on a holder or waste yarn.

Right Front

NOTE: Work the selvedge stitches in stockinette stitch. When you start shaping the neck, work the increases inside the selvedge stitches. Work the stitches outside the markers in stockinette stitch.

The fronts are worked as those for Willa except there is no saddle. See figure 2 on page 15.

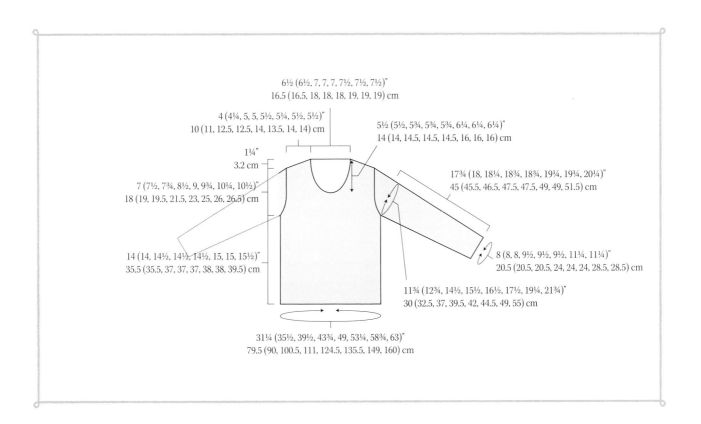

6½ (6½, 7, 7, 7, 7½, 7½, 7½)"
16.5 (16.5, 18, 18, 18, 19, 19, 19) cm

4 (4¼, 5, 5, 5½, 5¼, 5½, 5½)"
10 (11, 12.5, 12.5, 14, 13.5, 14, 14) cm

5½ (5½, 5¾, 5¾, 5¾, 6¼, 6¼, 6¼)"
14 (14, 14.5, 14.5, 14.5, 16, 16, 16) cm

1¼"
3.2 cm

17¾ (18, 18¼, 18¾, 18¾, 19¼, 19¼, 20¼)"
45 (45.5, 46.5, 47.5, 47.5, 49, 49, 51.5) cm

7 (7½, 7¾, 8½, 9, 9¾, 10¼, 10½)"
18 (19, 19.5, 21.5, 23, 25, 26, 26.5) cm

8 (8, 8, 9½, 9½, 9½, 11¼, 11¼)"
20.5 (20.5, 20.5, 24, 24, 24, 28.5, 28.5) cm

14 (14, 14½, 14½, 14½, 15, 15, 15½)"
35.5 (35.5, 37, 37, 37, 38, 38, 39.5) cm

11¾ (12¾, 14½, 15½, 16½, 17½, 19¼, 21¾)"
30 (32.5, 37, 39.5, 42, 44.5, 49, 55) cm

31¼ (35½, 39½, 43¾, 49, 53¼, 58¾, 63)"
79.5 (90, 100.5, 111, 124.5, 135.5, 149, 160) cm

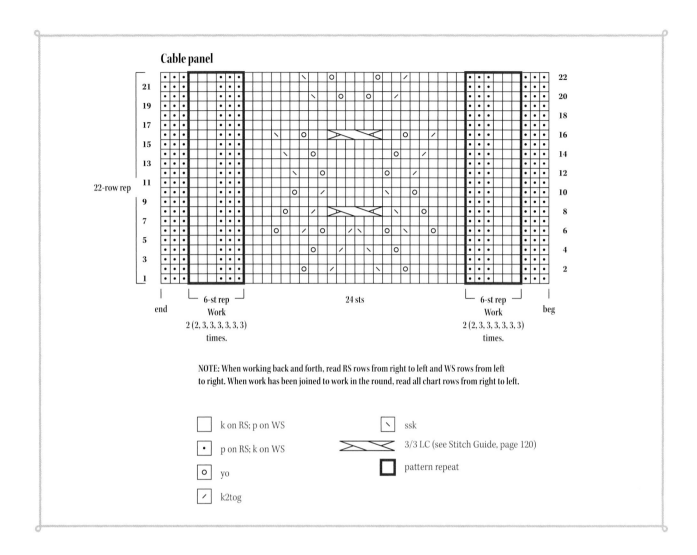

Cable panel

22-row rep

end — 6-st rep — Work 2 (2, 3, 3, 3, 3, 3) times.

24 sts

6-st rep — Work 2 (2, 3, 3, 3, 3, 3) times. — beg

NOTE: When working back and forth, read RS rows from right to left and WS rows from left to right. When work has been joined to work in the round, read all chart rows from right to left.

	k on RS; p on WS		ssk
•	p on RS; k on WS		3/3 LC (see Stitch Guide, page 120)
o	yo		pattern repeat
∕	k2tog		

With CO edge at top and RS facing, pick up and k16 (17, 20, 20, 22, 21, 22, 22) sts from armhole edge to locking m, CO 1 selvedge st—17 (18, 21, 21, 23, 22, 23, 23) sts.

Shape shoulder
Set-up row (WS): P1, k2 (2, 1, 1, 1, 0, 0, 0), [p3, k3] 2 (2, 3, 3, 3, 3, 3, 3) time(s), pm for the cable panel, purl to end.

Short-row 1 (RS): Knit to m, work Row 2 of the Cable Panel chart to last st, k1.

Short-row 2: P1, work row 3 of the Cable Panel chart for 3 (3, 4, 4, 4, 4, 4, 4) sts, w&t.

Short-row 3: Work in established patt to last st, k1.

Short-row 4: P1, work in patt to wrapped st, hide wrap, work 3 (3, 4, 4, 4, 4, 4, 4) more sts in patt, w&t.

Short-rows 5 and 6: Rep Short-rows 3 and 4.

After last turn, work to end of row. Work 13 more rows over all sts in established patt, hiding the last wraps as you come to them, ending with Row 21 of the chart.

Cut yarn and place sts on a holder or waste yarn.

Left front
With CO edge at top and RS facing, beg at second locking m, pick up and k16 (17, 20, 20, 22, 21, 22, 22) sts to armhole edge.

Shape shoulder

Set-up row (WS): P2 (3, 1, 1, 3, 3, 4, 4), pm for cable panel, [k3, p3] 2 (2, 3, 3, 3, 3, 3, 3) times, k2 (2, 1, 1, 1, 0, 0, 0), CO 1 selvedge st—17 (18, 21, 21, 23, 22, 23, 23) sts.

Short-row 1 (RS): K1, work Row 2 of the Cable Panel chart for 3 (3, 4, 4, 4, 4, 4, 4) sts, w&t.

Short-row 2: Work Row 3 of the Cable Panel chart to last st, p1.

Short-row 3: K1, work in established patt to wrapped st, hide wrap, work 3 (3, 4, 4, 4, 4, 4, 4) more sts, w&t.

Short-row 4: Work in established patt to last st, p1.

Short-rows 5 and 6: Rep Short-rows 3 and 4.

Work 14 more rows over all sts in established patt, hiding the last wrap as you come to it, ending with Row 21 of the chart.

Yoke

NOTE: Neck shaping begins on the next row. Follow the chart to determine if the increase stitch is worked as a knit or purl stitch. See figure 3 on page 15.

With RS facing, return held right front and back sts to the needle as foll: left front, back, right front.

Begin sleeves

Next row (RS): Beg at left front neckline, k1, m1l, work Row 22 of the Cable Panel chart to m, knit to armhole edge, pm for armhole, pick up and k22 sts evenly along armhole edge, pm for armhole, work back sts in established patt, pm for armhole, pick up and k22 sts evenly along armhole edge, pm for armhole, knit to m, work Row 22 of the chart to last st, m1r, k1—138 (142, 156, 156, 164, 162, 166, 166) sts; 18 (19, 22, 22, 24, 23, 24, 24) sts for each front, 22 sts for each sleeve, and 58 (60, 68, 68, 72, 72, 74, 74) sts for the back.

Next row: P1, working new st into patt, work as established to m, [purl to m, sl m] 3 times, work 54 (54, 66, 66, 66, 66, 66) sts in established patt, [sl m, purl to m] 3 times, work in patt to last st, p1.

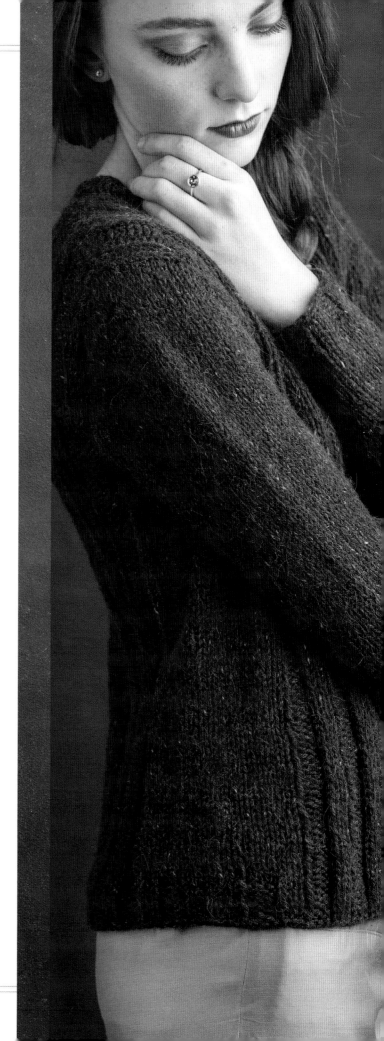

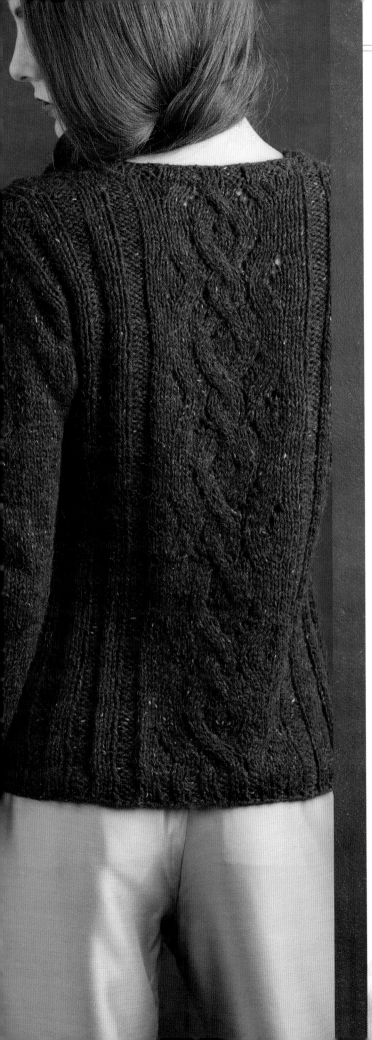

Inc row: K1, m1l, work to armhole m, sl m, RLI, knit to armhole m, LLI, sl m, work back sts, sl m, RLI, knit to armhole m, LLI, sl m, work to last st, m1r, k1—6 sts inc'd.

Work 1 WS row even.

Rep last 2 rows 1 (1, 2, 2, 2, 3, 3, 3) more time(s)—150 (154, 174, 174, 182, 186, 190, 190) sts; 20 (21, 25, 25, 27, 27, 28, 28) sts for each front, 26 (26, 28, 28, 28, 30, 30, 30) sts for each sleeve, and 58 (60, 68, 68, 72, 72, 74, 74) sts for the back.

Join to work in the round
Joining row (RS): [Work to armhole m, sl m, RLI, knit to m, LLI, sl m] 2 times, work to end, CO 18 sts, work left front sts—172 (176, 196, 196, 204, 208, 212, 212) sts; 28 (28, 30, 30, 30, 32, 32, 32) sts for each sleeve and 58 (60, 68, 68, 72, 72, 74, 74) sts each for the front and the back.

Place unique color m for beg of rnd.

Increase sleeve stitches
Next rnd: [Knit to m, sl m] 2 times, work next row of chart over next 54 (54, 66, 66, 66, 66, 66, 66) sts, [knit to m, sl m] 3 times, work next row of chart over next 54 (54, 66, 66, 66, 66, 66, 66) sts, sl m, knit to end.

Inc rnd: [RLI, knit to next m, LLI, sl m, work in established patt to next armhole m, sl m] 2 times—4 sts inc'd.

Rep last 2 rnds 5 (5, 6, 6, 6, 5, 5, 6) more times—196 (200, 224, 224, 232, 232, 236, 240) sts; 40 (40, 44, 44, 44, 44, 44, 46) sts for each sleeve and 48 (60, 68, 68, 72, 72, 74, 74) sts each for the front and the back.

Work 1 WS rnd even.

Increase body stitches
Inc rnd: [Knit to m, sl m, k1, RLI, work to 1 st before next armhole m, LLI, k1, sl m] 2 times—4 sts inc'd.

Work 1 rnd even.

Rep last 2 rnds 0 (1, 0, 2, 3, 5, 6, 6) more time(s)—200 (208, 228, 236, 248, 256, 264, 268) sts; 40 (40, 44, 44, 44, 44, 44, 46) sts for each sleeve and 60 (64, 70, 74, 80, 84, 88, 88) sts each for the front and the back.

Divide body and sleeves

Dividing rnd: Removing armhole m as you go, place next 40 (40, 44, 44, 44, 44, 44, 46) sts on a holder or waste yarn for left sleeve, CO 2 (4, 5, 7, 9, 11, 14, 18) sts, pm for beg of rnd, CO 2 (4, 5, 7, 9, 11, 14, 18) sts, work back sts in established patt, place next 40 (40, 44, 44, 44, 44, 44, 46) sts on a holder or waste yarn for right sleeve, CO 4 (8, 10, 14, 18, 22, 28, 36) sts, work front sts in established patt, knit to beg-of-rnd m—128 (144, 160, 176, 196, 212, 232, 248) sts.

Body

Working CO sts in St st, work evenly until piece measures 13 (13, 13, 13½, 13½, 13½, 14, 14)" (33 [33, 33, 34.5, 34.5, 34.5, 35.5, 35.5] cm) from armhole, ending with an odd-numbered rnd of the chart.

Bottom Band

Next rnd: Knit to first cable panel m, *sl m, [p3, k3] 3 (3, 4, 4, 4, 4, 4, 4) times, [p2, k2] 4 times, p2, [k3, p3] 3 (3, 4, 4, 4, 4, 4, 4) times, sl m, [k3, p3] 0 (1, 1, 1, 2, 3, 4, 4) time(s), k10 (6, 2, 10, 8, 4, 2, 10), [p3, k3] 0 (1, 1, 1, 2, 3, 4, 4) time(s); rep from * once more.

NOTE: The first cable marker becomes the new beginning of the round for the bottom band.

Rep the last rnd 4 more times. BO all sts loosely in the patt.

Sleeves

With dpn and RS facing, beg at center of underarm and pick up and k2 (4, 5, 7, 9, 11, 14, 18) sts evenly along CO edge, knit held 40 (40, 44, 44, 44, 44, 44, 46) sleeve sts, pick up and k2 (4, 5, 7, 9, 11, 14, 18) sts evenly along rem CO edge—44 (48, 54, 58, 62, 66, 72, 82) sts.

Pm for beg of rnd and join for working in rnds, taking care to not twist sts.

Work 10 (7, 6, 10, 5, 5, 5, 4) rnds even.

Dec rnd: K1, k2tog, knit to last 2 sts, ssk—2 sts dec'd.

Rep dec rnd every 11 (8, 7, 7, 6, 6, 6, 5) rnds 6 (8, 5, 10, 12, 7, 7, 7) more times, then every 0 (0, 6, 0, 0, 5, 5, 4) rnds 0 (0, 6, 0, 0, 7, 7, 12) times—30 (30, 30, 36, 36, 36, 42, 42) sts rem.

Cont evenly until sleeve measures 16¼ (16½, 16¾, 17¼, 17¼, 17¾, 17¾, 18¾)" (41.5 [42, 42.5, 44, 44, 45, 45, 47.5] cm) from armhole.

Cuff

Next rnd: *K3, p3; rep from * to end.

Work 4 more rnds in established rib patt. BO all sts loosely in patt.

Finishing
Work neckline

With cir needle and RS facing, beg at right back neck and pick up and k26 (26, 28, 28, 28, 30, 30, 30) sts along back neck, pick up and k20 (20, 22, 22, 22, 24, 24, 24) sts evenly along left front neck, pick up and k18 sts along front neck CO sts, then pick up and k20 (20, 22, 22, 22, 24, 24, 24) sts evenly along right front neck—84 (84, 90, 90, 90, 96, 96, 96) sts. Pm for beg of rnd and join for working in rnds.

Rnd 1: *K3, p3; rep from * to end.

Work 3 more rnds in established rib patt.

BO all sts loosely in patt.

Weave in loose ends. Block to finished measurements.

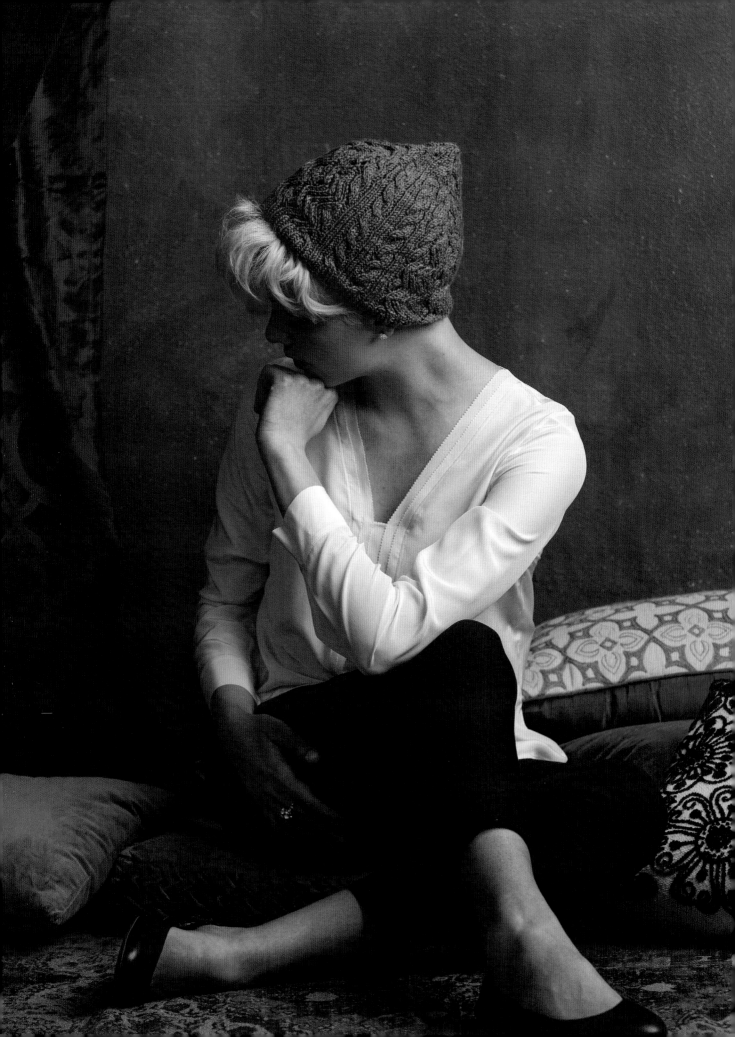

FINISHED SIZE

About 18½" (47 cm) circumference and 9" (23 cm) tall.

YARN

DK weight (#3 Light).

Shown here: Shalimar Breathless DK (75% merino, 15% cashmere, 10% silk; 270 yd (247 m)/4 oz [125 g]), tamarillo, 1 skein or 151 yd (138m) of similar yarn.

NEEDLES

Size U.S. 6 (4 mm): 16" (40 cm) circular (cir) and set of 4 or 5 double-pointed (dpn).

Adjust needle size if necessary to obtain the correct gauge.

NOTIONS

Stitch marker (m); cable needle (cn); tapestry needle.

GAUGE

28 sts and 30 rnds = 4" (10 cm) in chart patt, blocked.

Billie
HAT

This is a fun, tomboyish hat, just like its name, with strong geometric shapes. The name Billie means resolute protection, and this warm, cozy hat will protect your head in wintery weather.

I discovered this stitch pattern in one of my Japanese stitch dictionaries. The cables buried in the lace stitches caught my eye—they are almost unseen, but they add nice directional changes. I rearranged the stitch pattern to work for a hat, beginning with mostly lace stitches, gradually moving into mostly cable stitches, and then ending in a fun rounded point.

I used Shalimar Breathless DK, a wonderful superwash blend of merino, cashmere, and silk. It is very soft while retaining good stitch definition, making it a perfect choice for this pretty lace and cable hat.

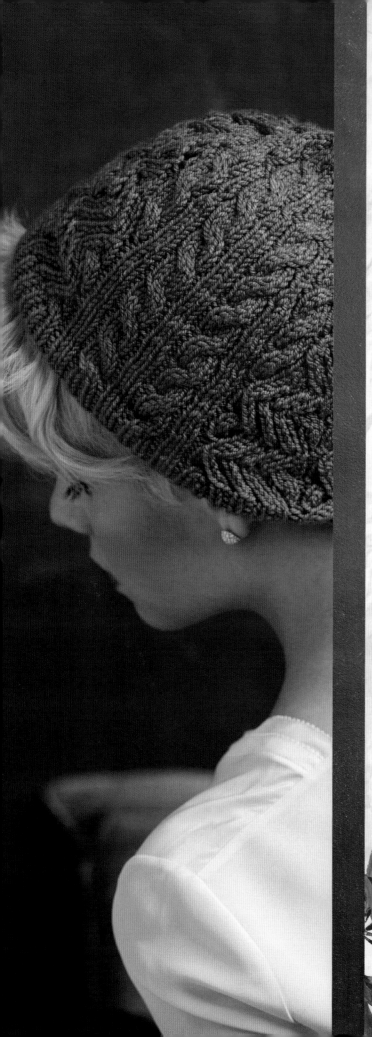

STITCH GUIDE

 2/2 LC (2 over 2 left cross): Sl 2 sts onto cn and hold in front, k2, k2 from cn.

- **2/2 RC (2 over 2 right cross):** Sl 2 sts onto cn and hold in front, k2, k2 from cn.

- **3/3 LC (3 over 3 left cross):** Sl 3 sts onto cn and hold in front, k3, k3 from cn.

- **3/3 RC (3 over 3 right cross):** Sl 3 sts onto cn and hold in back, k3, k3 from cn.

Turn to the Glossary on page 144 to learn how to work these stitches:

K1tbl
K2tog
P1tbl
P2tog
Ssk
Ssp

A word about construction:

This hat is worked in the round from the brim up. Slip all markers as you come to them, unless instructed otherwise.

HAT

Ribbed Band

With cir needle, CO 123 sts using the long-tail method (Techniques, page 144).

Place marker (pm) for beg of rnd and join for working in rnds, being careful not to twist sts.

Set-up rnd: [P1, (k1, p1) 2 times, k2, (p1, k1) 12 times, p1, k2, (p1, k1) 2 times, p1, k2, pm] 2 times, P1, (k1, p1) 2 times, k2, (p1, k1) 12 times, p1, k2, (p1, k1) 2 times, p1, k2.

Next rnd: [P1, (k1, p1) 2 times, k2, (p1, k1) 12 times, p1, k2, (p1, k1) 2 times, p1, k2] 3 times.

Rep last rnd 5 more times.

Inc rnd: [P1, (k1, m1, k2, p1, k2, (p1, k1) 12 times, p1, k2, p1, k1, m1, k2, p1, k2] 3 times—129 sts.

Work Rows 1–38 of the Aran Lace chart—111 sts.

Crown

NOTE: Change to double-pointed needles when there are too few stitches to work comfortably on circular needle.

Dec rnd 1: [P1, k4, p1, k1, p1, (k1, ssk, k1, p1) 2 times, (k1, k2tog, k1, p1) 2 times, k1, p1, k4, p1, k2] 3 times—99 sts rem.

Work 1 rnd even.

Dec rnd 2: [P1, k4, p1, k1, p1, k2, ssk, k3, p1, k3, k2tog, k2, p1, k1, p1, k4, p1, ssk] 3 times—90 sts rem.

Work 1 rnd even.

Dec rnd 3: [P1, 2/2 LC, ssp, p1, 3/3 LC, p1, 3/3 RC, p1, p2tog, 2/2 RC, p1, k1] 3 times—84 sts rem.

Work 1 rnd even.

Dec rnd 4: [P1, k4, p2, k2, ssk, k2, p1, k2, k2tog, k2, p2, k4, p1, k1] 3 times—78 sts rem.

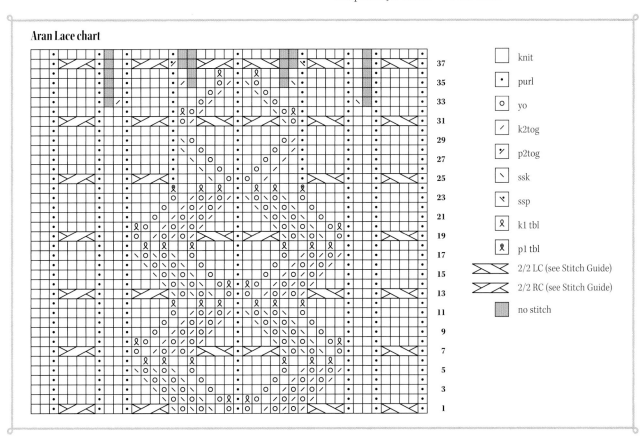

Aran Lace chart

	knit
•	purl
o	yo
/	k2tog
⅋	p2tog
\	ssk
↖	ssp
℟	k1 tbl
↑	p1 tbl
⟋⟍	2/2 LC (see Stitch Guide)
⟍⟋	2/2 RC (see Stitch Guide)
▨	no stitch

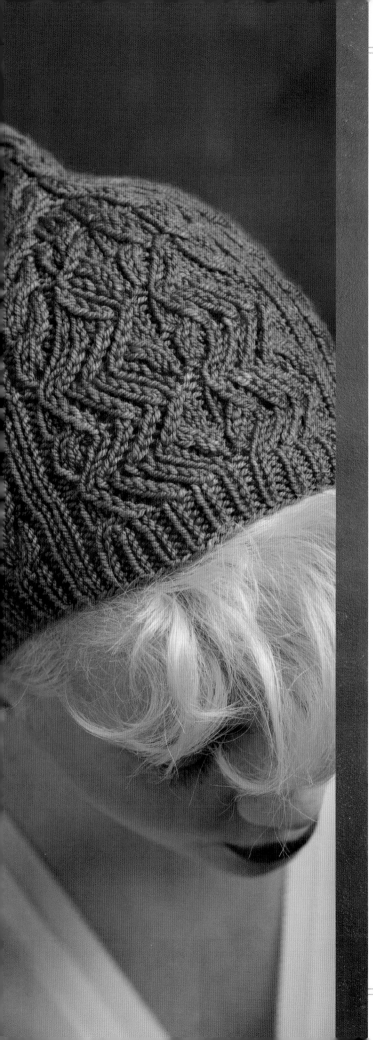

Work 1 rnd even.

Dec rnd 5: [P1, k4, p2, k1, ssk, k2, p1, k2, k2tog, k1, p2, k4, p1, k1] 3 times—72 sts rem.

Work 1 rnd even.

Dec rnd 6: [P1, 2/2 LC, ssp, 2/2 LC, p1, 2/2 RC, p2tog, 2/2 RC, p1, k1] 3 times—66 sts rem.

Work 1 rnd even.

Dec rnd 7: [P1, (k1, ssk, k1, p1) 2 times, (k1, k2tog, k1, p1) 2 times, k1] 3 times—54 sts rem.

Work 1 rnd even.

Dec rnd 8: [P1, k2, ssk, k3, p1, k3, k2tog, k2, p1, k1] 3 times—48 sts rem.

Work 1 rnd even.

Next rnd: [P1, 3/3 LC, p1, 3/3 RC, p1, k1] 3 times.

Dec rnd 9: [P1, k1, (ssk) 2 times, k1, p1, k1, (k2tog) 2 times, k1, p1, k1] 3 times—36 sts rem.

Work 1 rnd even.

Dec rnd 10: [P1, (ssk) 2 times, p1, (k2tog) 2 times, p1, k1] 3 times—24 sts rem.

Dec rnd 11: [P1, ssk, p1, k2tog, p1, k1] 3 times—18 sts rem.

Work 1 rnd even.

Dec rnd 12: P1, [ssk] 8 times, ssk last st of rnd with first st, removing beg-of-rnd m—9 sts rem.

Cut yarn, leaving an 8" (20.5 cm) tail. Thread yarn tail on tapestry needle, draw yarn through rem sts, pull tight to close hole, and secure on WS.

Finishing
Weave in loose ends. Block to finished measurements.

THREE TIPS FOR
Choosing Yarns for
CABLED PROJECTS

As I found out the hard way, not all yarns work equally well for all types of stitch patterns. What works beautifully for lace doesn't necessarily translate into a perfect cabled design. This is how I choose yarn for knitting Aran designs:

1 **Fiber:** I like to use a yarn that has some elasticity. This will give you the stitch definition needed for the cables to really pop. So, look for wool or a wool blend. For example, 100 percent wool is perfect for a classic cabled sweater such as Willa (page 8).

If you want more drape to make a sweater such as Maisie (page 138), look for a merino and silk combination. I wanted the body of Idril (page 28) to have a nice drape, so I used a merino, cashmere, and silk blend. This gives you a very soft yarn that feels wonderful next to the skin, so I also used it for Billie (page 126).

2 **Ply:** The ply of the yarn can also be a factor. A smooth plied yarn will give your cables a crisp look, such as the 3-ply blend I used for Corinne (page 110). For a more rustic appearance, try a single-ply yarn.

3 **Color:** It's impossible to overstate the importance of color. Solid, semisolid, and tweeds are the best. If you use a variegated yarn, your stitch pattern will be completely lost, and your sweater will look crazy busy. And why do all that work when it will not show?

Some dark colors will also lose some of the stitch pattern. A very dark color with some sheen will show cables better than a matte dark color. Dark colors work even better when you have some lace mixed in with the cables, as in Keavy (page 118).

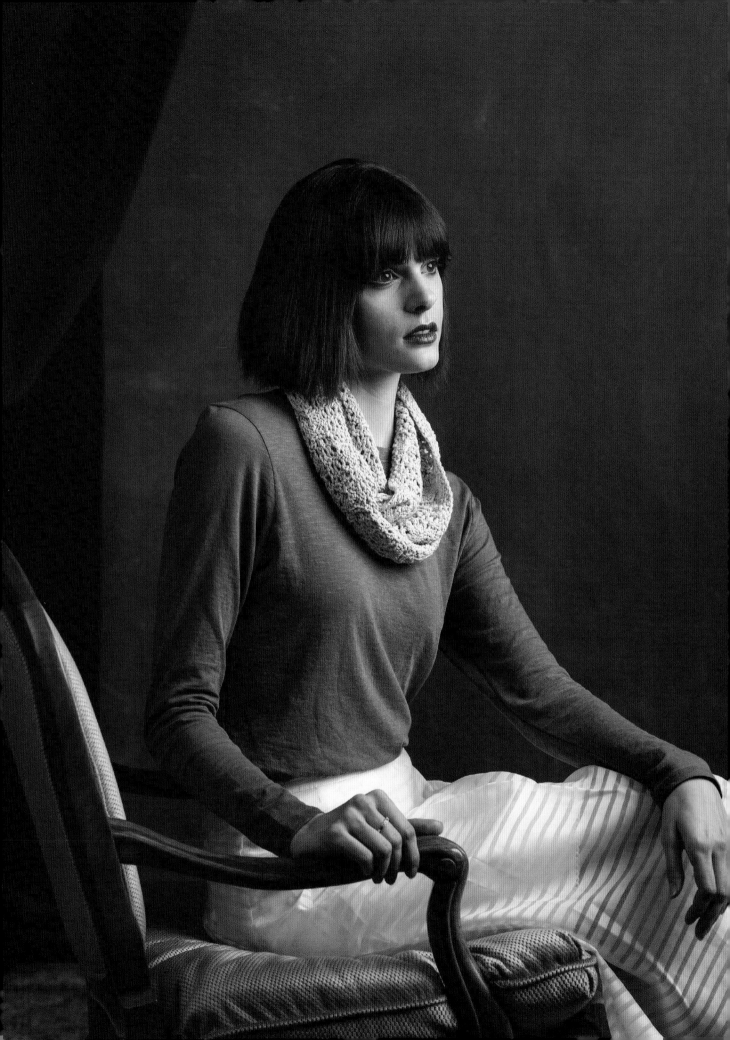

FINISHED SIZE
About 48½" (123 cm) in circumference and 5½" (14 cm) wide.

YARN
Worsted weight (#4 Medium).

Shown here: Berroco Maya (85% cotton, 15% alpaca; 137 yd [125 m]/1¾ oz [50 g]), cielo 5611, 2 skeins or 241 yd (220 m) of similar yarn.

NEEDLES
Size U.S. 7 (4.5 mm): 24" (60 cm) circular (cir).

Adjust needle size if necessary to obtain the correct gauge.

NOTIONS
Stitch marker (m); cable needle (cn); tapestry needle.

GAUGE
20 sts and 28 rnds = 4" (10 cm) in St st.

16 sts and 38 rnds = 4" (10 cm) in lace cable pattern, blocked.

Gauge is not critical.

Estee
LIGHT COWL

Estee—pronounced "es-TEE"—means star, and the cables worked among the eyelets in this cowl remind me of stars.

I discovered this stitch pattern in one of my Japanese stitch dictionaries. I love the way that two common stitch patterns—yarnovers with decreases plus a four-stitch cable—mix to make a sweet, feminine fabric.

I added a seed-stitch border. Combining simple patterns can create a lovely, lightweight cowl that is perfect for year-round wear. Estee has a simple lace stitch, making it appropriate for a novice lace knitter. It is a good design for practicing cabling without a needle because the cables are small and spread apart.

I used Berroco Maya for Estee, an unusual blend of Pima cotton and alpaca fibers. The alpaca makes it soft, and the high content of cotton makes it wearable during warmer seasons.

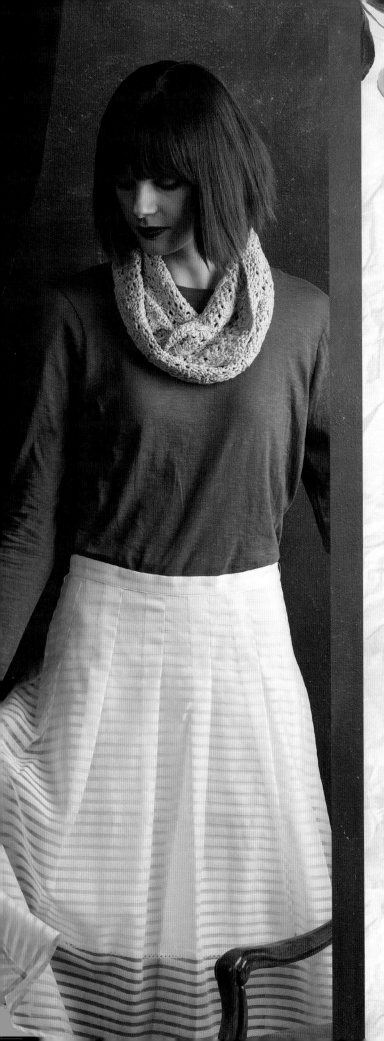

STITCH GUIDE

- **2/2 LC (2 over 2 left cross):** Sl 2 sts onto cn and hold in front, k2, k2 from cn.

Seed stitch (multiple of 2 sts):
- **Rnd 1:** *K1, p1; rep from *.
- **Rnd 2:** *P1, k1; rep from *.
- Rep Rnds 1 and 2 for patt.

Turn to the Glossary on page 144 to learn how to work these stitches:

K2tog

Ssk

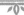

A word about construction:

Estee is worked in the round. If you desire a wider cowl, work additional rounds of the Aran Lace chart. If you'd prefer a longer or shorter cowl, add or subtract stitches in increments of 12, which will result in a difference of 2¾" (7 cm) per repeat in the Aran Lace chart. See Doing the Math on page 76.

The cables may be worked without a cable needle if desired (page 136).

Berroco Maya is a chainette yarn, which is similar to a knitted I-cord. It has more give and stretch than a traditional plied yarn, but it retains the crispness characteristic of cotton yarns. Maya is combed with a bit of alpaca, which gives it a slight halo without distracting from the stitch definition.

LIGHT COWL

CO 192 sts using the long-tail method (Techniques, page 144).

Place marker (pm) for beg of rnd and join for working in rnds, being careful not to twist sts.

Work 5 rnds in seed st.

Work Rows 1–9 of the Aran Lace chart.

Next rnd: Work Row 10 of the Aran Lace chart, knit to end, remove m, k1, pm for new beg of rnd.

Work Rows 11–19 of the Aran Lace chart.

Next rnd: Work Row 20 of the Aran Lace chart, knit to 1 st before end, sl st to RH needle, remove beg-of-rnd m, sl st back to LH needle, pm for new beg of rnd.

Work Rows 1–18 of the Aran Lace chart once more as established.

Work 5 rnds in seed st.

BO all sts loosely in patt.

Finishing
Weave in loose ends. Block to finished measurements.

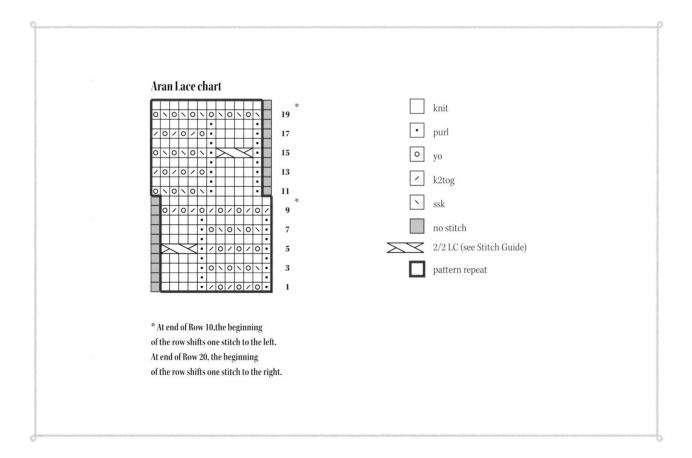

Aran Lace chart

knit	
•	purl
o	yo
∕	k2tog
∖	ssk
	no stitch
✕	2/2 LC (see Stitch Guide)
	pattern repeat

* At end of Row 10, the beginning
of the row shifts one stitch to the left.
At end of Row 20, the beginning
of the row shifts one stitch to the right.

HOW TO CABLE
Without
A CABLE NEEDLE

My method for working cable crosses without a cable needle is a little bit different than other methods. Even though you're slipping live stitches off of your needles, it's an easy, efficient way to work cables, especially small ones. Here's how I do it:

Step 1: On a cable-crossing row, work to just before the full cable group. With the yarn in the back of the work for a left-crossed cable and yarn in front of work for a right-crossed cable, slip half of the stitches from the group purlwise to the RH needle.

Example 3/3 LC cable: Slip 3 stitches to the right needle tip with the yarn in back. The stitches must be in front of the yarn.

Step 2: Work the stitches for the cable that are still on the left needle tip. For a left-crossed cable, bring the left needle tip to the front of the work and insert it into the fronts of all stitches that were slipped *(figure 2).*

For a right-crossed cable, bring the left needle tip to the back of the work and insert it into the backs of all the stitches that were slipped *(figure 1).*

Step 3: Pinch the base of the knitted stitches firmly between your left thumb and forefinger. Pull the right needle tip completely free of all 6 stitches *(figure 3),* maintain front/back position as established, and quickly reinsert it into the free stitches.

The knitted stitches will be on the RH needle and the slipped stitches will be on the LH needle ready to be worked.

Step 4: Work the stitches that were just put on the left needle tip *(figure 4).*

Example 3/3 LC cable: K3 from LH needle.

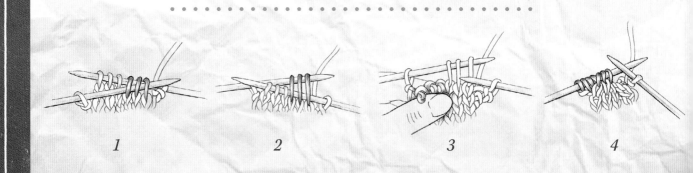

1 2 3 4

5 TIPS FOR CABLING *Without* A CABLE NEEDLE

1. Cabling without a separate needle works best with yarn that is not slippery.

2. Save this technique for smaller cables with fewer than 4 or 5 stitches crossing over each other, especially when you're learning this technique.

3. Always get the stitches from the opposite side of where you carried the yarn. For example, for a left-cross cable, you slip the stitches with the yarn in back, so get the stitches with the left-hand needle from the front of the work.

4. Push the stitches on the right-hand needle toward the tip when you are slipping the stitches off the needle. There will be less pull on these stitches, and you're less likely to lose a stitch.

5. Smash the stitches into the left-hand needle when slipping the right-hand needle out.

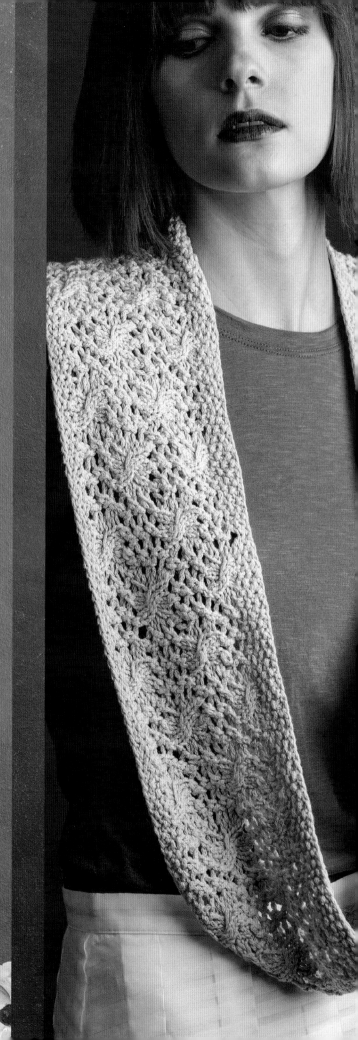

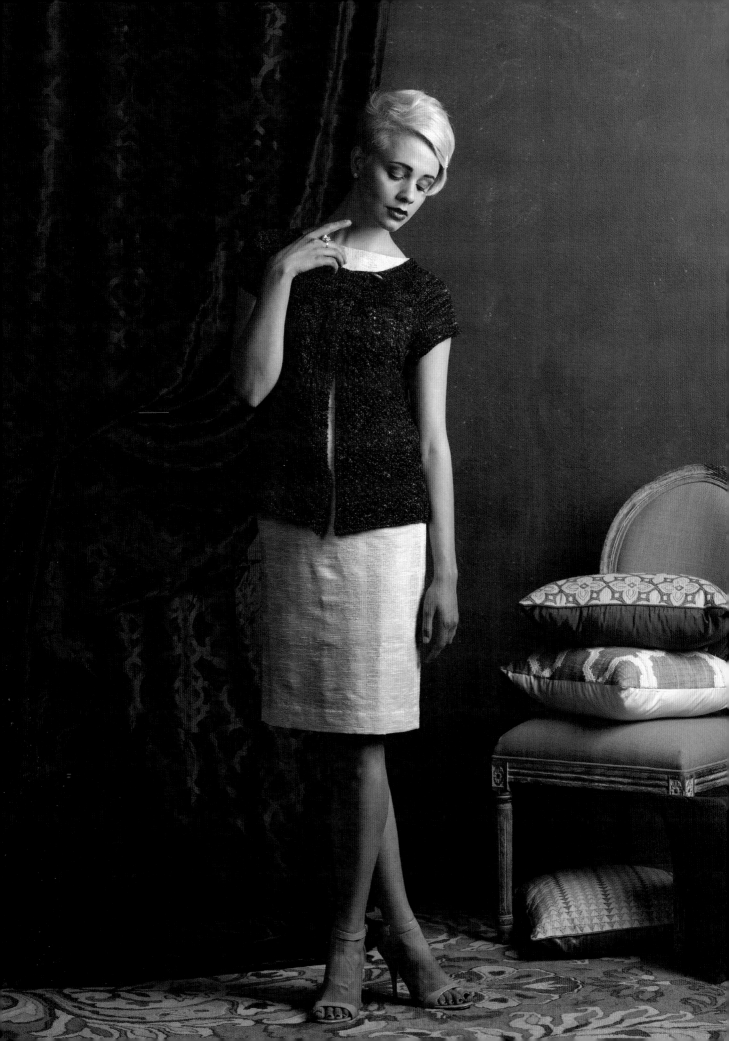

FINISHED SIZE

About 37¼ (40¾, 44¼, 47½, 51, 54½, 58, 61¼)" (94.5 [103.5, 112.5, 120.5, 129.5, 138.5, 147.5, 155.5] cm) bust circumference, with 6" (15 cm) overlap at neck and 20¾ (21, 21¾, 23¼, 24¼, 24½, 26½, 27)" (52.5 [53.5, 55, 59, 61.5, 62, 67.5, 68.5] cm) long.

Cardigan shown is size 40¾" (103.5 cm).

YARN

Worsted weight (#4 Medium).

Shown here: Handmaiden Smitten (80% superwash merino, 20% silk; 202 yd [185 m]/ 3½ oz [100 g]), radient orchid, 4 (4, 4, 5, 5, 6, 6, 7) skeins or 621 (680, 738, 849, 911, 974, 1,106, 1,168) yd (568 [622, 675, 776, 833, 890, 1,022, 1,068] m) of similar yarn.

NEEDLES

Size U.S. 6 (4 mm): 24" (60 cm) circular (cir) and set of 4 or 5 double-pointed (dpn).

Size U.S. F-5 (3.75 mm) crochet hook.

Adjust needle size if necessary to obtain the correct gauge.

NOTIONS

Stitch markers (m) in two colors; cable needle (cn); stitch holders or waste yarn; tapestry needle; one 1⅛" (28mm) oblong button; hook half of hook-and-eye set.

GAUGE

21 sts and 29 rows = 4" (10 cm) in cable lace patt, blocked.

21 sts and 30 rows = 4" over rib patt, blocked.

Maisie
SHORT-SLEEVE CARDIGAN

I have been playing around with this open stitch pattern for several years and finally found the perfect design for it: a short-sleeve wrap cardigan for summer. It is from the Vogue Knitting *stitch dictionary, and I added the rib stitch to flow into it. The lace stitches are only worked on the right side of the knitting, and the lace and cable stitches enter gradually as you work your way down the cardigan.*

This is a fun, light-hearted cardigan with plenty of eyelet holes to let in the breeze and light. Maisie is a fun, somewhat precocious name that means child of light or pearl.

I used Handmaiden Smitten, a superwash merino twisted yarn with pure mulberry silk, which creates a lovely mix of shade and hue. It is also soft with good stitch definition.

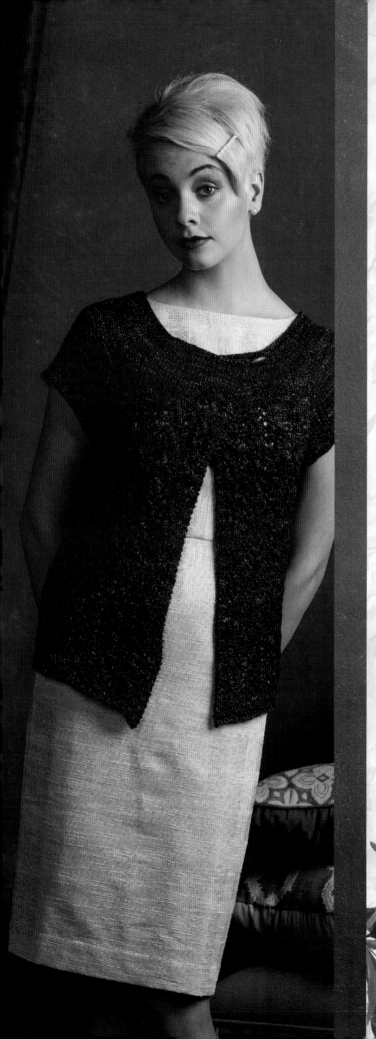

STITCH GUIDE

- **Crochet chain:** Make a slipknot and place it on crochet hook. *Yarn over hook and draw through loop on hook; rep from * for desired number of sts. To fasten off, cut yarn and draw end through last loop formed.
- **2/2 LC (2 over 2 left cross):** Sl 2 sts onto cn and hold in front, k2, k2 from cn.

Turn to the Glossary on page 144 to learn how to work these stitches:

Hide wrap
K2tog
M1
M1L
M1R
M1P
M1P-R
Short-rows
Ssk
W&t

A word about construction:

This rounded yoke cardigan is knitted in one piece from the top down with raglan increases to shape the bodice. To create a comfortable fit, short-rows are used to shape the back neckline. Maisie is designed for the fronts to overlap just at the neckline, so determine your size according to how much overlap you desire.

If the size you want to make has a wider neckline than you desire, CO with a needle one or two sizes smaller than the one required to get gauge. Work the CO and one or two rows with the smaller needle, then switch to the needle size that gives you the correct gauge.

SHORT-SLEEVE CARDIGAN

Yoke

With cir needle, CO 138 (138, 166, 166, 194, 194, 222, 222) sts using the long-tail method (Techniques, page 144). Do not join.

Next row (WS): Knit.

Next row: Beg at right side of the Yoke Rib chart with Row 1, work first 2 sts, rep next 7 sts 19 (19, 23, 23, 27, 27, 31, 31) times, work 3 sts at left side of chart.

Next row: Beg at left side of the Yoke Rib chart with Row 2, work first 3 sts, rep next 7 sts 19 (19, 23, 23, 27, 27, 31, 31) times, work 2 sts at right side of chart.

NOTE: Work only Rows 1 and 2 of the Yoke Rib chart when working the short-rows.

Short-row 1 (RS): Work Row 1 of the Yoke Rib chart to last 31 (31, 36, 36, 40, 40, 45, 45) sts, w&t.

Short-row 2: Work Row 2 of the Yoke Rib chart to last 31 (31, 36, 36, 40, 40, 45, 45) sts, w&t.

Short-rows 3–6: Work to wrapped st, hide wrap, work 10 (10, 13, 13, 15, 15, 17, 17) more sts, w&t.

Next 2 rows : Working Rows 3 and 4 of the Yoke Rib chart, work to end of row and hide wraps as you come to them.

Work Rows 5–11 of the Yoke Rib chart—178 (178, 214, 214, 250, 250, 286, 286) sts.

Set-up row 1: (WS) Working Row 12 of the Yoke Rib chart, work 34 (34, 39, 39 43, 43, 48, 48) sts for right front, place marker (pm) for raglan, p1, pm for raglan, work 27 (27, 35, 35, 45, 45, 53, 53) sts for right sleeve, pm for raglan, p1, pm for raglan, work 52 (52, 62, 62, 70, 70, 80, 80) sts for back, pm for raglan, p1, pm for raglan, work 27 (27, 35, 35, 45, 45, 53, 53) sts for left sleeve, pm for raglan, p1, pm for raglan, work 34 (34, 39, 39, 43, 43, 48, 48) sts for left front.

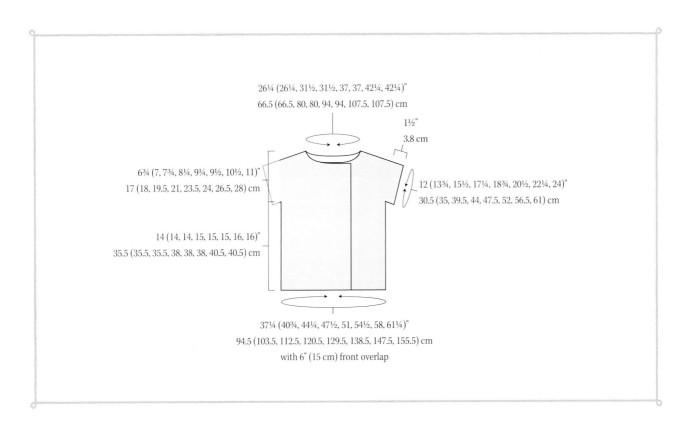

26¼ (26¼, 31½, 31½, 37, 37, 42¼, 42¼)"
66.5 (66.5, 80, 80, 94, 94, 107.5, 107.5) cm

1½"
3.8 cm

6¾ (7, 7¾, 8¼, 9¼, 9½, 10½, 11)"
17 (18, 19.5, 21, 23.5, 24, 26.5, 28) cm

12 (13¾, 15½, 17¼, 18¾, 20½, 22¼, 24)"
30.5 (35, 39.5, 44, 47.5, 52, 56.5, 61) cm

14 (14, 14, 15, 15, 15, 16, 16)"
35.5 (35.5, 35.5, 38, 38, 38, 40.5, 40.5) cm

37¼ (40¾, 44¼, 47½, 51, 54½, 58, 61¼)"
94.5 (103.5, 112.5, 120.5, 129.5, 138.5, 147.5, 155.5) cm
with 6" (15 cm) front overlap

Set-up row 2: Working Row 13 of the Yoke Rib chart, [work to raglan m, sl m, m1p, k1, m1p-r, sl m] 4 times, work to end—186 (186, 222, 222, 258, 258, 294, 294) sts; 34 (34, 39, 39, 43, 43, 48, 48) sts for each front, the 27 (27, 35, 35, 45, 45, 53, 53) sts for each sleeve, 52 (52, 62, 62, 70, 70, 80, 80) sts for the back, and 12 raglan sts.

Next row: Working Row 14 of the Yoke Rib chart, [work to raglan m, sl m, k1, p1, k1, sl m] 4 times, work to end.

NOTES: The yoke will transition from the ribbed pattern to the cable and lace pattern in 8-row repeats. The Yoke Cable and Lace chart will start at each front edge (the first 13 stitches and the last 12 stitches) and at the 9 center back stitches; all other stitches are worked in the established rib pattern.

After 8 rows, each Cable and Lace chart repeat will add 9 more stitches toward each sleeve; so, the second time the chart is worked, there will be 2 repeats on each front edge and 3 repeats at the center back.

At the same time, raglan increases are worked on every right-side row. The m1l and m1r increases are worked either knitwise or purlwise to maintain the rib pattern.

Set-up row (RS): *For left front and sleeve,* beg at right edge of chart and work Row 1 of the Yoke Cable and Lace chart over 13 sts, pm for cable, [work in established patt to raglan m, m1l, sl m, p1, k1, p1, sl m, m1r] 2 times;

For back and right sleeve, cont in established patt, work to first full rep of Yoke Rib chart, work 9-st rep 2 (2, 3, 3, 3, 3, 4, 4) times, pm for cable, work Row 1 of 9-st rep of the Yoke Cable and Lace chart once, pm for cable, [work in established patt to raglan m, m1l, sl m, p1, k1, p1, sl m, m1r] 2 times;

For right front: work in established patt to last 12 sts, pm for cable, work 9-st rep of Row 1 of the Yoke Cable and Lace chart, work last 3 sts of chart—8 sts inc'd.

Work 1 WS row even in established patt.

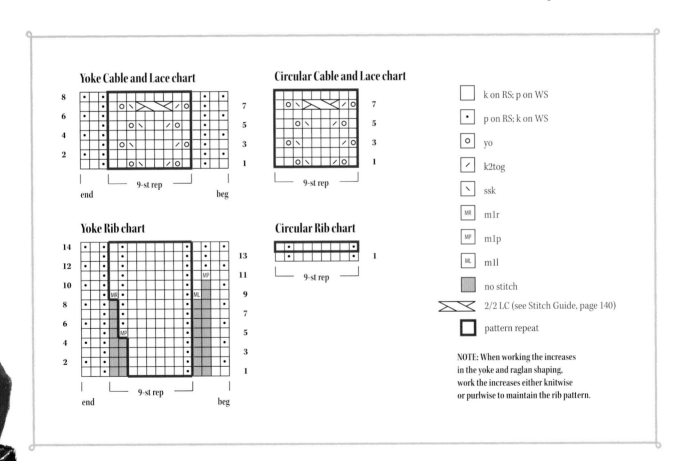

Yoke Cable and Lace chart

end 9-st rep beg

Circular Cable and Lace chart

9-st rep

Yoke Rib chart

end 9-st rep beg

Circular Rib chart

9-st rep

☐ k on RS; p on WS

• p on RS; k on WS

O yo

╱ k2tog

╲ ssk

MR m1r

MP m1p

ML m1l

▨ no stitch

⨯ 2/2 LC (see Stitch Guide, page 140)

☐ pattern repeat

NOTE: When working the increases in the yoke and raglan shaping, work the increases either knitwise or purlwise to maintain the rib pattern.

Increase body and sleeve stitches

Inc row: Work in established patt to raglan m, m1l, sl m, p1, k1, p1, sl m, m1r] 4 times, work to end—8 sts inc'd.

Work 1 WS row even.

Rep last 2 rows 2 more times.

Move all cable m 9 sts toward sleeves on last WS row—218 (218, 254, 254, 290, 290, 326, 326) sts; 38 (38, 43, 43, 47, 47, 52, 52) sts for each front, 35 (35, 43, 43, 53, 53, 61, 61) sts for each sleeve, 60 (60, 70, 70, 78, 78, 88, 88) sts for the back, and 12 raglan sts.

Rep inc row every RS row 7 (8, 9, 11, 12, 13, 14, 16) more times, moving all cable m 9 sts toward sleeves every 8 rows—274 (282, 326, 342, 386, 394, 438, 454) sts; 45 (46, 52, 54, 59, 60, 66, 68) sts for each front, 49 (51, 61, 65, 77, 79, 89, 93) sts for each sleeve, 74 (76, 88, 92, 102, 104, 116, 120) sts for the back, and 12 raglan sts.

Work 1 WS row even.

Divide body and sleeves

Next row (RS): Removing raglan m as you go, [work to raglan m, work 2 raglan sts, place next 51 (53, 63, 37, 79, 81, 91, 95) sts on a holder or waste yarn for sleeve, CO 12 (19, 17, 22, 20, 27, 25, 30) sts, work next 2 sts] 2 times, work to end—196 (214, 232, 250, 268, 286, 304, 322) sts rem.

Body

Working CO sts at underarms in established rib patt, cont in patt, moving all cable m 9 sts toward underarms every 8 rows until all sts are worked in the Yoke Cable and Lace chart.

Cont evenly until piece measures 14 (14, 14, 15, 15, 15, 16, 16)" (35.5 [35.5, 35.5, 38, 38, 38, 40.5, 40.5] cm) from armholes, ending with a RS row.

BO all sts kwise.

Sleeves

With dpn and RS facing, beg at center of underarm, pick up and k6 (10, 9, 11, 10, 14, 13, 15) sts evenly along CO edge, work held 51 (53, 64, 68, 79, 81, 92, 96) sleeve sts in established patt, then pick up and k6 (9, 8, 11, 10, 13, 12, 15) sts evenly along rem CO edge to center of underarm—63 (72, 81, 90, 99, 108, 117, 126) sts.

Pm for beg of rnd and join for working in rnds, taking care to not twist sts.

Next rnd: K6 (10, 9, 11, 10, 14, 13, 15), work in established rib patt to underarm picked up sts, cont in patt to end of the rnd, remove m, work enough sts to complete last 9-st rep, pm for new beg of rnd.

Work 1 rnd even, incorporating rem picked up sts into rib patt.

Work Rows 1–8 of the Circular Cable and Lace chart, then work Row 1 once more.

BO all sts pwise.

Finishing

Weave in loose ends. Block to finished measurements.

Work button loops

With crochet hook, work a chain 10 sts long, leaving a tail about 6" (15 cm) long. Fasten off chain, leaving a tail about 6" (15 cm) long. With one tail threaded in tapestry needle, sew end of chain to underside of front edge below CO edge. Sew rem tail below first tail.

Rep with rem chain on opposite side of front.

Try cardigan on. Mark placement for button on RS of left front and for hook on WS of right front. Sew button and hook to fronts as marked.

GLOSSARY
and
TECHNIQUES

Glossary

ABBREVIATIONS

beg: begin(s); beginning
BO: bind off
CC: contrast color
cir: circular
cm: centimeter(s)
cn: cable needle
CO: cast on
cont: continue(s); continuing
dec('d): decrease(d); decreasing
dpn: double-pointed needle(s)
foll: follow(s); following
g: gram(s)
inc('d): increase(d); increasing
k: knit
kwise: knitwise
k1f&b: knit into front and back of same stitch
k1tbl: knit 1 through back loop
k2tog: knit 2 together
k3tog: knit 3 together
LH: left hand
LLI: left lifted increase
LLI-P: left lifted purl increase
m: marker
MC: main color
mm: millimeter(s)
m1: make one (1 st increased)
m1l: make 1 left-slanting
m1p: make one purlwise
M1P-R: raised make 1 purlwise—right slanting
m1r: make 1 right-slanting
p: purl
patt: pattern(s)
p1f&b: purl into front and back of same stitch
p1tbl: purl 1 through back loop
p2tog: purl 2 together
p3tog: purl 3 together

pm: place marker
psso: pass slipped stitch over
pwise: purlwise
rem: remain(s); remaining
rep: repeat(s); repeating
rev St st: reverse stockinette stitch
RH: right hand
RLI: right lifted increase
RLI-P: right lifted purl increase
rnd(s): round(s)
RS: right side
sk2p: slip 1, knit 2 together, pass slipped stitch over (2 stitches together)
sl: slip
sm: slip marker
ssk: slip, slip, knit (decrease)
ssp: slip, slip, purl (decrease)
sssk: slip, slip, slip, knit (2 stitches decreased)
sssp: slip, slip, slip, purl (2 stitches decreased)
st(s): stitch(es)
St st: stockinette stitch
s2kp: slip 2 together, knit 1, pass slipped stitches over (2 stitches decreased)
tbl: through back loop
tog: together
WS: wrong side
wyib: with yarn in back
wyif: with yarn in front
w&t: wrap and turn
yd: yard(s)
yo: yarnover
***:** repeat starting point
(): alternate measurements and/or instructions
[]: work instructions as a group a specified number of times

Techniques

BIND-OFF

Standard Bind-Off

Knit the first st, *knit next stitch (2 sts on the right needle), insert the left needle tip into first stitch on RH needle *(figure 1)* and lift this stitch up and over the second stitch *(figure 2)* and off the needle *(figure 3)*. Repeat from * for desired number of sts.

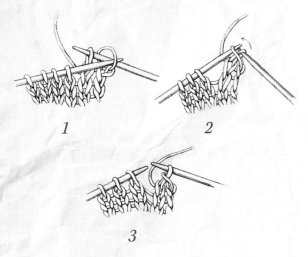

1 *2*

3

CAST-ONS

Backward-Loop

*Loop the working yarn and place it on the needle backward so that it doesn't unwind. Repeat from *.

Cable Cast-On

If there are no stitches on the needles, make a slipknot of working yarn and place it on the needle, then use the knitted cast-on method to cast on 1 more stitch—2 stitches on the needle.

Hold the needle with the working yarn in your left hand. *Insert right needle between the first 2 stitches on LH needle *(figure 1)*, wrap yarn around the needle as if to knit, draw yarn through *(figure 2)*, and place new loop on left needle *(figure 3)* to form a new stitch. Repeat from * for desired number of stitches, always working between the 2 stitches closest to the tip of the left needle.

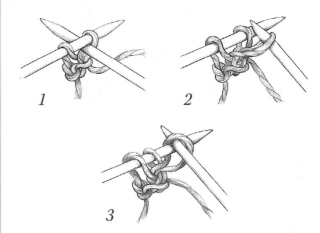

1 *2*

3

Knitted Cast-On

Make a slipknot of working yarn and place it on the left needle if there are no stitches on the needle. *Use the right needle to knit the first stitches (or slipknot) on the left needle *(figure 1)* and place the new loop onto the left needle to form a new stitch *(figure 2)*. Repeat from * for desired number of stitches, always working into the last stitch made.

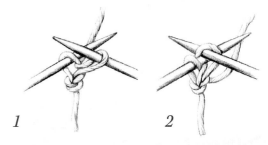

1 *2*

Long-Tail Cast-On

Leaving a long tail (about ½" [1.3 cm] for each stitch to be cast on), make a slipknot and place it on RH needle. Place thumb and index finger of your left hand between the yarn ends so that the working yarn is around your index finger and the tail end is around your thumb and secure the yarn ends with your other fingers. Hold your palm upward, making a V of yarn *(figure 1)*.

*Bring the needle up through the loop on your thumb *(figure 2)*, catch the first strand around your index finger and go back down through the loop on your thumb *(figure 3)*. Drop the loop off of your thumb and, placing your thumb back in the V configuration, tighten the resulting stitch on the needle *(figure 4)*. Repeat from * for desired number of stitches.

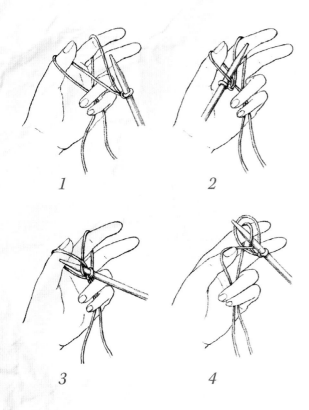

Provisional Cast-On

With waste yarn and a crochet hook, make a loose crochet chain about 4 stitches more than you need to cast on. With knitting needle, working yarn, and beginning 2 stitches from the end of the chain, pick up and knit 1 stitch through the back loop of each crochet chain for desired number of stitches. When you're ready to work in the opposite direction, pull out the crochet chain to expose the live stitches.

CABLES

Slip the designated number of stitches onto a cable needle, hold the cable needle in front of the work for a left-leaning twist *(figure 1)* or in the back of the work for a right-leaning twist *(figure 2)*, work the specified number of stitches from the left needle, then work the stitches from the cable needle in the order in which they were placed on the needle *(figure 3)*.

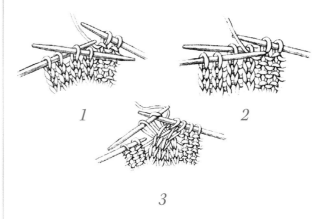

TWISTED STITCHES

Left Twist (LT)
Slip 1 stitch to a cable needle, hold in front, k1, k1 from the cable needle.

Right Twist (RT)
Slip 1 stitch to a cable needle, hold in back, k1, k1 from the cable needle.

Working Twisted Stitches without a Cable Needle

Left Twist (LT): Knit through the back loop of the second stitch on the left needle without dropping it. Bring the right needle to the front and knit the first stitch on the left needle as you normally would. Drop both stitches off of the left needle.

Right Twist (RT) on the right side: Skip the first stitch, knit the second stitch in the front loop, knit the skipped stitch in the front loop, and then slip both stitches from the needle together.

Right Twist (RT) on the wrong side: Skip the next stitch and purl the second stitch, then purl the skipped stitch, and then slip both stitches from the needle together.

Knit Through Back Loop (ktbl)

Insert the right needle through the loop on the back of the left needle from front to back, wrap the yarn around the needle, and pull a loop through while slipping the stitch off the left needle. This is similar to a regular knit stitch, but it is worked into the back loop of the stitch instead of the front.

Purl Through Back Loop (ptbl)

Insert the right needle into the back of the stitch from back to front, wrap the yarn around the needle, and pull a loop through while slipping the stitch off of the left needle. This is similar to a regular purl stitch, but it is worked into the back loop of the stitch instead of the front.

INCREASES

Bar Increase (k1f&b)

Knit into a stitch but leave it on the left needle (*figure 1*), then knit through the back loop of the same stitch (*figure 2*) and slip the original stitch off the needle (*figure 3*).

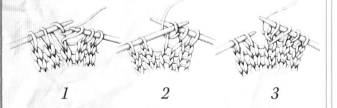

1 *2* *3*

Bar Increase (p1f&b)

Purl into a stitch but leave it on the left needle (*figure 1*), then purl through the back loop of the same stitch (*figure 2*) and slip the original stitch off of the needle.

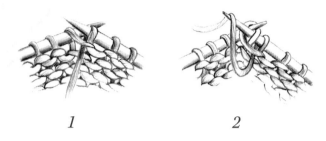

1 *2*

Inc 2

Use the right needle to pick up the right leg in the row below the next stitch on the left needle. Place it on the left needle, then knit this new stitch, slip marker (*figure 1*), knit into the back of the next stitch (*figure 2*), then slip marker. With the left needle, pick up the left side of the same stitch in the row below the knitted stitch (*figure 3*) and knit into the back of this strand. Two stitches have been increased (*figure 4*).

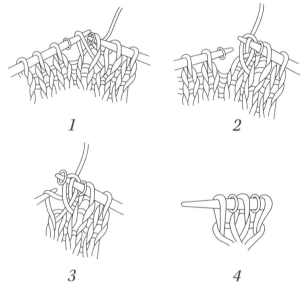

1 *2*

3 *4*

Left Lifted Purl Increase (LLI-P)

Use the left needle to pick up the back of the stitch 2 rows below the stitch just knitted, then purl this new stitch.

Right Lifted Purl Increase (RLI-P)

Use the right needle to pick up the stitch below the next stitch on the left needle. Place it on the left needle, then purl this new stitch.

Lifted Increase—Left Slant (LLI)

Insert the left needle tip into the back of the stitch below the stitch just knitted *(figure 1)*, then knit this stitch *(figure 2)*.

1 2

Lifted Increase—Right Slant (RLI)

Knit into the back of the stitch (in the "purl bump") in the row directly below the stitch on the left needle *(figure 1)*, then knit the stitch on the needle *(figure 2)*, and slip the original stitch off the needle.

NOTE: If no slant direction is specified in the instructions, use the right slant.

1 2

Raised Make One Purlwise (M1P)

With the left needle tip, lift the strand between the needles from front to back, then purl the lifted loop through the back of the loop.

Raised Make One Purlwise— Right Slant (M1P-R)

Insert the LH needle from the back to front, under the strand of yarn that runs between the last stitch on the LH needle and first stitch on the RH needle *(figure 1)*; purl this stitch through the front of the loop *(figure 2)*.

1 2

Raised Make One—Right Slant (M1R)

With the left needle tip, lift the strand between the needles from back to front *(figure 1)*. Knit the lifted loop through the front *(figure 2)*.

1 2

Raised Make One—Left Slant (M1L)

With the left needle tip, lift the strand between the last knitted stitch and the first stitch on the left needle from front to back *(figure 1)*. Knit the lifted loop though the back *(figure 2)*.

NOTE: If no slant direction is specific in the instructions, use the left slant.

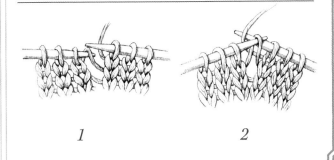

1 2

DECREASES

Slip, Slip, Knit (ssk)

Slip 2 stitches individually knitwise (*figure 1*), insert the left needle tip into the front of these 2 slipped stitches, and use the right needle to knit them together through the back loops (*figure 2*).

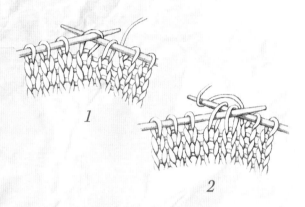

Slip, Slip, Purl (ssp)

Holding yarn in front, slip 2 stitches individually knitwise (*figure 1*), then slip these 2 stitches back onto the left needle (they will be turned on the needle) and purl them together through the back loops (*figure 2*).

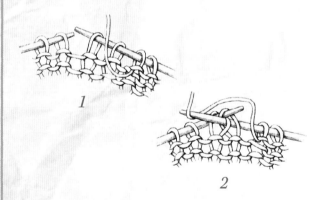

Slip, Slip, Slip, Knit (sssk)

Slip 3 stitches individually knitwise, insert the left needle tip into front of these 3 slipped stitches, and use the right needle to knit them together through the back loops. Two stitches have been decreased.

Slip, Slip, Slip, Purl (sssp)

Holding yarn in front, slip 3 stitches individually knitwise, then slip these 3 stitches back onto the left needle (they will be turned on the needle) and purl them together through the back loops. Two stitches have been decreased.

Purl Three Together (p3tog)

Purl 3 stitches together as if they were a single stitch.

Centered Double Decrease (s2kp)

Slip 2 stitches together knitwise (*figure 1*), knit 1 (*figure 2*), then pass the slipped stitches over the knitted stitch (*figure 3*). Two stitches have been decreased.

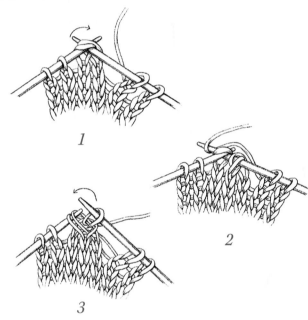

Left-Slant Double Decrease (sk2p)

Slip 1 stitch knitwise, knit the next 2 stitches together (*figure 1*), pass the slipped stitch over the knitted stitches (*figure 2*). Two stitches have been decreased.

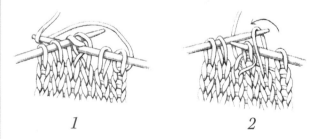

SHORT-ROWS

Wrap & Turn (w&t)

Knit row: With yarn in back, slip next stitch as if to purl, then bring yarn to front *(figure 1)*. Slip the stitch from the right needle back to the left needle and turn *(figure 2)*.

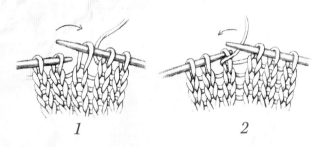

1 2

Purl row: With yarn in front, slip next stitch as if to purl, bring yarn to back *(figure 1)*. Slip the stitch from the right needle back to the left needle and turn *(figure 2)*.

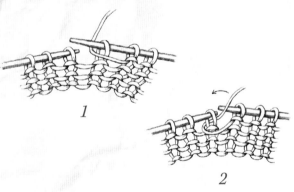

1

2

Hide Wrap

Knitting a wrapped stitch: Pick up the wrap with the right needle from front to back. Insert the right needle into the stitch that is wrapped. Knit together the wrap and the stitch.

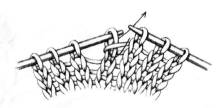

Purling a wrapped stitch: Pick up the wrap with the right needle from back to front. Place the wrap onto the left needle. Purl together the wrap and the stitch.

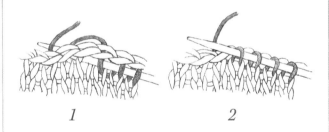

PICK UP AND KNIT

Pick Up and Knit Along a CO or BO Edge

With right side facing and working from right to left, insert the tip of the needle into the center of the stitch below the cast-on or bind-off edge *(figure 1)*, wrap yarn around the needle, and pull through a loop *(figure 2)*. Pick up 1 stitch for every existing stitch.

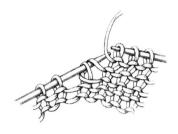

1 2

Pick Up and Knit Along a Shaped Edge

With right side facing and working from right to left, insert the tip of the needle between the last and second-to-last stitches, wrap yarn around needle, and pull through a loop. Pick up and knit about 3 stitches for every 4 rows, adjusting as necessary so the picked-up edge lays flat.

GRAFTING

Kitchener Stitch

Arrange stitches on two needles so there are the same number of stitches on each needle. Hold the needles parallel to each other with the wrong sides of the knitting together. Allowing about ½" (1.3 cm) per stitch to be grafted, thread matching yarn on a tapestry needle. Work from right to left as follows:

Step 1: Bring the tapestry needle through the first stitch on the front needle as if to purl. Leave the stitch on the needle *(figure 1)*.

Step 2: Bring the tapestry needle through the first stitch on the back needle as if to knit. Leave the stitch on the needle *(figure 2)*.

Step 3: Bring the tapestry needle through the first front stitch as if to knit and slip this stitch off the needle, then bring the tapestry needle through the next front stitch as if to purl. Leave the stitch on the needle *(figure 3)*.

Step 4: Bring tapestry needle through the first back stitch as if to purl and slip this stitch off the needle, then bring the tapestry needle through the next back stitch as if to knit. Leave the stitch on the needle *(figure 4)*.

Repeat Steps 3 and 4 until 1 stitch remains on each needle, adjusting the tension to match the rest of the knitting as you go. To finish, bring the tapestry needle through the front stitch as if to knit and slip this stitch off the needle, then bring the tapestry needle through the back stitch as if to purl and slip this stitch off the needle.

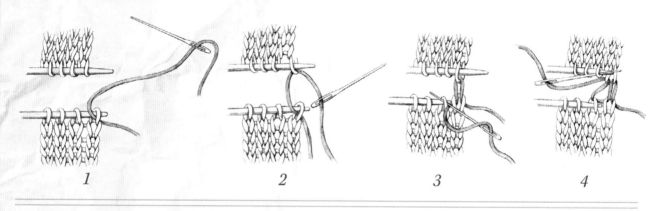

1 2 3 4

INVISIBLE VERTICAL SEAM
(or Mattress Seam)

Place the pieces to be seamed on a table, right sides facing up. Begin at the lower edge and work upward as follows: Insert threaded needle under one bar between the 2 edge stitches on one piece, then under the corresponding bar plus the bar above it on the other piece *(figure 1)*. *Pick up the next two bars on the first piece *(figure 2)*, then the next two bars on the other piece *(figure 3)*. Repeat from *, ending by picking up the last bar, or pair of bars, on the first piece.

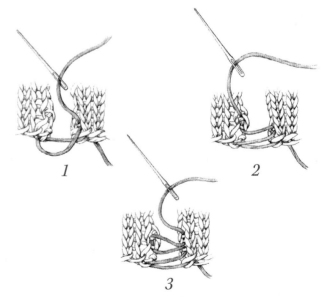

1 2

3

WEAVE IN LOOSE ENDS

Thread the ends on a tapestry needle and trace the path of a row of sts *(figure 1)* or work on the diagonal, catching the back side of the stitches *(figure 2)*. To reduce bulk, do not weave two ends in the same area.

1

2

SEWING LOOSE ENDS

With a sewing needle threaded with coordinating single thread and leaving a tail, thread the needle back and forth through the back side of the last stitch that the loose end was threaded through and through the loose end. As you do this, thread the needle back in close to where it came out. Thread it back out to a different place. Do this many times, coming out where the tail of the thread was with the last stitch. Tie the two ends of thread together in a knot. Cut the threads off very close to the knot, then cut the loose end off very close to the last stitch that the loose end was threaded through.

MEASURING GAUGE

Knit a swatch at least 4" (10 cm) square. Remove the stitches from the needles or bind them off loosely. Lay the swatch on a flat surface. Place a ruler over the swatch and count the number of stitches across and number of rows down (including the fractions of stitches and rows) in 2" (5 cm). Divide this number by two to get the number of stitches (including fractions of stitches) in one inch. Repeat two or three times on different areas of the swatch to confirm the measurements.

If you have more stitches or rows than called for in the instructions, knit another swatch on larger needles; if you have fewer stitches or rows called for in the instructions, knit another swatch on smaller needles.

RESOURCES
and
INDEX

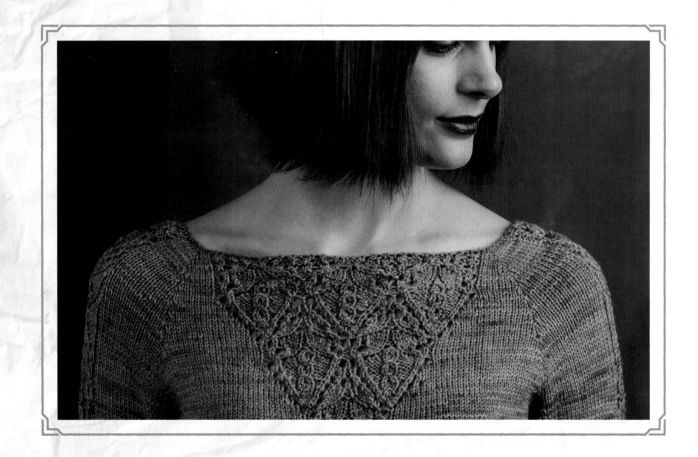

Resources

Anzula Yarns
740 H St.
Fresno, CA 93721
anzula.com

Berroco
1 Tupperware Dr. Ste 4
North Smithfield, RI
02896-6815
berroco.com

Brooklyn Tweed
135 NE 12 Ave.
Portland, OR 97232
brooklyntweed.com

Crave Yarn
Yarn & Coffee
1836 Cerrillos Rd.
Santa Fe, NM 87505
craveyarn.com

Ella Rae
c/o Knitting Fever Inc.
K. F. I.
PO Box 336
315 Bayview Ave.
Amityville, NY 11701
www.ellarae.com.au

The Fibre Company
228 Krams Ave.
Conshohocken, PA
19127
thefibreco.com

Handmaiden
c/o Fleece Artist
1174 Mineville Rd.
Mineville, NS
Canada B2Z 1K8
fleeceartist.com

Lorna's Laces
4229 N Honore St.
Chicago, IL 60613
lornaslaces.net

Madelinetosh
7515 Benbrook Pkwy.
Benbrook, TX 76126
madelinetosh.com

Rowan
c/o Westminster Fibers
8 Shelter Dr.
Greer, SC 29650
knitrowan.com

Shalimar Yarns
5917 Boyers Mill Rd.
New Market, MD 21774
shalimaryarns.com

Shibui Knits
1500 NW 18th Ste. 110
Portland, OR, 97209
shibuiknits.com

Sweet Georgia
110-408 East Kent Ave.
S. Vancouver, BC
CanadaV5X 2X7
sweetgeorgiayarns.com

. .

Stitch Dictionaries

Bush, Nancy. *Knitted Lace of Estonia*. Loveland, Colorado: Interweave, 2008.

Knitting Patterns Book 300. Japanese Stitch Book.

Knitting Patterns Book 1000. Japanese Stitch Book.

Knitting Patterns 300. Japanese Stitch Book.

Leapman, Melissa. *Cables Untangled*. New York: Potter Craft, 2006.

The Harmony Guides: Lace & Eyelets. Loveland, Colorado: Interweave, 2007.

Vogue Knitting Stitchionary Volume 2: Cables. New York: Sixth & Spring Books, 2006.

Vogue Knitting Stitchionary Volume 5: Lace Knitting. New York: Sixth & Spring Books, 2010.

Walker, Barbara G. *A Treasury of Knitting Patterns*. Pittsville, Wisconsin: Schoolhouse Press, 1998.

A Charted Knitting Design. Pittsville, Wisconsin: Schoolhouse Press, 1998.

Construction Inspiration and Technique

Righetti, Maggie. *Sweater Design in Plain English*. New York: St. Martin's Press, 1990.

Walker, Barbara G. *Knitting from the Top*. Pittsville, Wisconsin: Schoolhouse Press, 1996.

Online Sources

Seaming: vogueknitting.com

Attached I-Cord: purlbee.com

Kitchener Stitch: knitty.com

Index

· ·

abbreviations *145*

backward-loop cast-on *146*

bar increase (k1f&b, p1f&b) *148*

bind-off *146*

cable cast-on *146*

cables *136–137, 147–148*

cast-ons *146-147*

centered double decrease (s2kp) *150*

charts, reading lace *83*

construction *10*

decreases *150*

ends,

 sewing in *153*;

 weaving in *153*

gauge *153*

grafting *152*

increases *148–149*

increase 2 *148*

Kitchener stitch *152*

knit through back loop (ktbl) *148*

knitted cast-on *146*

left lifted purl increase (LLI-P) *148*

left-slant double decrease (sk2p) *150*

left twist (LT) *147*

left twist without cable needle *148*

lifted increase—left slant (LLI) *149*

lifted increase—right slant (RLI) *149*

long-tail cast-on *147*

mattress stitch *152*

pick up and knit *151*

provisional cast-on *147*

purl three together (p3tog) *150*

purl through back loop (ptbl) *148*

raised make one purlwise (M1P) *149*

raised make one purlwise—right slant
 (M1P-R) *149*

raised make one—right slant (M1R) *149*

raised make one—left slant (M1L) *149*

right lifted purl increase (RLI-P) *149*

right twist *147*

right twist without cable needle *148*

seam, invisible vertical *152*

short-rows *151*

sizing, cowl *76*

slip, slip, knit (ssk) *150*

slip, slip, purl (ssp) *150*

slip, slip, slip, knit (sssk) *150*

slip, slip, slip, purl (sssp) *150*

twisted stitches *147–148*

wrap & turn (w&t) *151*

wrap, hide *151*

yarn, choosing *131*

EDITOR
Leslie T. O'Neill

PHOTOGRAPHER
Joe Hancock

TECHNICAL EDITOR
Therese Chynoweth

PHOTO STYLIST
Allie Liebgott

ART DIRECTION & DESIGN
Bekah Thrasher

HAIR & MAKEUP
Kathy MacKay

· ·

fw

a content + ecommerce company

www.fwcommunity.com

10 9 8 7 6 5 4 3 2 1

Distributed in Canada by Fraser Direct
100 Armstrong Avenue
Georgetown, ON, Canada L7G 5S4
Tel: (905) 877-4411

Distributed in the U.K. and Europe by
 F&W MEDIA INTERNATIONAL
Brunel House, Newton Abbot, Devon, TQ12 4PU, England
Tel: (+44) 1626 323200, Fax: (+44) 1626 323319
E-mail: enquiries@fwmedia.com

Distributed in Australia by Capricorn Link
P.O. Box 704, S. Windsor NSW, 2756 Australia
Tel: (02) 4560 1600, Fax: (02) 4577 5288
E-mail: books@capricornlink.com.au

SRN: 15KN13
ISBN-13: 978-1-63250-068-7

PDF SRN: EP9753
PDF ISBN-13: 978-1-63250-069-4

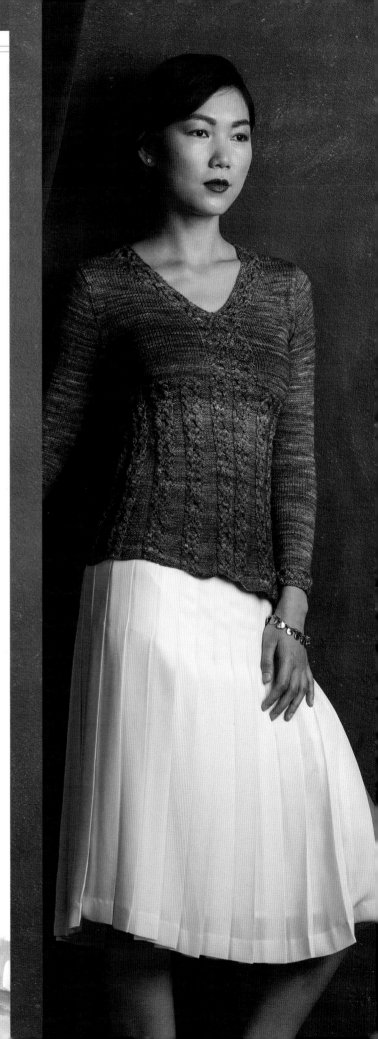

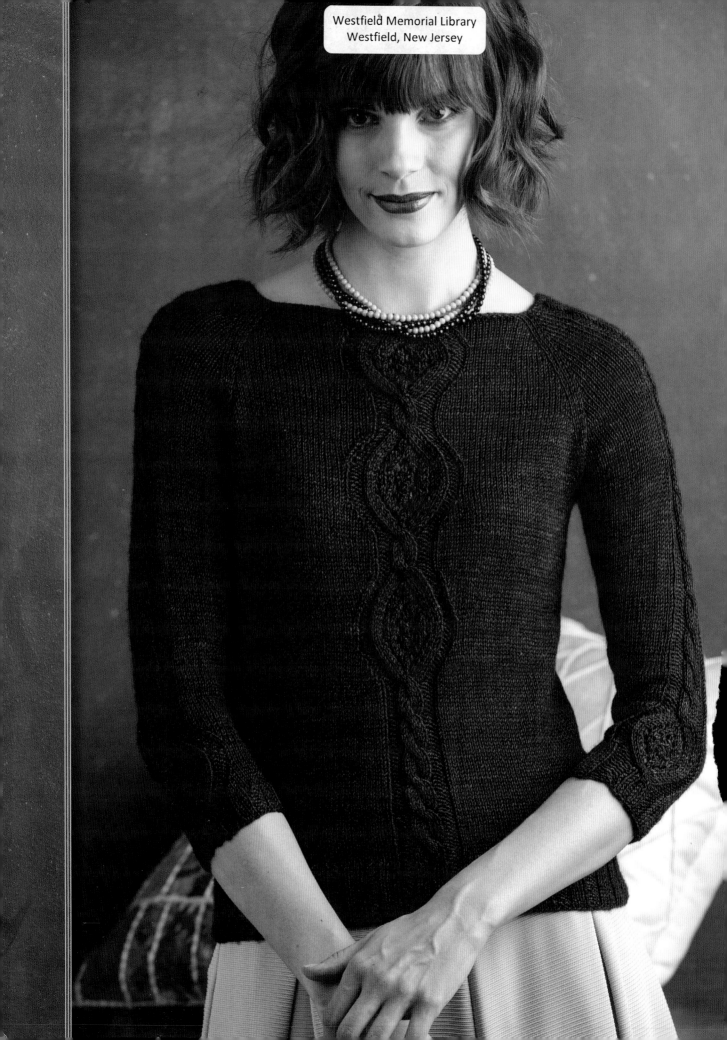